MAGNIFICENT
AFRICA

MAGNIFICENT AFRICA

Tom Schandy

DUNCAN BAIRD PUBLISHERS

LONDON

Magnificent Africa

Tom Schandy

This edition published in the United Kingdom and Ireland in 2004 by
Duncan Baird Publishers Ltd
Sixth Floor
Castle House
75–76 Wells Street
London W1T 3QH

Translated by Julie Martin in association with
First Edition Translations Ltd, Cambridge, UK

Managing Editor: Christopher Westhorp
Editor: Joanne Clay
Managing Designer: Manisha Patel
Design assistance: Sailesh Patel

British Library Cataloguing-in-Publication Data:
A CIP record for this book is available from the British Library

10 9 8 7 6 5 4 3 2 1

ISBN: 1-84483-069-1

Typeset in Joanna and Champion
Colour reproduction by Scanhouse, Malaysia
Printed in Singapore by Imago

CONTENTS

FOREWORD

When and if Africa is mentioned in the media of economically better-off industrialized nations, it is more often than not about civil wars, drought and hunger. This is an unbalanced and in many cases unfair picture of a continent that is teeming with life and joyful people, and which slowly but surely is on its way to democratization, despite all its economic problems. Africans themselves are often cynical about the negative perceptions of their continent in the richer parts of the world, particularly in light of the absence of serious commitments by these same countries to assist with economic recovery. Above all, these perceptions do not account for the tremendous riches that African governments have set aside as protected areas, covering a far larger proportion of their countries than is the case anywhere else in the world.

Revenue from tourism is certainly a motivating factor for the conservation of large and valuable landscapes. However, people in many African countries are also increasingly aware that in the long run, their economy depends on intact ecosystems – forests, wetlands, savannas and coastal areas – not least for the rural populations whose livelihoods are directly linked to these natural assets.

Tom Schandy's photographs cover but two aspects of Africa's present-day reality, its immensely diverse wildlife and magnificent landscapes. But this is the reality from which Africa as we know it originated – and which stood even at the birth of humanity. And, with ever-increasing pressures from economic development, human population increase, damaging land use, wildlife trade and climate change, this is the part of Africa that is most in need of our care and stewardship, whether we live in Africa or elsewhere.

Dr Claude Martin
Director General
WWF INTERNATIONAL

INTRODUCTION

Colours. Scents. Sounds. Starry skies. People. Laughter. Happiness. Smiles. Poverty. Lions. Elephants. Leopards. Horizons. Migrating animals. Sunrises. Sunsets. Acacia trees. Lightning. Rain. Rivers. Water. Mirages. Storks. Massages. Sun. Warmth. Sand. Drought. Waterholes. AFRICA!

I shall never forget my first encounter with Africa. I was seventeen years old and was allowed to go with two Norwegian friends on a bird-watching trip to the Gambia. The airport in the capital, Banjul, consisted of a single landing strip and a simple shed which served as the terminal building. We landed in the evening and I remember the heat that hit me as I stepped out of the plane. I also remember all the noises – the cicadas singing in the bushes. And I remember the crowds of people waiting on the other side of the very basic passport control. Their poverty was manifest, yet everywhere I saw smiles and an obvious love of life. Everything was different, exotic and exciting.

The bird-life was incomparably rich. I remember my first encounter with the red-breasted Barbary shrike singing a duet with his mate in a thicket. I remember how the beautiful sunbirds with their long tail feathers sucked nectar from brightly coloured flowers, and how the shimmering blue kingfishers dived for small fish in the swamps. In the little bush reserve of Abuko I walked smack into a cobra. It did what cobras always do when they feel threatened – lifted its head, spread its characteristic hood and hissed. I took close-up shots as fast as I could and withdrew. The snake slithered into the bushes and disappeared.

From that very first trip to the Gambia I was hooked on Africa. Seven years later I visited Kenya and travelled around the world-famous national parks. I saw elephants, lions, leopards and beautiful birds. I met the proud and stately Masai people. Again I was spellbound by this immense continent.

I have now visited Africa more than ten times. I have been to Madagascar, seen the mountain gorillas in Rwanda, paddled a mokoro canoe in Okavango and climbed the world's highest sand dunes in Namibia. I have seen the Ngorongoro crater in Tanzania, hiked on Mount Kenya and snorkelled among the coral reefs off Mombasa. I have been attacked by a rhinoceros and heard elephants trampling around my tent at night. But I have not been struck down with malaria, sleeping sickness or bilharzia. And I have never been bitten by a snake. Africa is actually not as

dangerous as many people claim. But it has a unique landscape – and a fabulous variety of wildlife. Nowhere else in the world can you find so many predatory and herbivorous animals as on the East African savanna. Here there are pretty much intact ecosystems which still function in the same way as they have since the dawn of time. And yet there are fewer and fewer truly wild areas, and those that remain are growing smaller and smaller. Our modern world is encroaching ever further into the African wilderness. This will have tragic consequences, not just for the animals, but also for the people – its thriving wildlife and stunning natural landscapes are, of course, among Africa's main resources.

This book is my tribute to the wild, untouched Africa. I hope that parts of that continent can be preserved as a wilderness even in the future. At the same time, I hope that the terrible downward spiral of poverty will turn upward one day – that this poor continent will be granted a new lease of life. I also hope that democracy and justice will spread, and that the disaster of famine will cease. If these goals are to be reached, economic development has to take place – development to which the rest of the world must contribute.

So with these words in mind, please join me on my travels through the African wilderness. Experience the animals, experience the untouched landscape, experience the people. I can provide the pictures, but you will have to imagine for yourself the sounds and scents. Have a good journey – or safari, which means journey in Swahili.

Tom Schandy

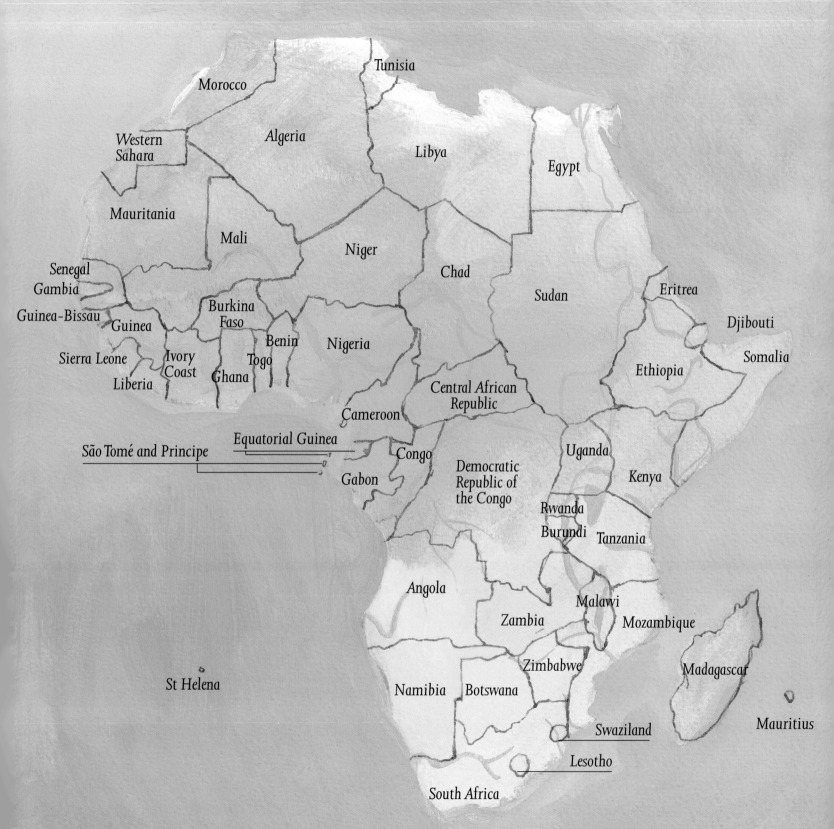

ILLUSTRATION: IDA BJÖRS

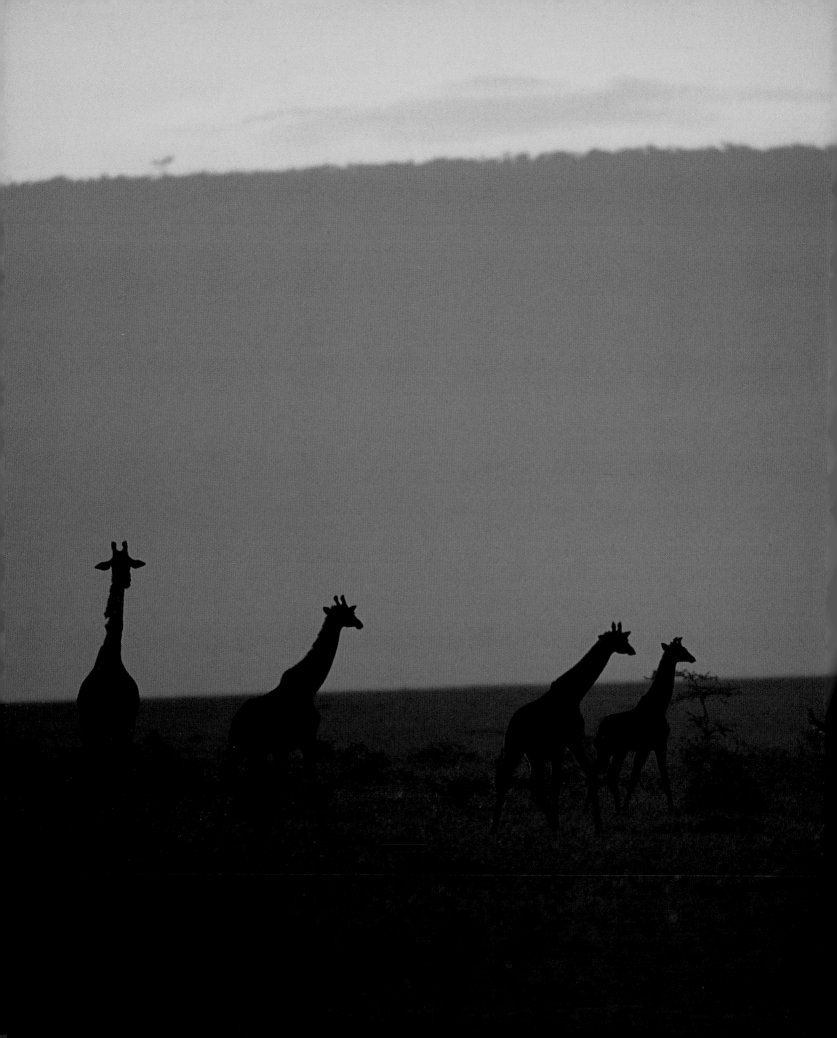

SAVANNA

Nearly 4 million square miles (10 million sq km) of the surface of the African landmass is covered with savanna – in other words almost one third of the entire continent. Savanna is found in Africa's tropical and subtropical regions, where annual rainfall is between 2 and 64 inches (50 and 1,600 mm).

There is a striking range of savanna landscapes – from the grass plains of the Serengeti to the tree and scrub savannas of southern Africa. Differences are largely due to variations in rainfall. Bushes and trees have deep root systems and can only grow where there is plenty of rain; in areas of scarce rainfall, the grass, which has a dense root system in the upper layer of the soil, takes all the life-giving moisture for itself. But if it rains more than 64 inches (1,600 mm) a year, the grass is completely pushed out and the forest takes over. Africa's many grazing animals help to keep the landscape open, as do the great grass fires which regularly rage across the savannas.

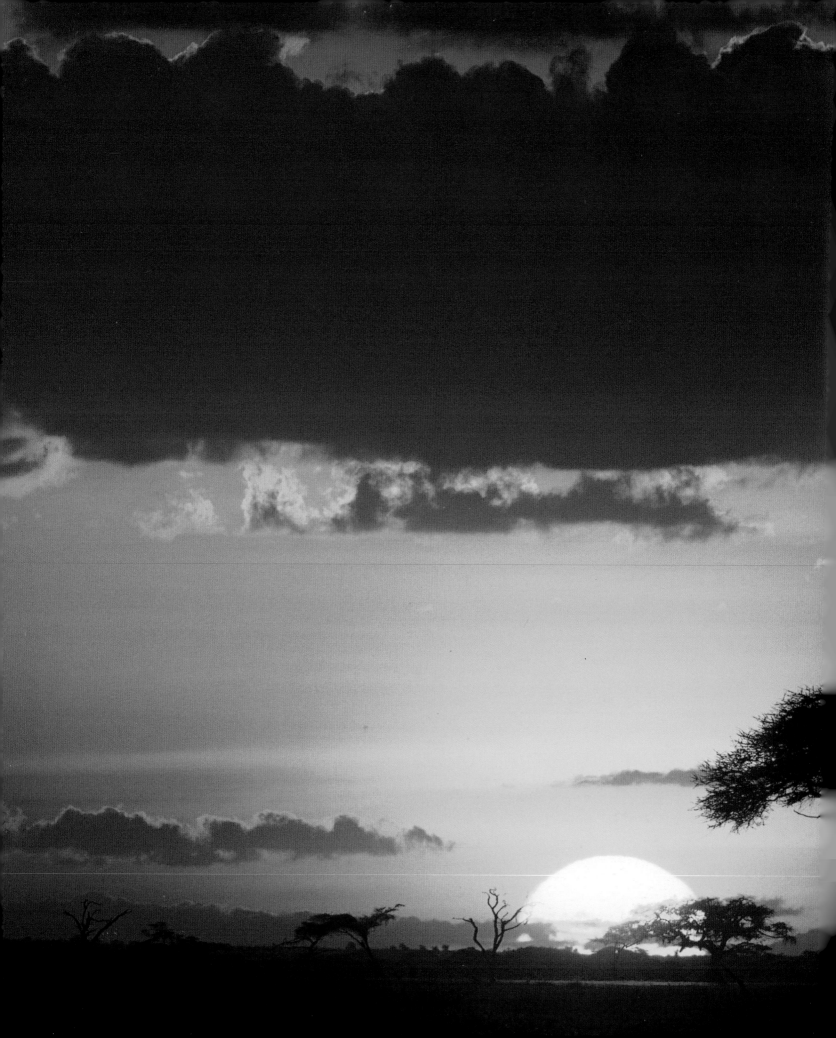

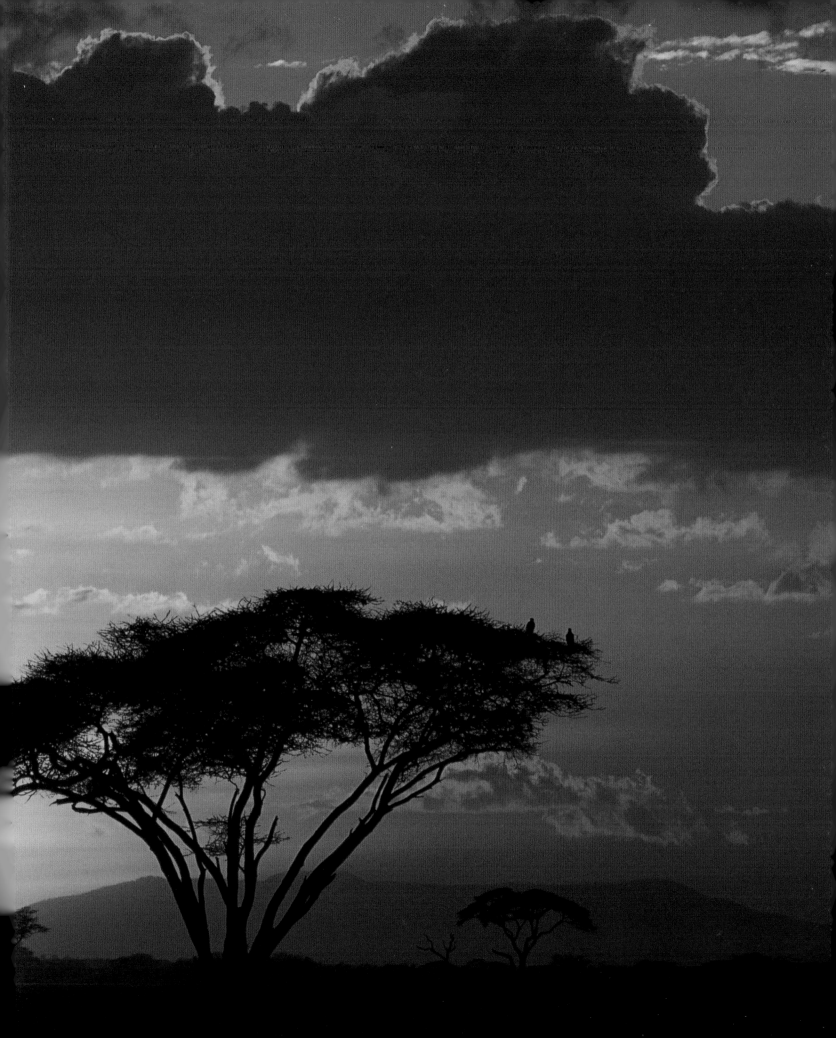

The arrival of the giraffes. The African day has only just begun when we catch sight of the giraffes. Like miniature Eiffel towers they glide over the savanna with quiet, measured strides. There is something timeless about the giraffe – it seems to belong to another age.

Always on the move. The nasal calls of the wildebeest, also known as the brindled gnu, can be heard right across the savanna as the long line of animals is silhouetted against the morning sky. It is August in the Masai Mara and the middle of the world-famous wildebeest migration. Nowhere else on earth can you experience an animal migration of such dimensions as this one.

The wildebeest are constantly on the move, looking for water and fresh grass. From December to June they stay in the southern part of the Serengeti in Tanzania. When the dry season begins in June and the plains turn to dusty, burnt-out deserts, the great herds set off northward to the promised land – Kenya's Masai Mara. Here there is juicy grass and plenty to drink. In November, when the rains begin and the dry plains to the south become luxuriant grazing pastures once again, the wildebeest return to the Serengeti.

The river crossing. The migrating wildebeest face many dangers on their epic journey, one of the greatest of which is the Mara River. Large herds of wildebeest and zebra collect on its banks, uncertain whether they dare attempt the crossing. They may stand there for several hours, just staring down into the water where the crocodiles lie in wait. Finally it happens – the first few animals take the plunge. Immediately, the others follow them, and for a long time a rapid stream of animals crosses the river. The crocodiles float toward the herds like logs. A young wildebeest falls victim while the others hurry to safety on the far bank. Sometimes there is chaos during the crossing. Panic breaks out among the animals – some are trampled to death, others drown. Crocodiles, vultures, hyenas and other scavengers quickly arrive to obliterate all traces of such a tragedy. Without a backward glance, the rest of the herd moves tirelessly onward in its search for fresh water and green pastures.

PAGE 12: *At about 16 feet, 6 inches (5 m) the giraffe is not just tall, it is also heavy; fully grown males can weigh up to 2 tons. Masai Mara, Kenya.*

PREVIOUS PAGE: *A new day dawns in the Amboseli national park in Kenya. The rising sun emerges from behind one of the acacia trees that are scattered sparsely over the savanna.*

BELOW: *Some of the one and a half million wildebeest found in the Masai Mara and Serengeti head out into the perilous Mara River, Kenya.*

NEXT PAGE: *Wildebeest and zebra swimming across the Mara River, Masai Mara, Kenya.*

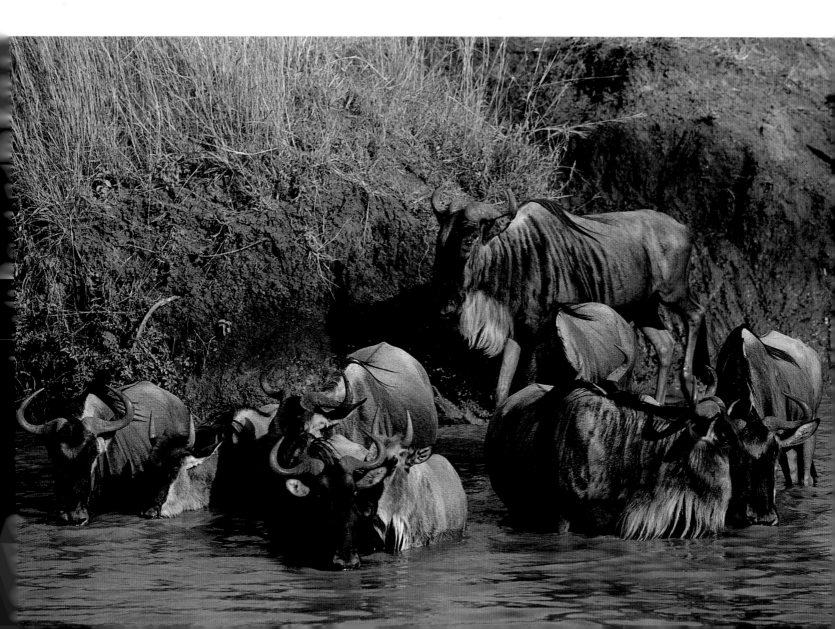

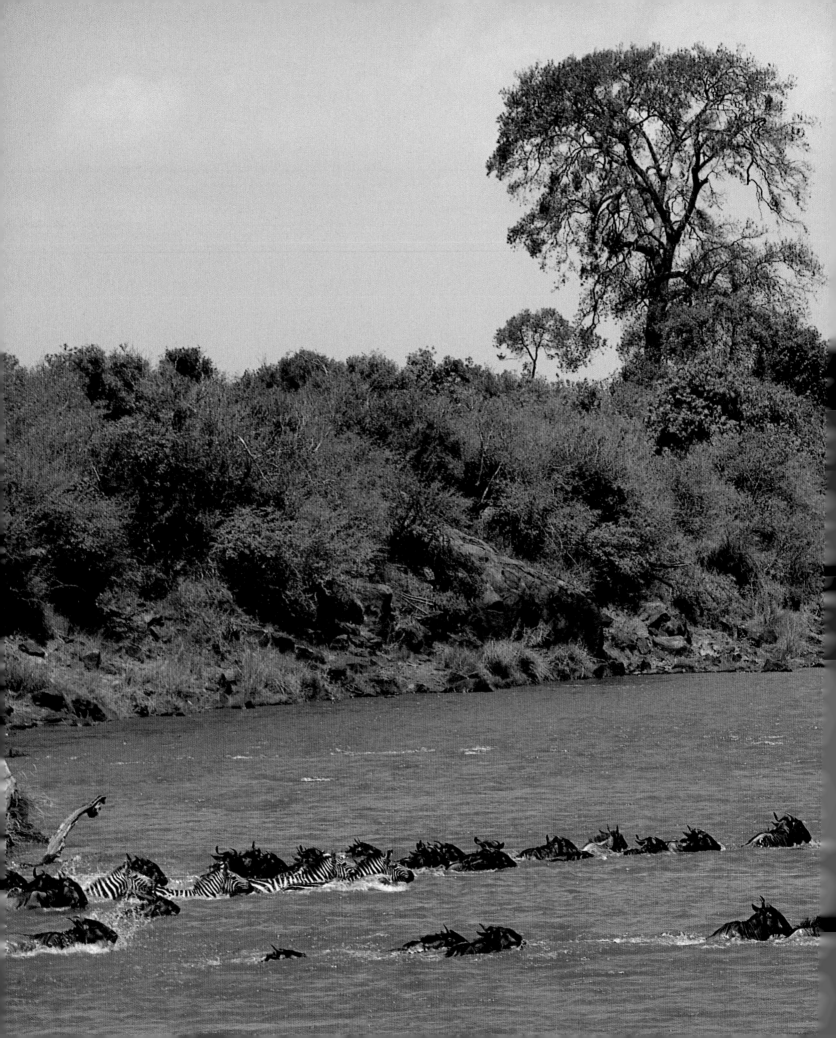

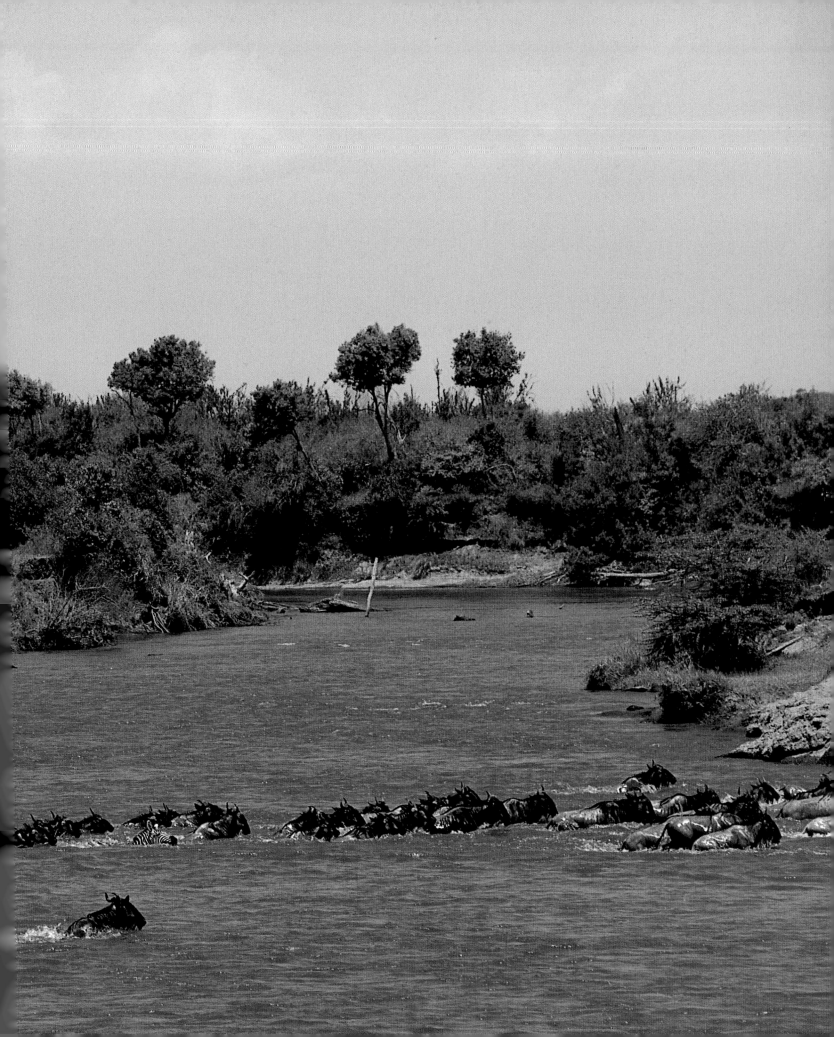

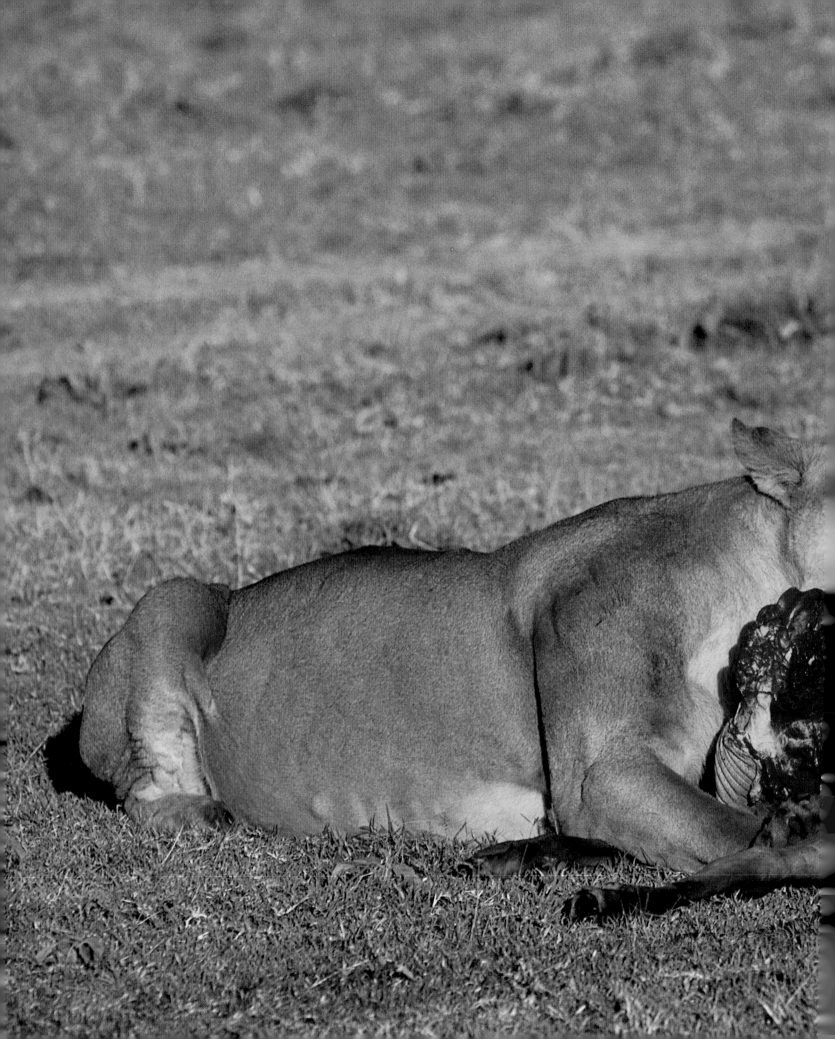

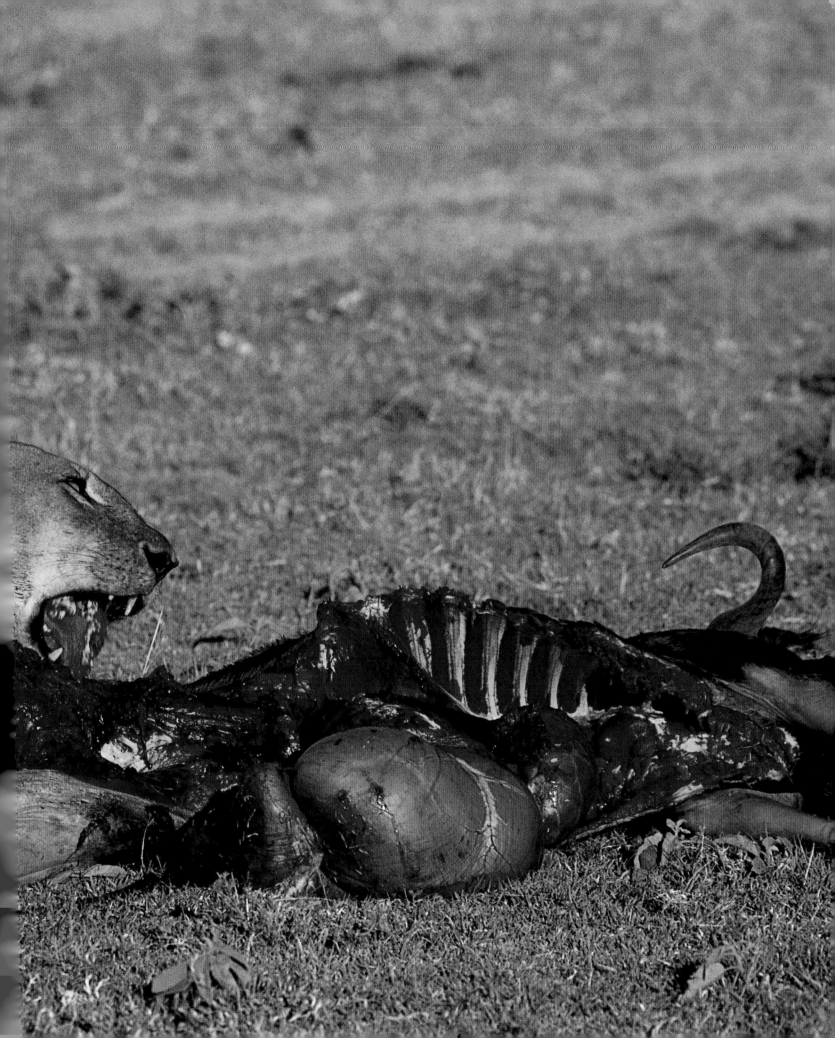

The prey. The lioness pictured on the previous page is just finishing a hearty breakfast. She had been lying in wait in the darkness of the night. When the wildebeest was about 100 feet (30 m) away she pounced. She probably grabbed her prey with her forelegs, or perhaps hit it hard on the rump. When the wildebeest fell, the lioness had to seize it by the throat as quickly as possible, or clamp her jaws tightly around its muzzle, smothering both the mouth and nostrils to suffocate it.

In spite of the lone lion's power and strength, only an average of one in five of its attacks is successful. Lions hunting in packs are far more lethal – one in three attacks results in the prey being felled. When several lionesses spread out and creep up on their prey from different angles, naturally the chances of a successful outcome to the hunt increase. Nevertheless, a study of more than a thousand lion hunts showed that lions hunted alone in almost half of the cases; two lions worked together in twenty per cent of cases; and packs of three to eight lions carried out the remaining hunts studied. In a few rare cases up to fourteen lions were involved in the same hunt.

The males do not usually hunt – in the lions' world it is the females who bring in most of the food. However, when the prey has been brought down it is the highest-ranking male who gets to feed first, followed by the other members of the pride. Only occasionally, if the prey is big enough, do all the lions in the pride feed at the same time.

As a rule, lions prey on large animals; wildebeest and zebra are among their favourite targets. Some lions hunt African buffalo, which can weigh four times as much as their aggressors, and in Botswana there are even lions that specialize in hunting elephants during periods of drought, attacking both calves and adult animals. An adult lioness requires 11 pounds (5 kg) of meat a day on average, and a male 15 pounds (7 kg).

PREVIOUS PAGE: *A lioness eats her fill of her prey, here a wildebeest. Masai Mara, Kenya.*

RIGHT: *A young male lion strikes a pose, yawning, just 13 feet (4 m) away. In the bushes lies a dead wildebeest. A good feed has tired the lion and he will probably spend the rest of the day completely at rest. Masai Mara, Kenya.*

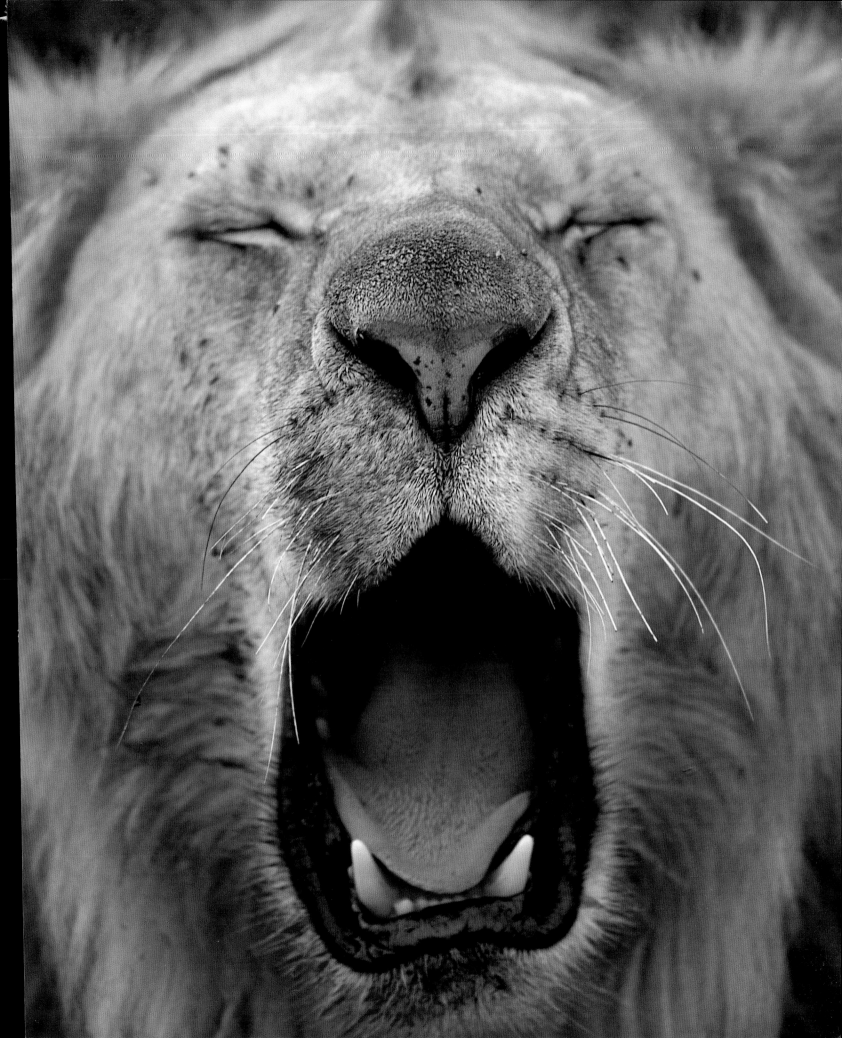

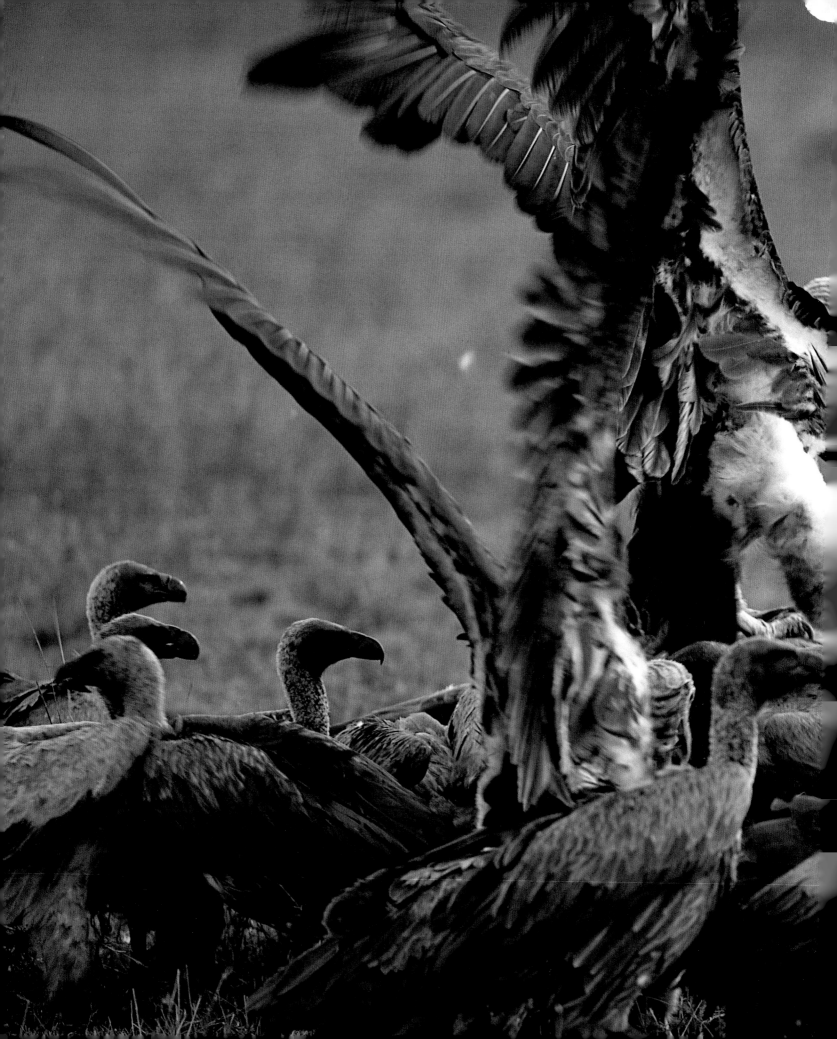

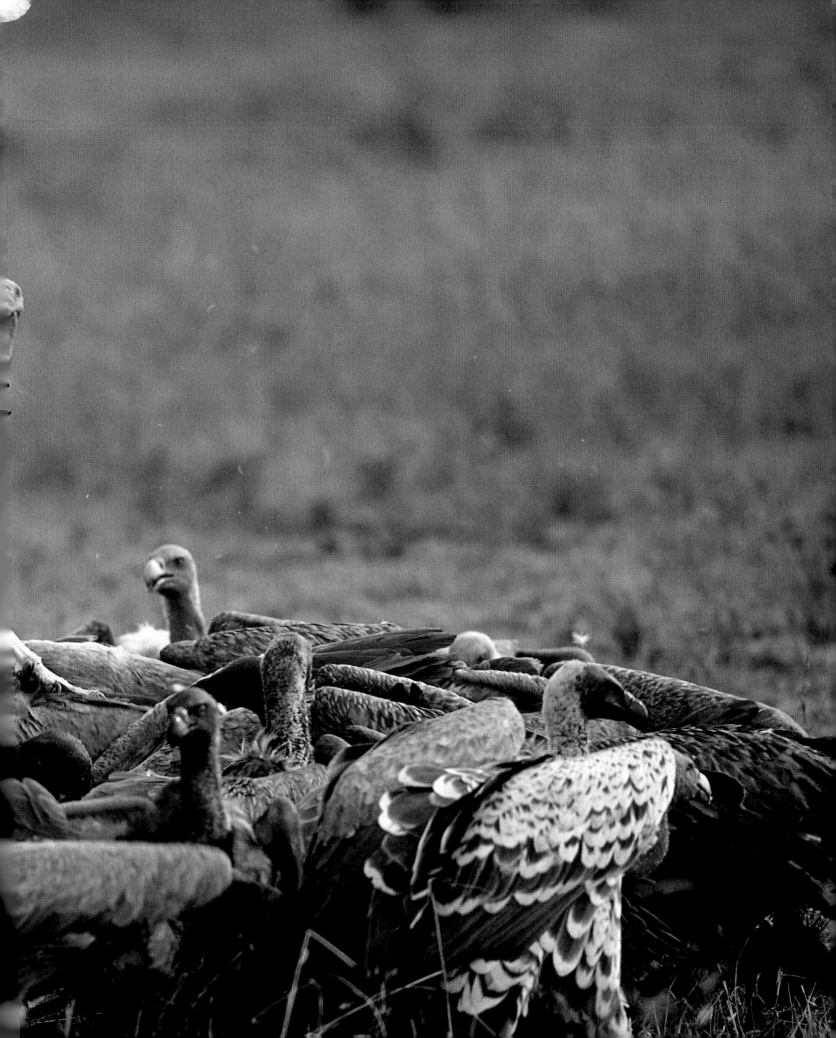

The lord of the vultures. On the ground lie the remains of an unfortunate wildebeest. Rüppell's griffon vultures and white-backed vultures from far and wide spot the feast and come gliding in on broad, powerful wings. Without the scavengers to keep the savanna clean, the whole landscape would be littered with animal carcasses.

About ten vultures are feasting on the prey when two lappet-faced vultures arrive. They are a lot bigger than the others, with more powerful beaks and red heads, and they are the ones that are highest in the pecking order. As soon as they have landed they spread their wings, pull their heads in toward their bodies and walk with measured steps toward the others. They stop and stare menacingly. One of the lappet-faced vultures jumps straight down among the others and thrusts its beak into the food. Then it spreads its wings again and chases the other vultures off.

Avoiding competition. Vultures are grey-brown with rather ugly plumage. They are far from graceful, but are perfectly adapted to soaring high up in the air and to poking their heads and necks into bloody animal carcasses. The white-backed vulture also has a specialized, tube-like tongue with backward-pointing hooks, allowing it to suck soft meat down into its throat.

There are several species of vulture on the African savanna, all of which attack a carcass in a different way in order to avoid competing with one another. The Rüppell's griffon vulture, the Cape vulture and the white-backed vulture like to peck small holes around the rectum and other soft tissues, or into wounds, in order to poke their long down-clad necks deep into the carcass and pull out the entrails. The lappet-faced vulture and the white-headed vulture have no difficulty in using their stronger beaks to peck holes in the toughest skin to get hold of the muscles and harder tissues. The smallest species – the Egyptian vulture – feeds on the remains that are left when the larger species have taken what they want.

During the day vultures soar at heights of up to 6,500 feet (2,000 m) or more above the savanna, keeping an eye on what is happening down on the ground and on what their kin are up to. If any one of them spots food and begins to dive, the others are bound to follow.

PREVIOUS PAGE: *A lappet-faced vulture pushes away other vultures to get to a dead wildebeest. Masai Mara, Kenya.*

RIGHT: *A lappet-faced vulture watches over its prey. Masai Mara, Kenya.*

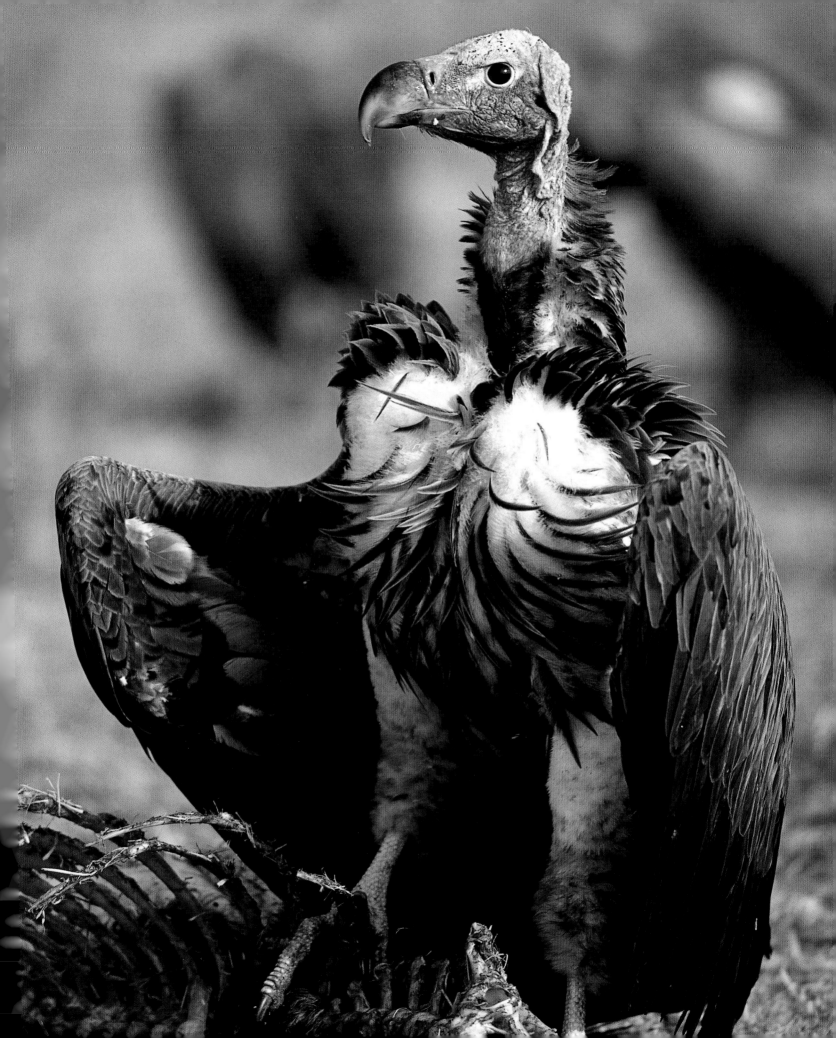

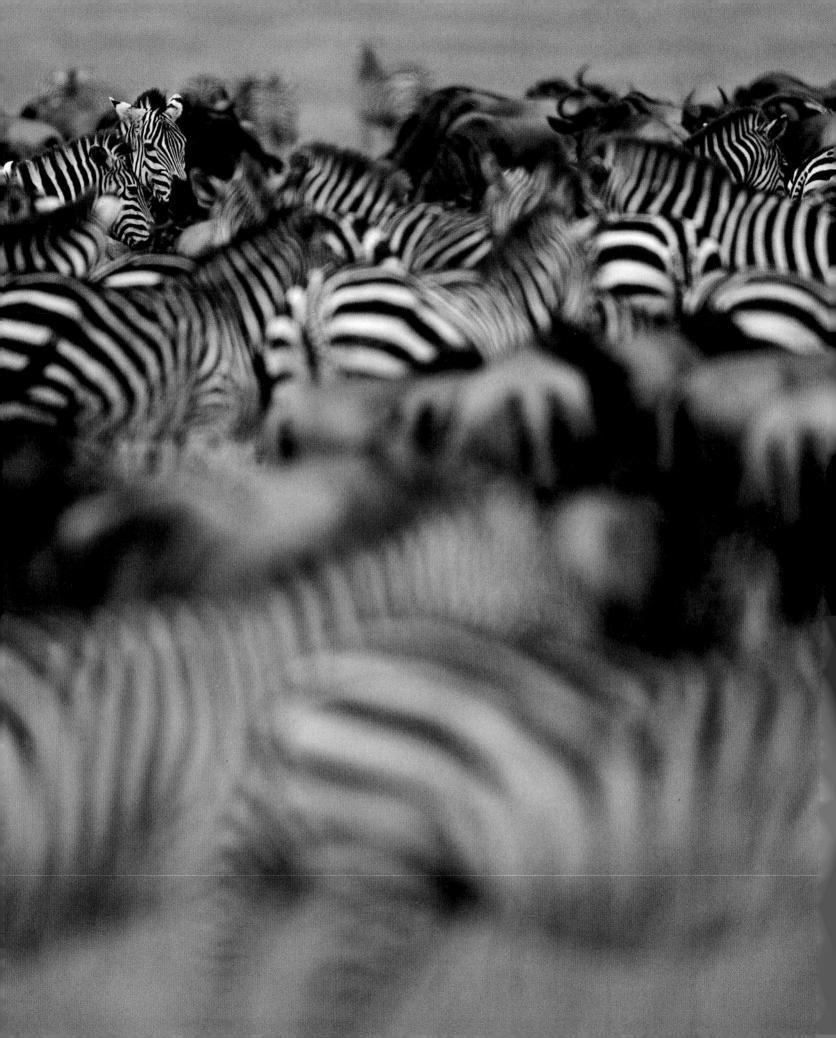

No two sets of stripes are alike. The ancestor of all equines (horses, zebras and asses) was probably striped, and in zebras the pattern was evidently such an advantage that it has been retained by subsequent generations. One might well wonder why, for the black-and-white colouring clearly does not offer the best camouflage to conceal the zebra from lions and other predators. Some people have theorized that the zebra's stripes may keep stinging insects at bay or perhaps play a part in temperature control. Others claim that the visual effect created by the stripes confuses predators or that it serves a social function – to attract other zebras. Moreover, the zebra's stripes are like human fingerprints – the pattern on each animal's hide is unique.

Zebras move like a huge black-and-white mass across the savanna, often among the wildebeest. The zebras' favourite food is the tall, tough and fibrous savanna grass, which they bite off at a particular height. The wildebeest is a ruminant and feeds off the grass on which the zebra has already grazed. Last of all comes the Thomson's gazelle, which crops the shortest grass. That way all the grass is consumed and none of the grazing species competes directly with the others for food.

LEFT AND BELOW: *As many as 250,000 zebras are constantly on the move in tightly packed herds. Masai Mara, Kenya.*

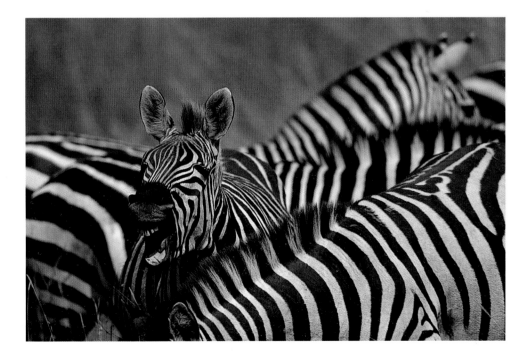

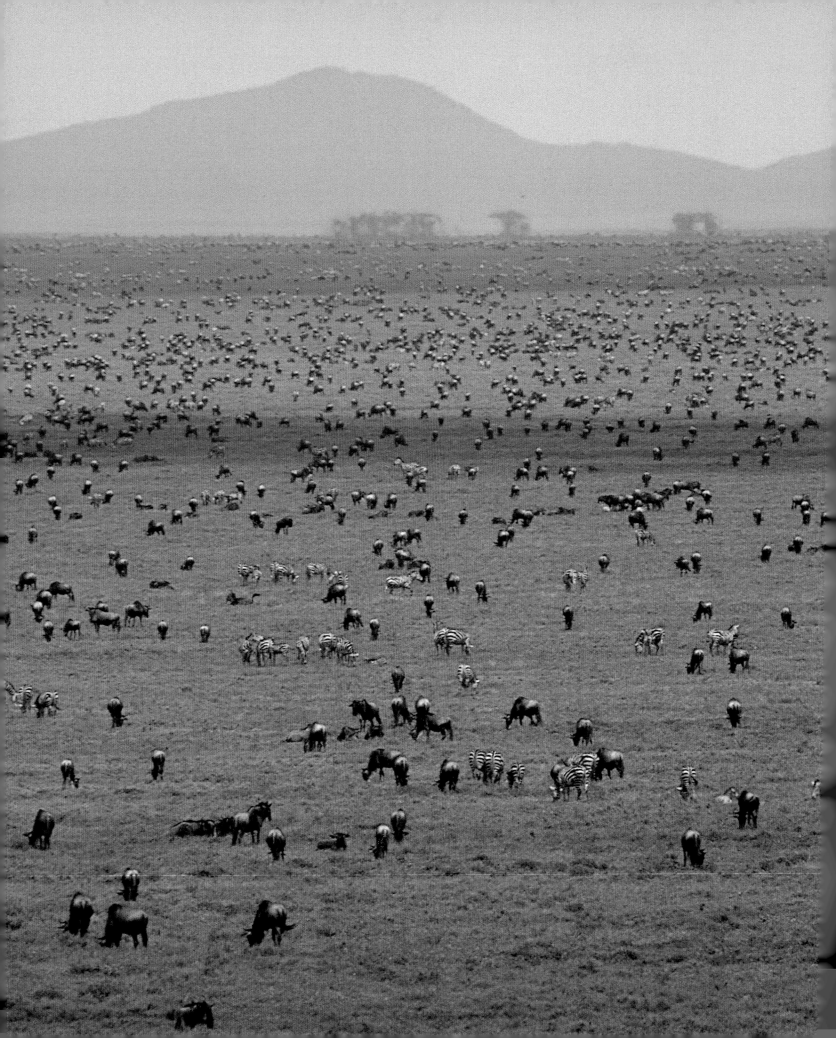

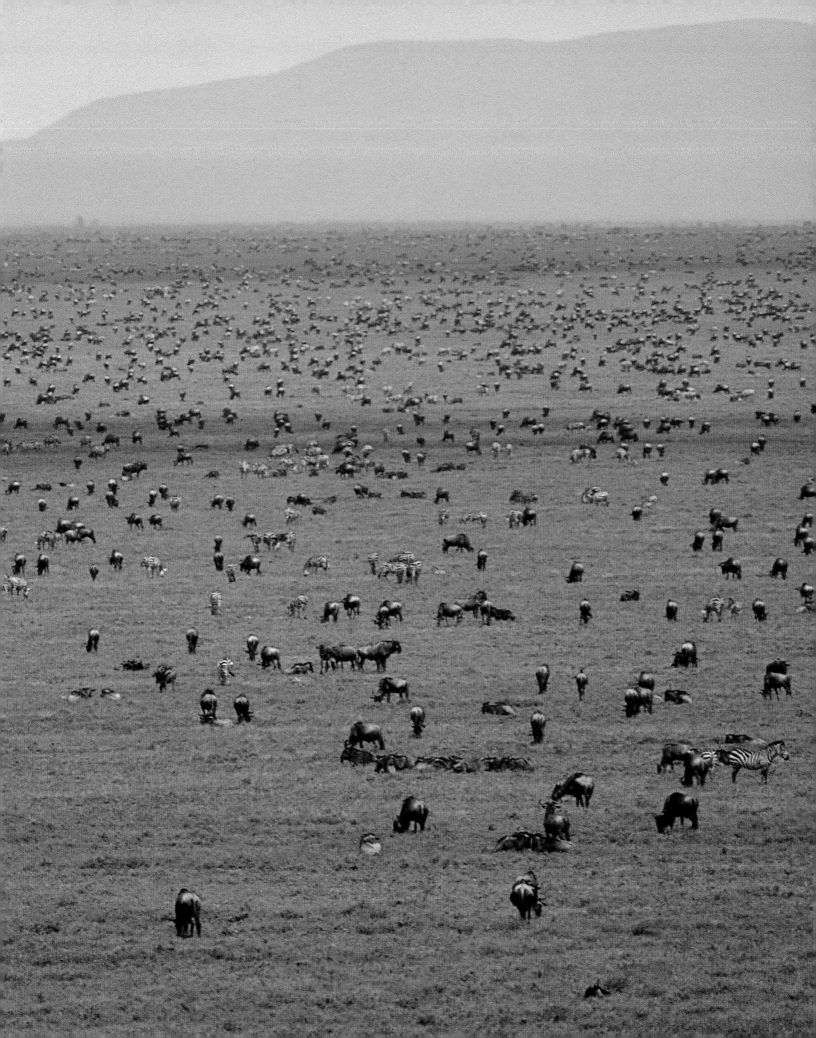

The world's largest herd of animals. The landscape is completely flat and treeless. The sky is blue, the grass is green and around us wildebeest, zebras and gazelles are grazing as far as the eye can see. We are standing in the middle of the world's largest herd of animals in the famous Serengeti national park in Tanzania. This immense herd is back in the southern part of the national park after spending several months in the Masai Mara to the north. Some of the herd's members died there, or on the return journey, but most have survived to gather here.

It is February and the calving season. Why did all these animals leave the Masai Mara? Perhaps because the flat plains of the Serengeti are a safer roaming ground than the more hilly terrain in parts of the Masai Mara. In addition the grass on the southern plains has a far higher calcium content, which is important because it enables the cows to produce enough milk to feed their newborn calves.

Most wildebeest mothers calve in the morning when the hyenas and lions are least active. That gives the newborn calves the whole day to struggle to their feet and learn to run. After just a couple of hours the calf can follow the mother and the rest of the herd. When its first night falls the calf is already so strong that it has a reasonable chance of evading hungry predators.

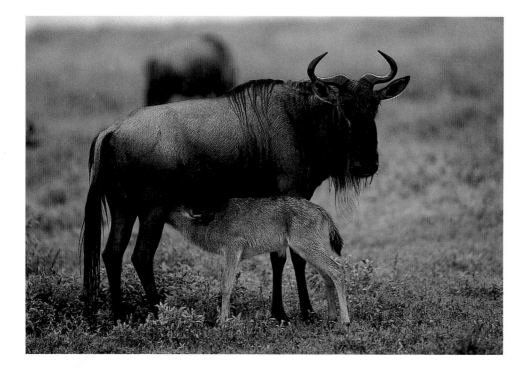

PREVIOUS PAGE: *Vast herds of wildebeest and zebra graze in the Serengeti, Tanzania.*

LEFT: *A female wildebeest with a young calf. Serengeti, Tanzania.*

BELOW: *Wildebeest and zebras in the rain. Ngorongoro crater, Tanzania.*

NEXT PAGE: *Africa has two seasons: the dry season and the rainy season. However in recent years the pattern of precipitation has changed — it now also rains outside the rainy season. Here, as in all other parts of the world, people talk of climate change and the El Niño effect. Masai Mara, Kenya.*

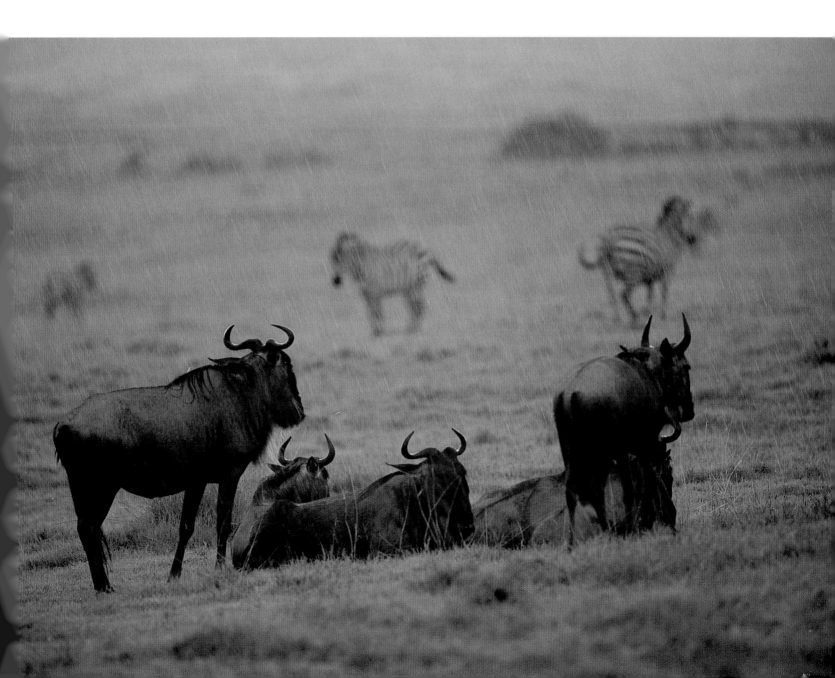

The monkey-bread tree. A gigantic baobab tree is outlined against the fading light of day in Tarangire national park in Tanzania. It is a remarkable tree – it looks almost as if it has grown upside down, with its roots in the air. According to local legend, God was angry when he planted the baobab, which is sometimes referred to as the "upside-down tree".

Many baobab trees have an enormous trunk – some actually measure 130 feet (40 m) in circumference and may be close to a thousand years old. The baobab is also known as the monkey-bread tree, for in December it bears 12-inch (30-cm) long, gourd-like fruits called monkey bread. The husk of the fruit is hard, but the flesh inside is juicy, slightly acid and tasty.

Local people have found more than thirty different uses for the baobab. The tree's green leaves are rich in vitamins and can be cooked like spinach, and the young shoots are eaten almost like asparagus. The kernels contain fifteen per cent oil and are eaten raw or toasted (baobab oil can also be made into soap), while the fruit's flesh is crushed and mixed with water or milk to make a refreshing and nutritious drink. When the fruit is burned it produces smoke which keeps irritating insects away from people and livestock. Monkey-bread husks are used as fuel, serving dishes and storage containers. The flowers may be eaten raw – or used to make glue.

Baobab bark can be used for tanning leather and the fibres of the bark for producing rope, fishing twine, baskets, mats and textiles. The fresh wood of the baobab contains a lot of water, and in dry periods both people and animals, particularly elephants, chew it to extract its moisture. The baobab tree is also used in folk medicine.

RIGHT: *The baobab tree is one of the biggest and most remarkable trees in Africa. Tarangire, Tanzania.*

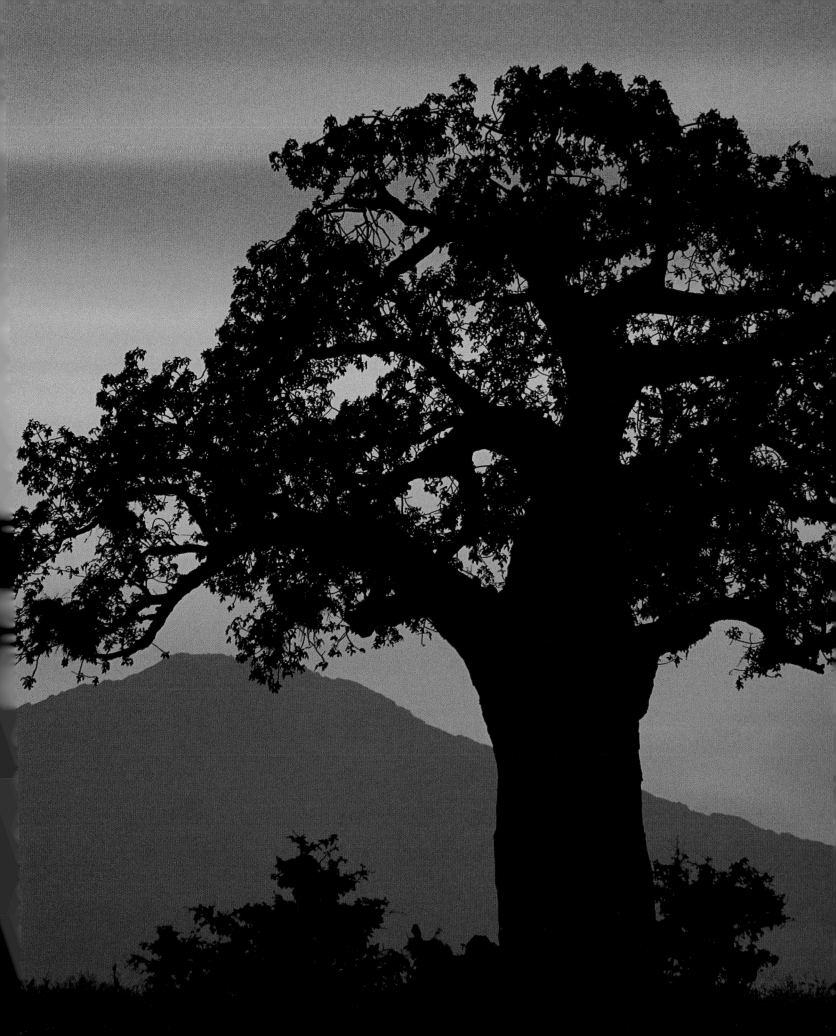

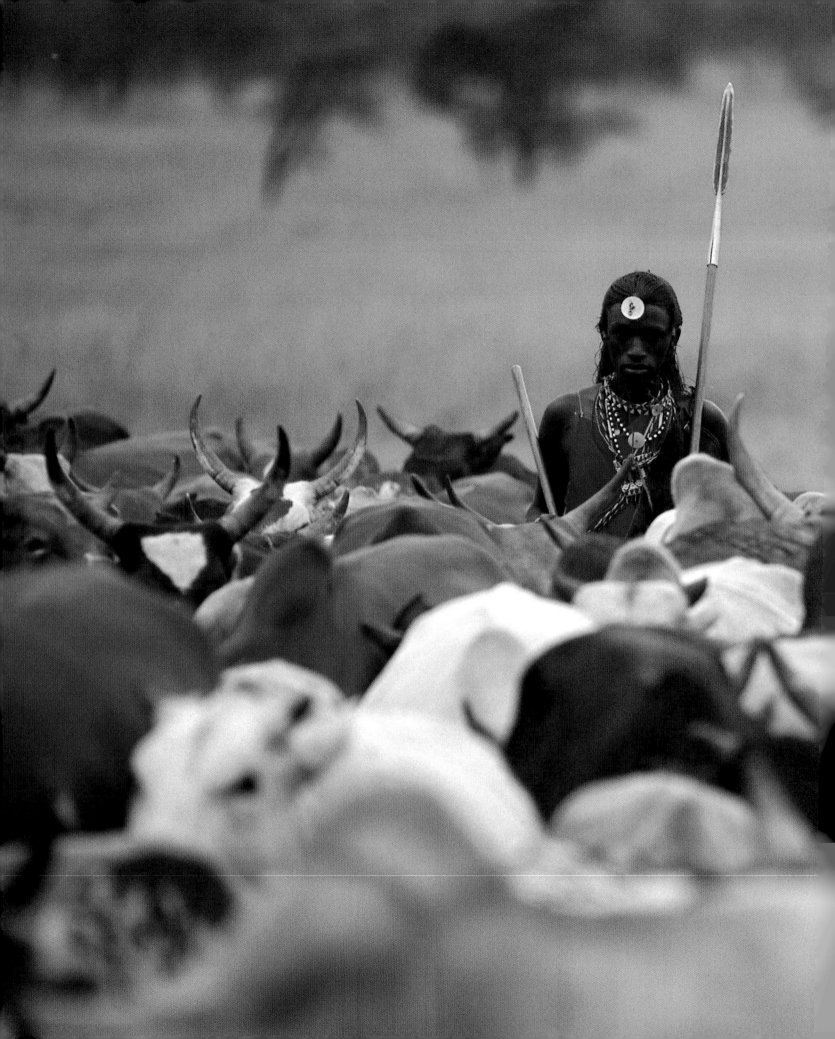

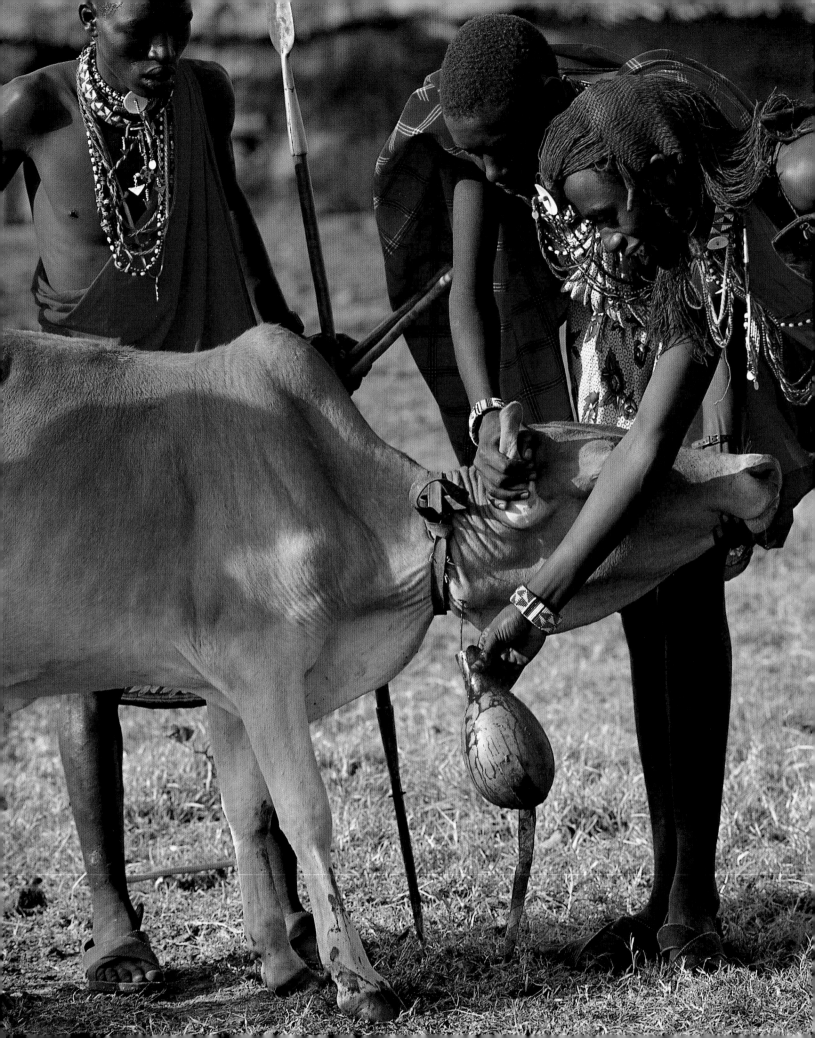

Lions are afraid of the Masai. The Masai are proud herdspeople who spend their time watching over their cattle, protecting them from lions. The Masai don't count their wealth in money, but in the number of cows they own.

The Masai often dress in colourful clothes and the men almost always carry a single spear. They are tall and can be seen from quite a distance. The lions keep a careful eye on their human neighbours. If the Masai approach them, the big cats rise quickly from their resting place and lope away. They know from experience that a Masai can be lethal.

According to legend, all livestock was given to the Masai by the rain god Ngai, which explains why the Masai often used to carry out raids against other tribes and steal their cattle. The thieves firmly believed that they were simply taking back something that they already owned.

The cow is vital to the Masai. Milk is by far the animal's most important product and constitutes the basis of the Masai diet; they drink milk fresh and also soured as yoghurt. For feasts and other important occasions the Masai kill a cow for its meat. Cow's urine is used as a detergent and for medicinal purposes.

Cow's blood also plays a large part in the Masai diet, particularly during the dry season when the cattle produce less milk. The animals are not slaughtered, they are simply bled. A band is placed around the cow's neck and pulled tight. A blunt arrow is then shot into an artery at close range, so that the blood spurts out and can be collected in a drinking vessel.

Masai culture has many rituals. Even in the third millennium of our time reckoning they continue to withstand the influence of modern society and live as they have always lived. After circumcision a moran – the proud warrior of Masai society – must prove that he is a real man. He is sent away from the tribe to learn to fend for himself in the desert for several months. The great test of his manhood is to kill a lion. Not for food, but as proof of his courage and strength, for the Masai warriors' task is to defend their people – and to safeguard their precious cattle.

PREVIOUS PAGE: *About 300,000 Masai live in the borderlands between Kenya and Tanzania. Masai Mara, Kenya.*

LEFT: *Masai warriors draw off blood from the artery of a cow into a drinking vessel. Masai Mara, Kenya.*

NEXT PAGE: *In the Masai dance the warriors stand side by side and sing, unaccompanied by instruments, while individuals take it in turns to demonstrate their vigour. Masai Mara, Kenya.*

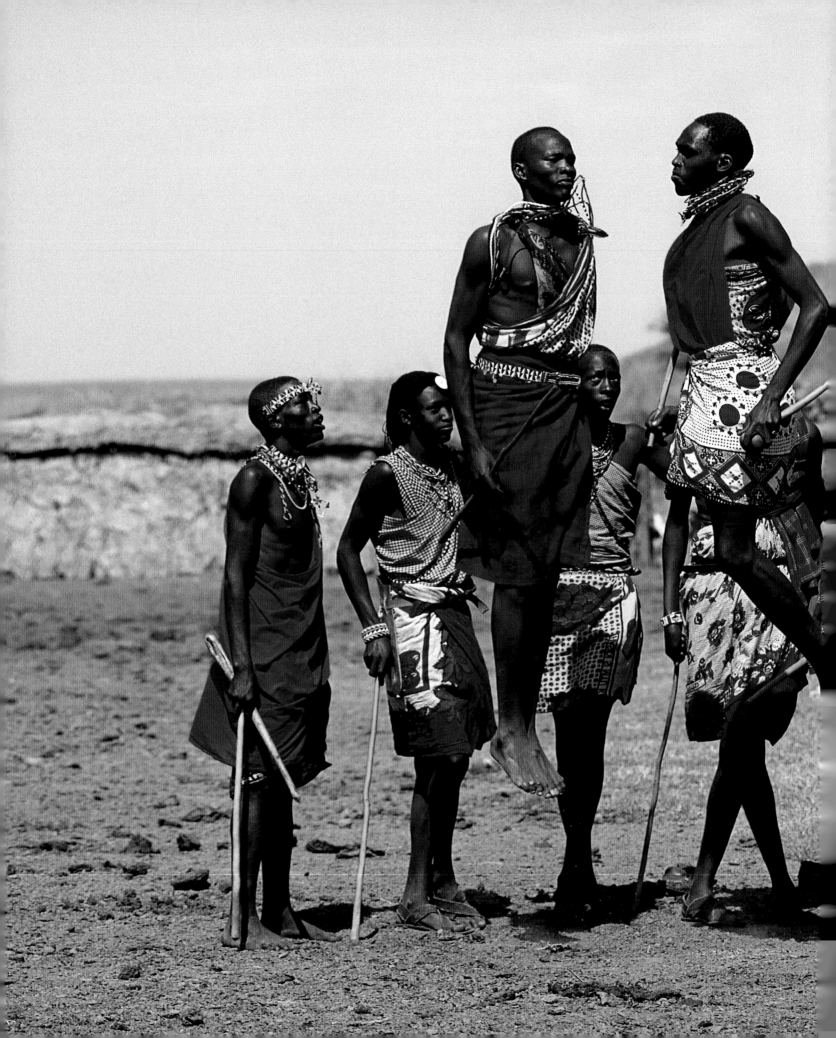

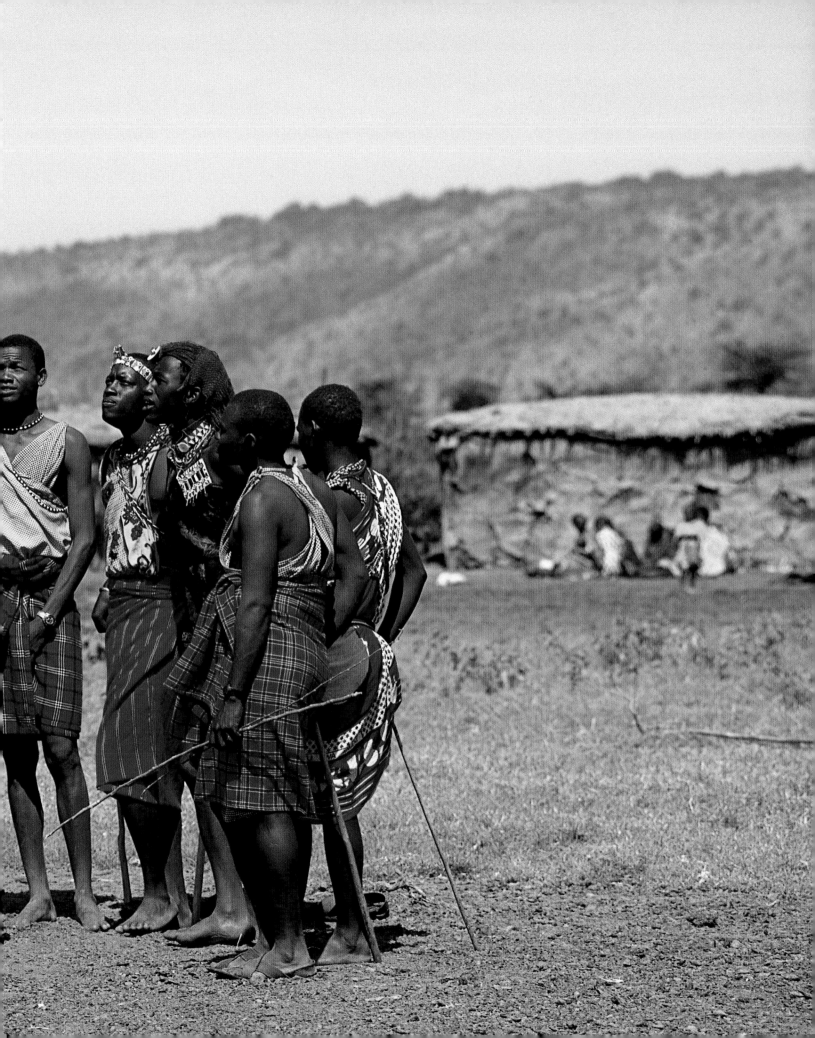

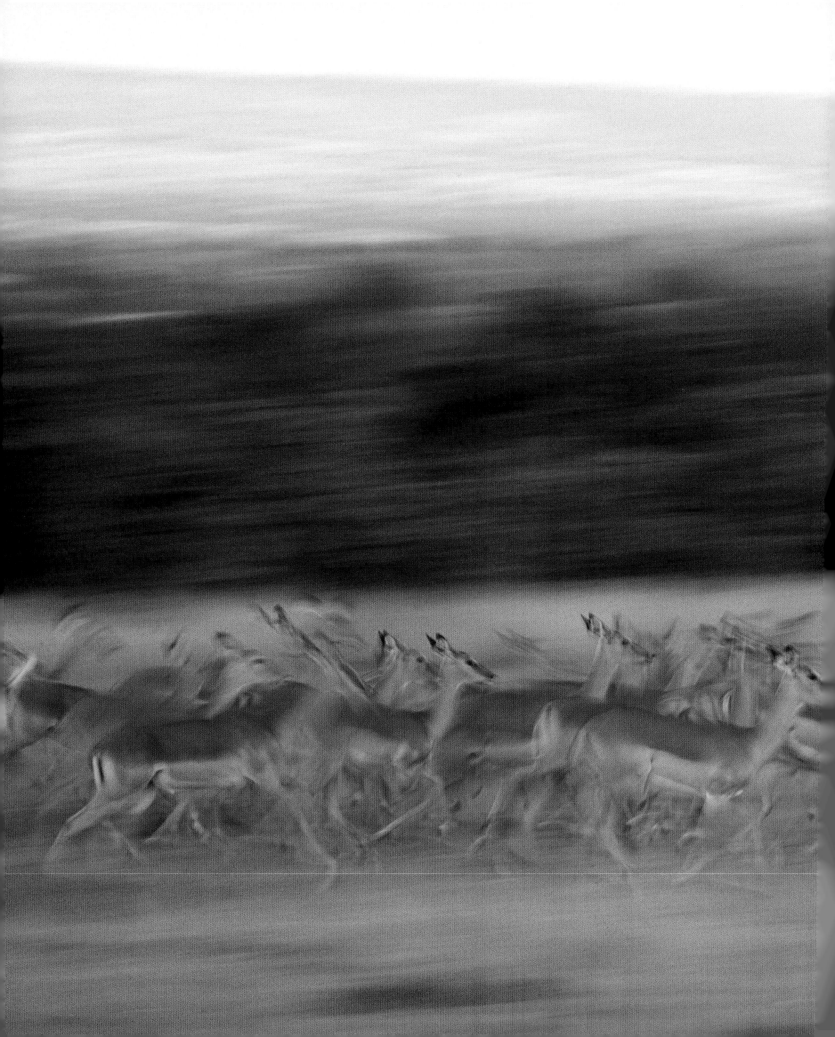

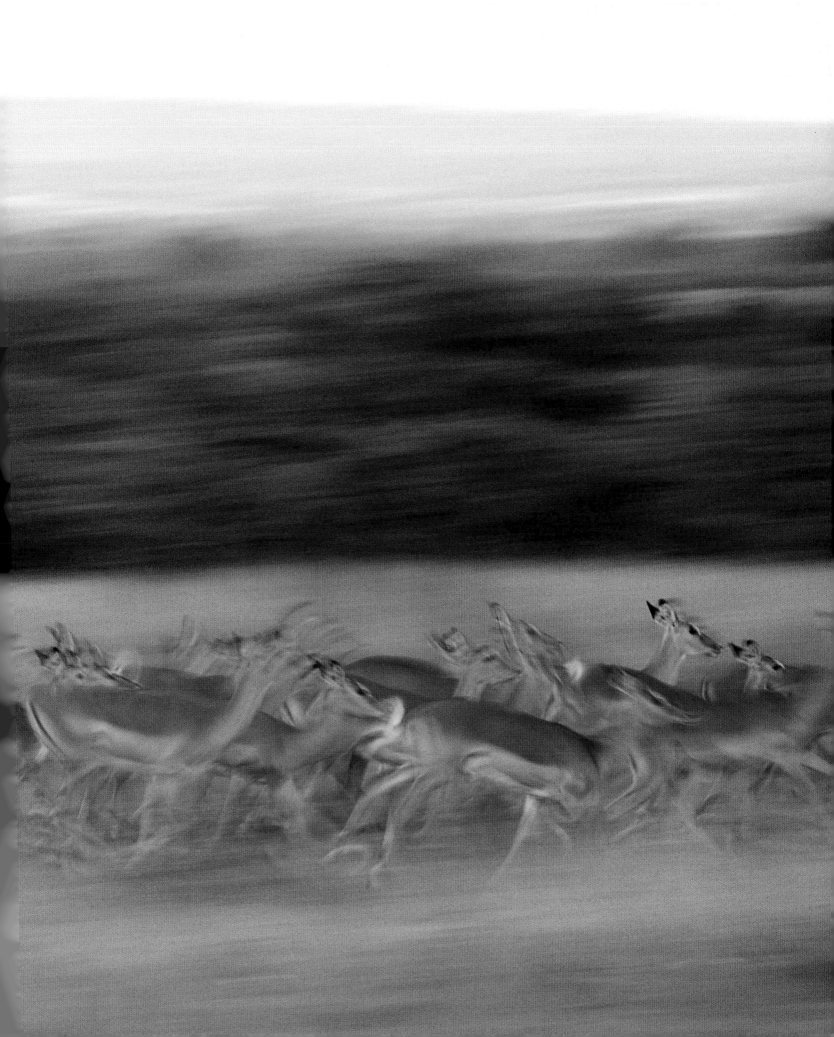

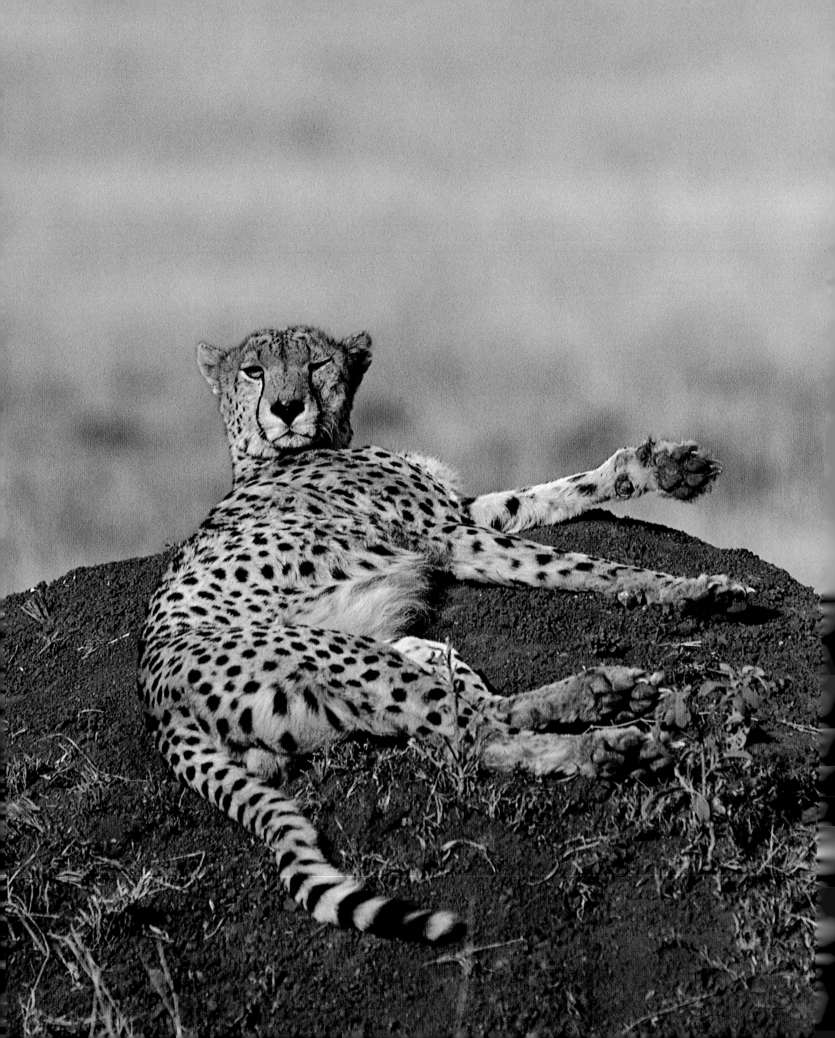

The world's fastest mammal. The cheetah is built for rapid acceleration and high speed (up to 60 miles an hour/95 km an hour). Its body is slim and streamlined, its head small and the ears neat and flat – all intended to minimize air resistance. The large claws give the animal a good grip on the ground and the wide nostrils ensure sufficient oxygen intake during a strenuous chase. However, if the cheetah fails to fell its prey after chasing it over a distance of 1,600 feet (500 m) it is forced to give up. That is why it is important for the big cat to get as close as possible to its potential victim – preferably about 100 to 130 feet (30 to 40 m) – before it makes the final charge. Despite its speed, only half of all the cheetah's hunting attempts are successful.

The hunt is on. The female cheetah storms toward the grazing impala. She has not run far when these antelopes realize that their life is hanging on a fine thread. The herd gallops off, but one of them cannot keep up and the cheetah quickly homes in on it. The impala runs in zigzags in an attempt to get away but the cheetah is snapping at its heels. The cheetah strikes the impala's back with its paw and the terrified animal loses its balance. In an instant the big cat is hanging over its prey. In a minute or two it has the impala in a stranglehold in its jaws. The corner teeth in the cheetah's upper jaw are small and have short roots on either side of the airways in the nose. That leaves plenty of space for large air ducts – she doesn't need to let go in order to catch her breath.

After her sprint the cheetah has no energy left to do anything with her prey for half an hour. Nor would she have the strength to defend it, if for example a lion or hyena were to turn up. On this occasion, however, the coast is clear and she can safely call to her cubs who are sitting in the grass 650 feet (200 m) away, waiting to be summoned for their next meal.

PAGES 44–45: *One of the advantages of living in a herd is that the individual impala's risk of being caught by a cheetah is significantly reduced. Together it is also easier to spot danger while the herd is grazing. Masai Mara, Kenya.*

PREVIOUS PAGE: *The cheetah's long, narrow body and flexible spine are designed for running at high speeds. Masai Mara, Kenya.*

LEFT: *The cheetah needs to rest between its exertions and from this termite mound it has a good view of any approaching quarry. Masai Mara, Kenya.*

A threatened existence. Previously there were cheetahs throughout the whole of Africa and also in Asia, but cheetah populations have long been dwindling. In Asia the cheetah is almost extinct and in Africa there are not many suitable habitats left. Cheetahs are found first and foremost on the wide savannas of the Masai Mara and Serengeti, on the border between Kenya and Tanzania, and in southern Africa, especially Namibia. It is estimated that there are about twelve thousand cheetahs left in the wild in Africa, dispersed over thirty countries.

In the 1950s it was common for Arab princes and Indian moguls to keep tame cheetahs for antelope hunting, hence the name "hunting leopard". The cheetah is easy to tame – the sixteenth-century Indian emperor Akbar had a hundred tame cheetahs, which his animal keepers led around on leashes.

However, although the capture of cheetahs has had a negative effect on stocks, particularly in Asia, nowadays it is mainly the cultivation of land and consequent conflicts with cattle owners which create problems for the cheetah. In both Zimbabwe and Namibia the cheetah is still hunted, and many farmers will shoot down this handsome beast if they get the chance.

Other predators also pose a threat. Lions and hyenas do not only steal the cheetah's prey – they also kill cheetah cubs. One study in the Serengeti revealed that other predators accounted for up to ninety-five per cent of deaths among cheetah cubs and that is perhaps the main reason why cheetah populations are rarely very dense. Cheetahs try to avoid areas where there are a lot of lions by moving away from the national parks, only to find themselves in conflict with the Masai and their cattle instead.

The cheetah also has another problem, which is difficult to resolve. Studies have shown that the genetic material of this big cat is so uniform that many experts fear that an epidemic disease could exterminate the whole population. Every cheetah can almost be seen as a clone of another. One study in South Africa showed that about seventy per cent of the male's sperm were abnormal, compared with about thirty per cent among cat species in general. Such genetic problems occur chiefly in species living on islands and other enclosed areas. Many researchers believe that the cheetah was forced through a genetic bottleneck several thousand years ago, which led to most of the species' genetic variation being lost.

BELOW: *A cheetah cub whose mother is busy hunting has no one watching over it and is therefore dangerously exposed. It has been shown that up to ninety-five per cent of deaths among cheetah cubs can be attributed to other predators. Masai Mara, Kenya.*

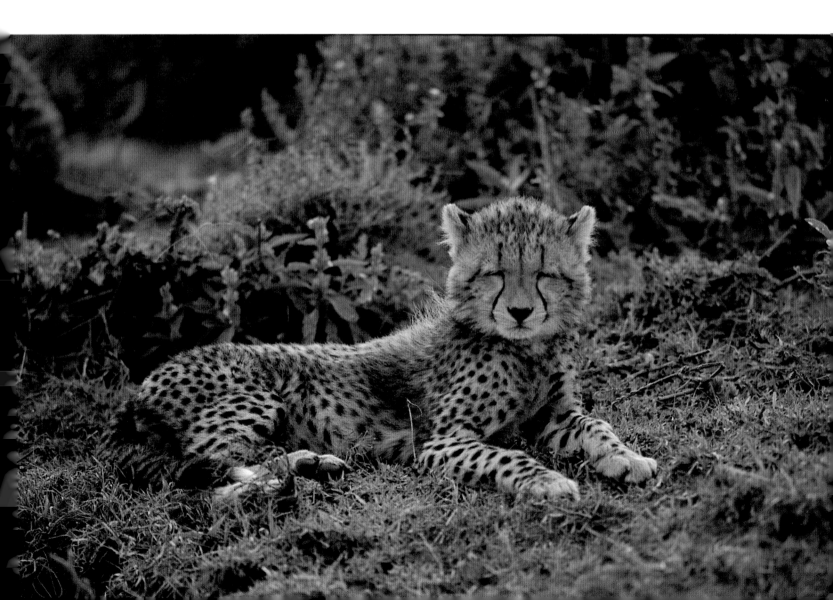

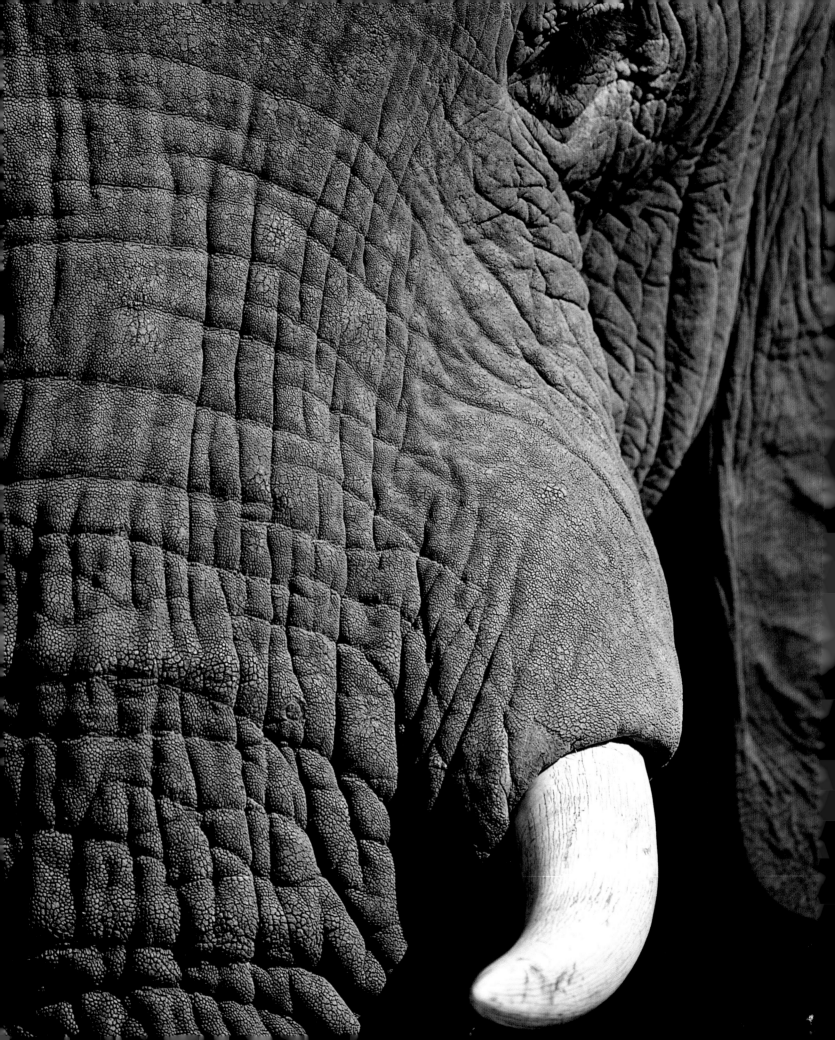

The proboscidean. The elephant is a unique animal. The African elephant is the world's largest land mammal; it can measure up to 13 feet (4 m) tall and 20 to 23 feet (6 to 7 m) long, and can weigh as much as 6 tons. With its flexible trunk (proboscis) and its shining white tusks of precious ivory, it looks almost prehistoric.

The elephant's foot is built like something between a human foot, the heel of which is the first part to touch the ground, and the horse's hoof, the heel of which doesn't touch the ground at all. The toes are covered with a soft padding of white elastic fibres surrounded by fatty tissue, allowing the elephant to move virtually noiselessly.

Most of the time, elephants move at speeds of 2.5 to 3.5 miles (4 to 6 km) an hour, but an elephant on the attack is said to be able to reach a speed of up to 25 miles (40 km) an hour. It is therefore important to be able to read an elephant's behaviour. Like all other animals, it sends out clear signals before it goes on the offensive: it blows through its trunk, stamps on the ground and lays its ears back. Such behaviour means it's time for observers to seek a safe hiding place. An enraged elephant is not to be trifled with.

The elephant's trunk is a splendid universal tool – it can pick up food from the ground or pull it down from the trees. It is used like a drinking straw to allow the elephant to consume the 22 to 44 gallons (100 to 200 l) of water it needs each day, and it can provide a marvellous shower if the animal wants to cool down. If the elephant has to cross a deep river, the trunk can also serve as a snorkel. When two kindly disposed elephants meet they greet each other with their trunks. The opposite is also true – if enemies meet they use their trunks to "arm-wrestle". Last but not least, the trunk is also a perfect trumpet.

LEFT: *Tusks begin to show when the elephant is about two years old and continue to grow throughout its life. An adult elephant's tusks may weigh up to 132 pounds (60 kg) each. Chobe, Botswana.*

A caring herd. Studies of African elephants have shown that the males and females mostly live apart. Cows and calves are led by the matriarch – the oldest female in the group. Bulls live alone or in smaller "bachelor" herds.

One of the ways in which elephants communicate is with low-frequency sound signals – known as infrasound. These powerful sounds transmit well through dense vegetation and make it possible for individuals in the herd to keep in touch with one another, even in bushy terrain and over considerable distances.

Elephants reach sexual maturity between the ages of ten and fifteen. After mating has taken place it is twenty-two months before the baby elephant is born. A newborn elephant weighs more than 265 pounds (120 kg) and puts on weight rapidly. At six years old it weighs about a ton. Provided it is not shot by poachers, and is lucky enough to avoid disease and disastrous droughts, the baby elephant can expect to live for as long as sixty years or more.

BELOW: Enormous feet ensure that an elephant's bodyweight is distributed over a large area, so much so that young animals leave almost no tracks. Chobe, Botswana.

RIGHT: Elephants take great care of one another. If one member of the group is injured the other elephants try to help it as much as they can, even attempting to keep dying calves with them as they roam. Sweetwaters, Kenya.

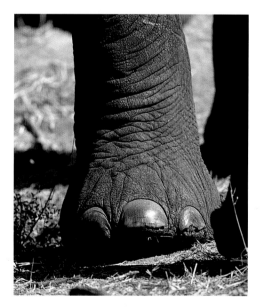

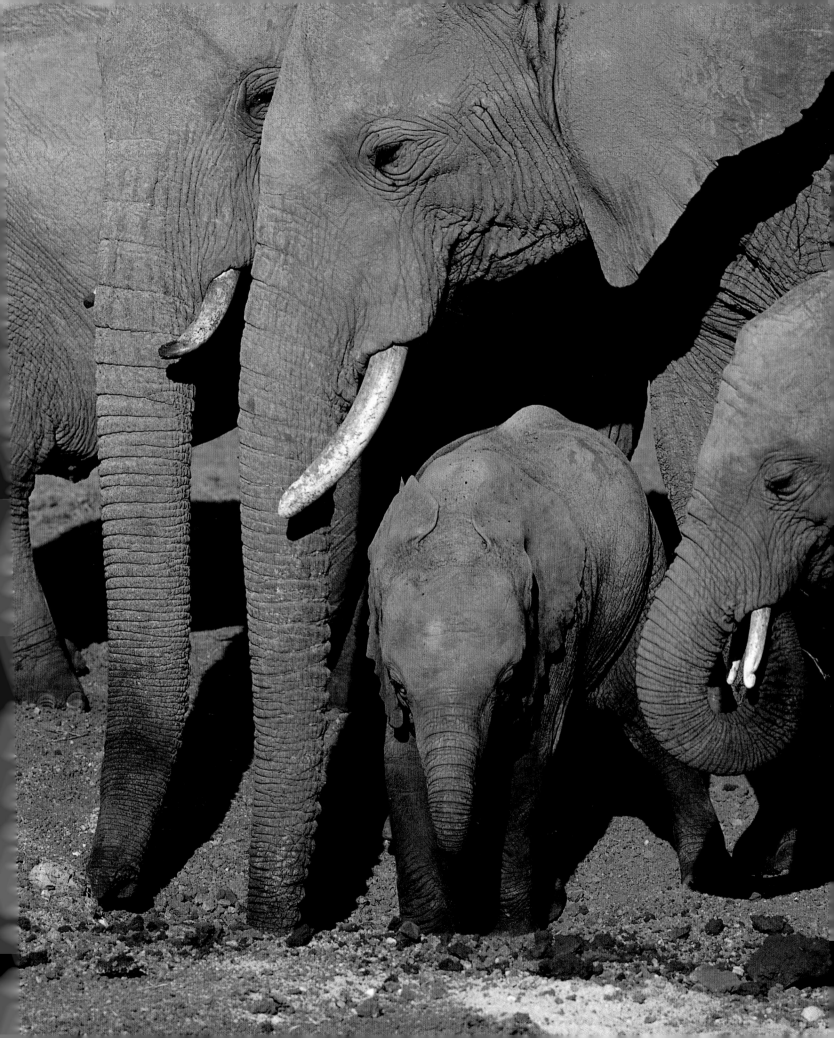

"Africa's whale". Historically, as well as in terms of size, the comparison is appropriate. Just as whales were killed for whale oil, first in the Arctic Ocean and then in the Antarctic, so elephants were killed for their tusks, which were used to manufacture various artefacts.

As early as the seventeenth century, African tribes were trading ivory with the Arabs, a commerce which particularly jeopardized the elephant stocks of West Africa. When the colonial powers conquered Africa the ivory trade grew still further, and at the beginning of the twentieth century a brutal hunt took place to satisfy the European and North American demand for ivory. The number of African elephants reached a historic low – at one point there were only just over a hundred of them left in South Africa. In Botswana and Zimbabwe there were a handful of survivors, while Angola's elephant population was completely wiped out. In East and West Africa the animals were also hunted mercilessly, but in the dense central African forests more of them survived.

Following this slaughter several national parks and game reserves were set up and elephant populations began to recover. The ivory war we hear about today flared up in the nineteen seventies, when the recession in the world economy led to more and more people buying ivory as a capital investment. Over the next twenty years the price of ivory increased ninefold. Exports grew from 200 tons in the sixties to more than 1,000 tons in the eighties. The hunt was intensive. It has been calculated that 70,000 elephants were killed every year from 1975 to 1989. That is almost 200 animals a day. Kenya, Uganda and Zambia lost between eighty and ninety per cent of their elephants in this period.

In 1979 the African-elephant population was estimated at 1.3 million – today they number somewhere between 280,000 and 580,000. Most inhabit the savanna, but one third are forest elephants. These had been classed as a subspecies, living in the rainforests of western and central Africa. However, the latest DNA research has shown that they actually constitute a separate species.

RIGHT: *Elephants throw up grass and leaves to frighten people away if they get too close. Chobe, Botswana.*

NEXT PAGE: *Thanks to their padded toes, a herd of elephants can move almost noiselessly. Amboseli, Kenya.*

PAGES 60–61: *Elephants crossing a river. Samburu, Kenya.*

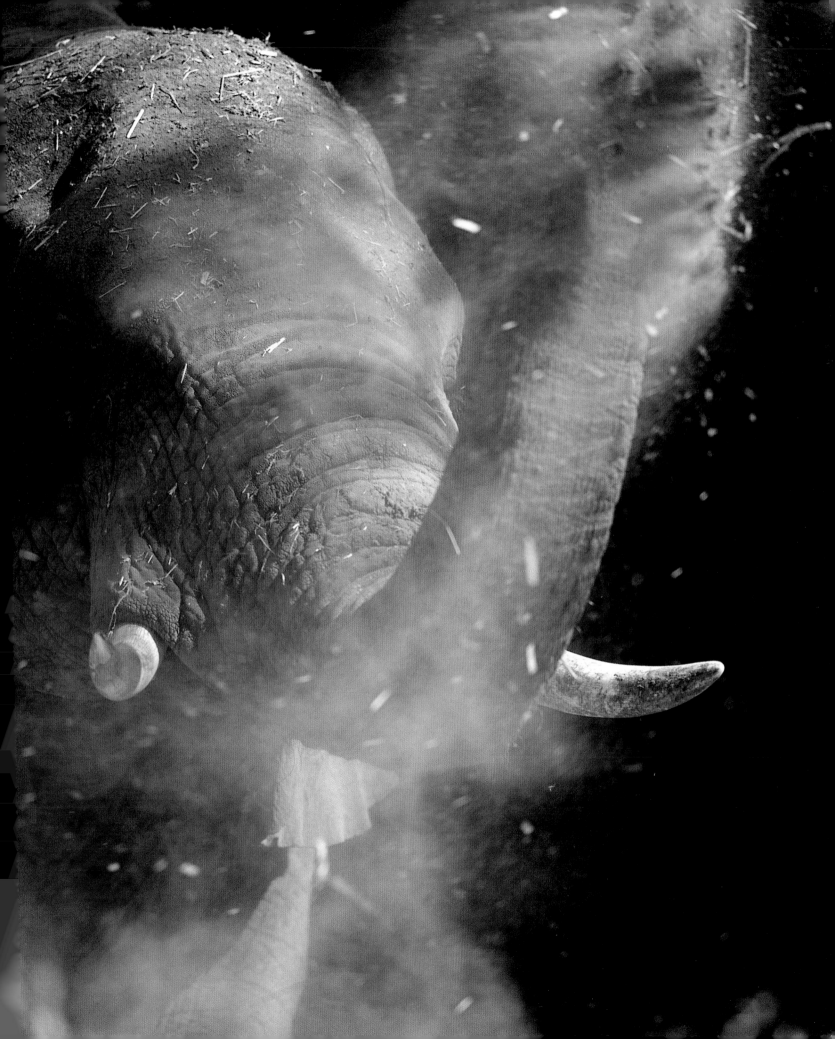

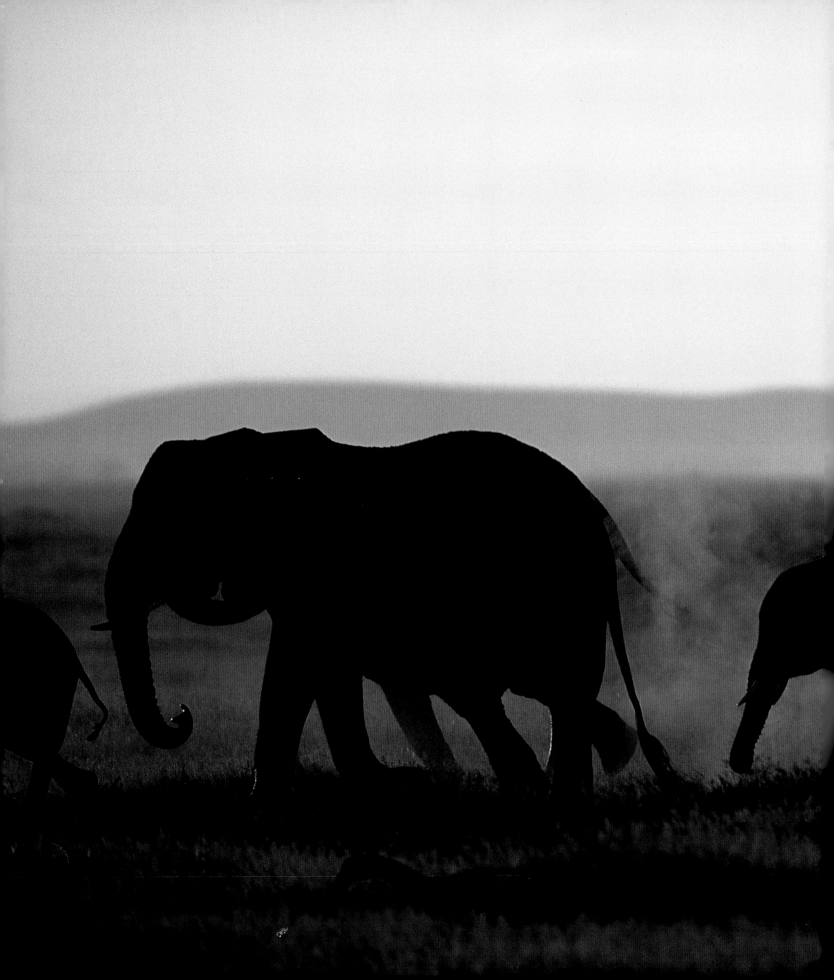

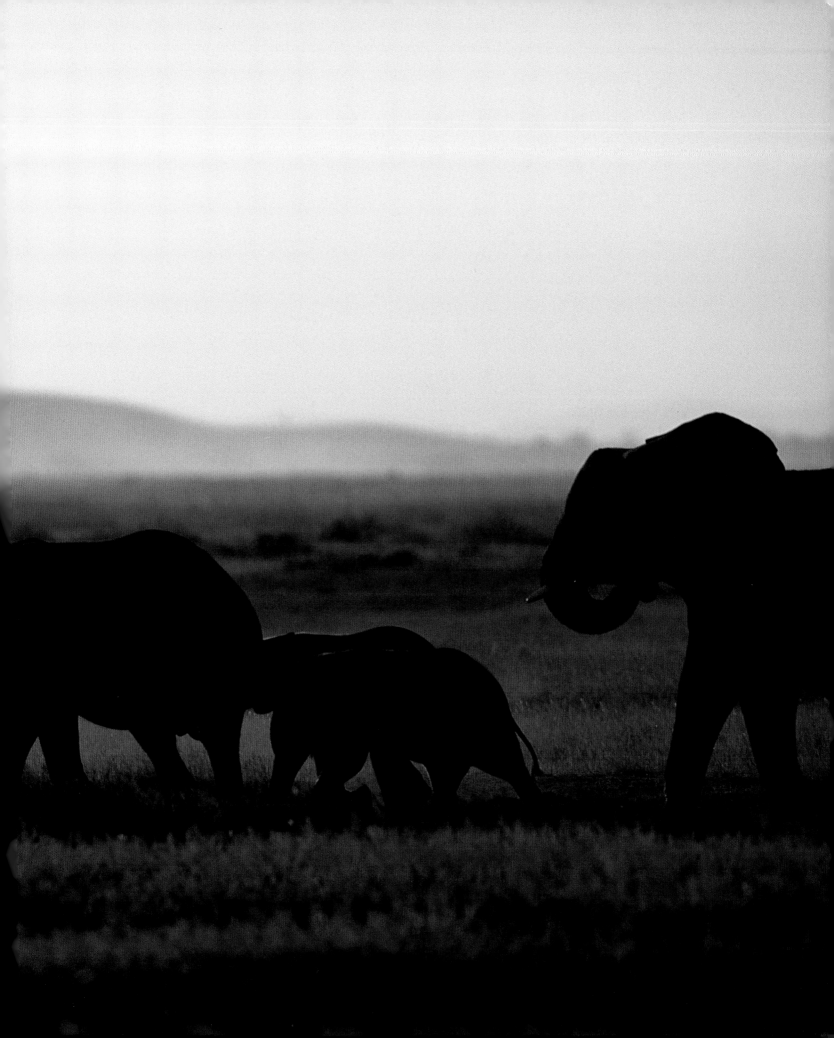

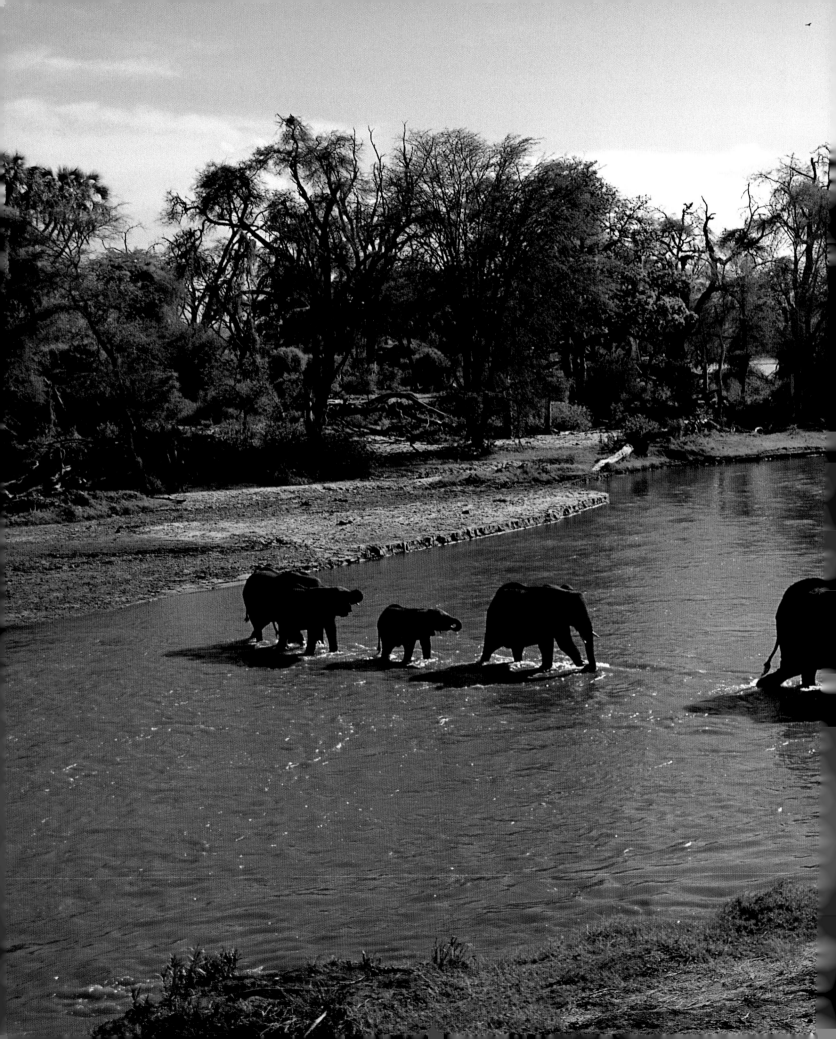

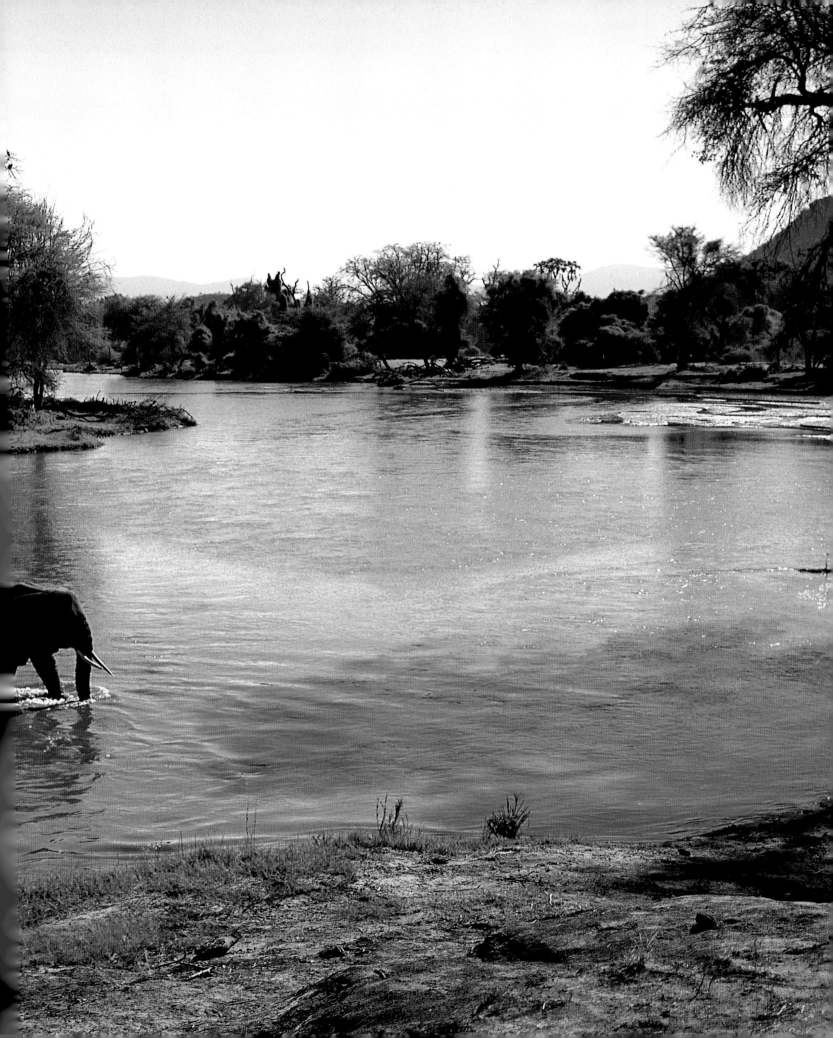

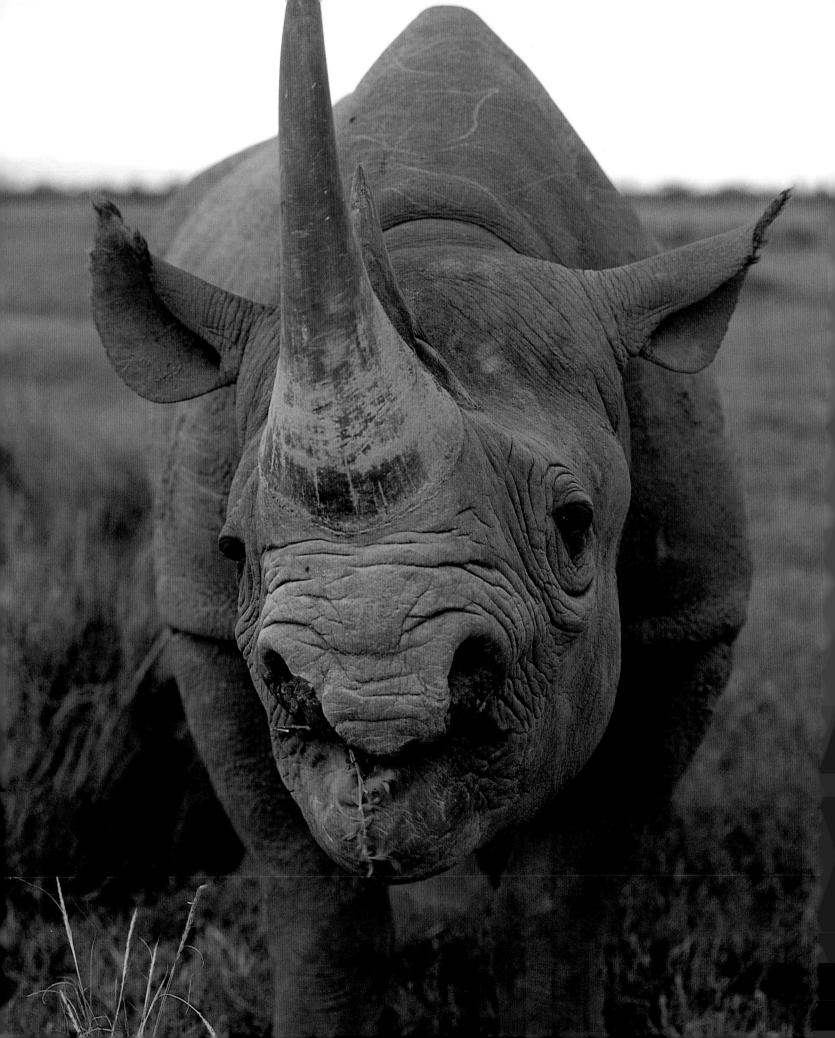

Heading for extinction. The lush Ngorongoro crater in Tanzania is one of the best places to visit for anyone who wants to see the rare black rhinoceros. The crater is 15.5 miles (25 km) in diameter and home to about 25,000 large mammals. When we were there, there were just a dozen rhinoceros in the area.

The rhinoceros is perhaps Africa's most threatened mammal. It is estimated that there were 65,000 black rhinoceros in Africa in 1970; today there are only about 2,700 (although, fortunately, a slight increase has recently been recorded). The reason for the sharp decline is well known – rhinoceros are poached for the sake of their horns. Today the medicinal market poses the greatest threat to the rhinoceros, in spite of the fact that the horn's claimed pharmacological effect has no scientific basis – rhinoceros horn is comprised of the same substance as our own fingernails.

The white rhinoceros is not white. Nor is the black rhinoceros black – both are grey. The white rhinoceros's name derives from a mistranslation of the Boer "weite", which means broad or wide, rather than white, and refers to the broad, blunt shape of the animal's upper lip. The black rhinoceros has a pointed upper lip.

There are two subspecies of the white rhinoceros – one northern and one southern. At the end of the nineteenth century the southern subspecies had been hunted almost to extinction. In Kenya the subspecies has now been introduced in several places, including Lake Nakuru national park. Total stocks now number more than 10,000 individuals, proving that protective measures can be effective. However, the northern subspecies is faring less well – only in the Gambia national park in the Democratic Republic of the Congo, formerly Zaire, do any white rhinoceros survive at all. There were between twenty and thirty individuals here a few years ago, and the civil war in that country can hardly have improved the situation.

LEFT: *Although it is smaller than the white rhinoceros, the black rhinoceros may still weigh up to 1.3 tons and reach a shoulder height of 5 feet, 3 inches (1.6 m). It has two horns, the larger of which can grow to about 3 feet, 3 inches (1 m) long. Sweetwaters, Kenya.*

NEXT PAGE: *The white rhinoceros is sometimes more appropriately called the blunt-nosed rhinoceros because of the square shape of its muzzle. Lake Nakuru, Kenya.*

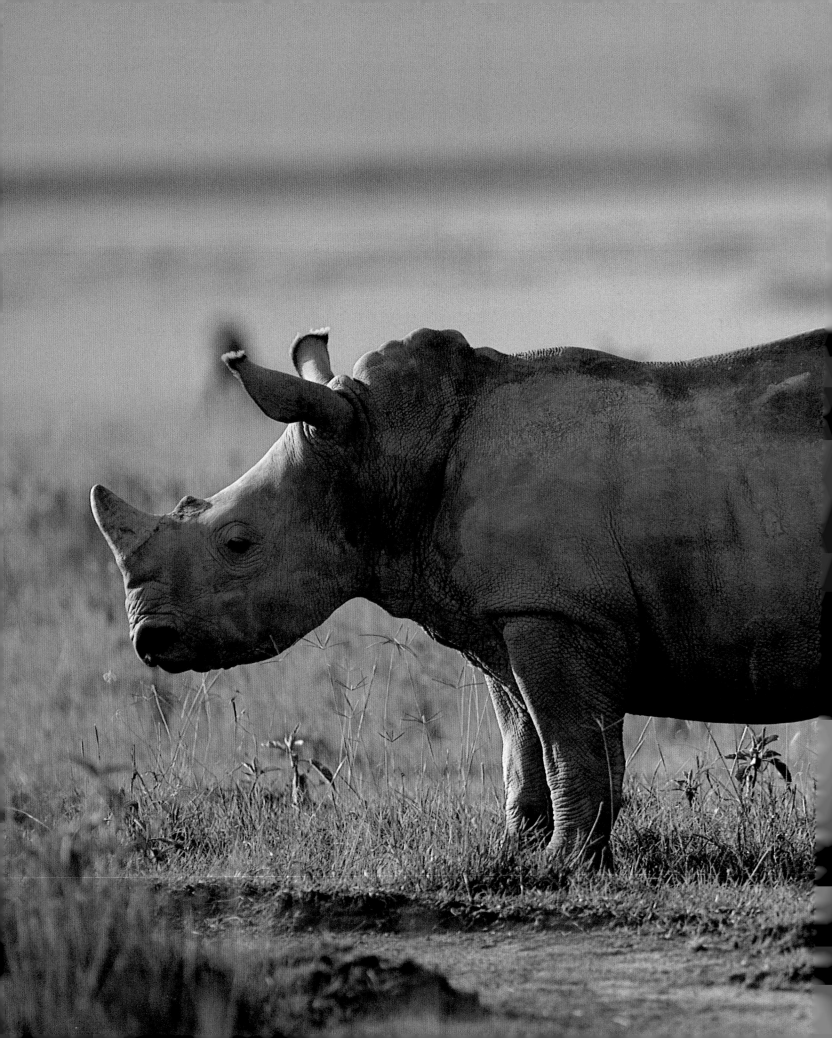

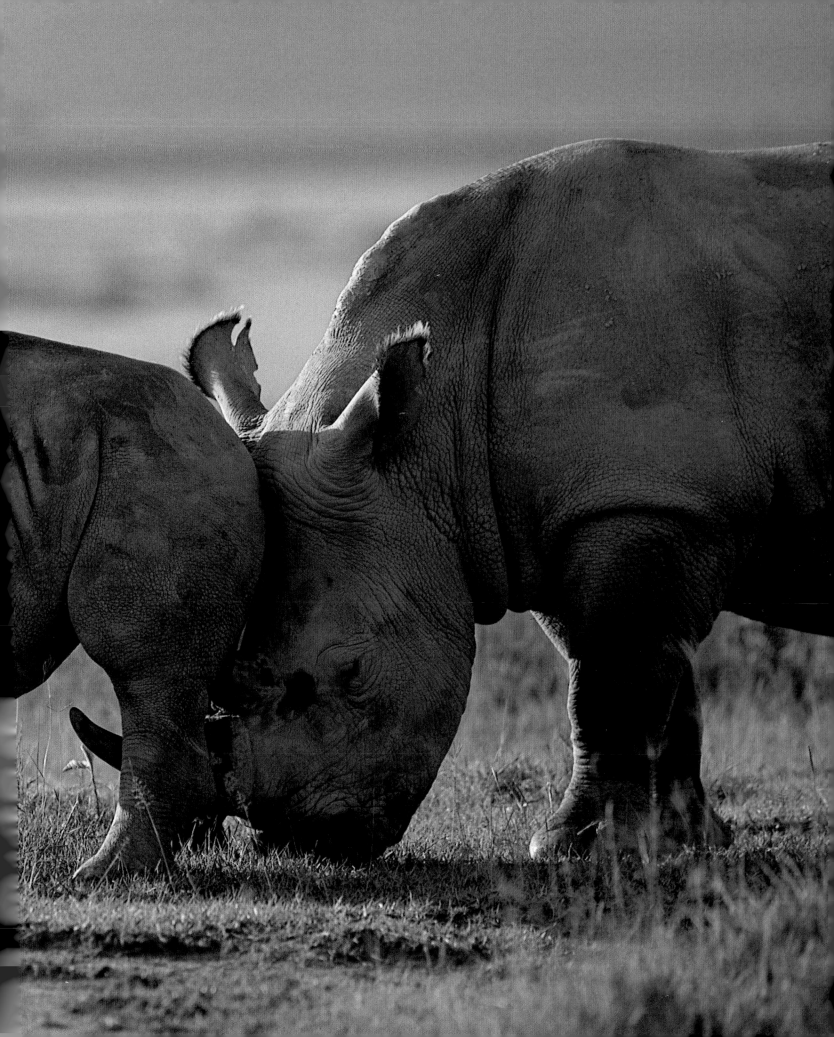

Why is the warthog so ugly? An East African story offers the following answer: "In the beginning the warthog was a small but beautiful animal. Unfortunately it was also unpopular because it was vain and arrogant.

"The warthog used to make itself a comfortable home – often in an old porcupine hole. During the day the warthog never wandered too far from its hole, where it felt safe from predators. However, one bright morning the warthog was out feeding, and was so preoccupied that it did not notice a porcupine disappearing down into its hole. After several hours spent eating, the warthog went to a nearby water hole to wallow in the mud. Just when the warthog was about to set off to forage for some more food a lion came past. The warthog could not resist making a few impertinent remarks about the fact that the lion's mane was unkempt. This was too much for the lion and it lunged forward to teach the cheeky warthog a lesson.

"The warthog panicked and raced to its hole for safety. The lion stood patiently outside and waited. The noise created by the warthog's sudden return awoke the porcupine from a deep sleep. Convinced that a predator was on its way into the hole it prepared itself for an attack and raised the long sharp spines on its back. Unable to stop itself, the warthog ran headlong into the porcupine and got a face full of sharp, prickly spines.

"Shrieking loudly, the warthog came charging up out of the hole with a dozen spines embedded in its cheeks, snout and forehead. The lion waiting outside saw what a state the warthog was in and, realizing that it had already been taught a lesson, decided not to chase it.

"Although the warthog was a sorry sight, none of the other animals was prepared to help pull out the spines. The hog's snout swelled up and even today the creature is covered with warts as a result of that excruciating experience."

BELOW: The warthog's knobbly countenance actually serves a purpose. When two hogs attack each other head on, the "warts" act as protection against the opponent's upturned, curved tusks, which have developed from the canine teeth of the lower jaw.

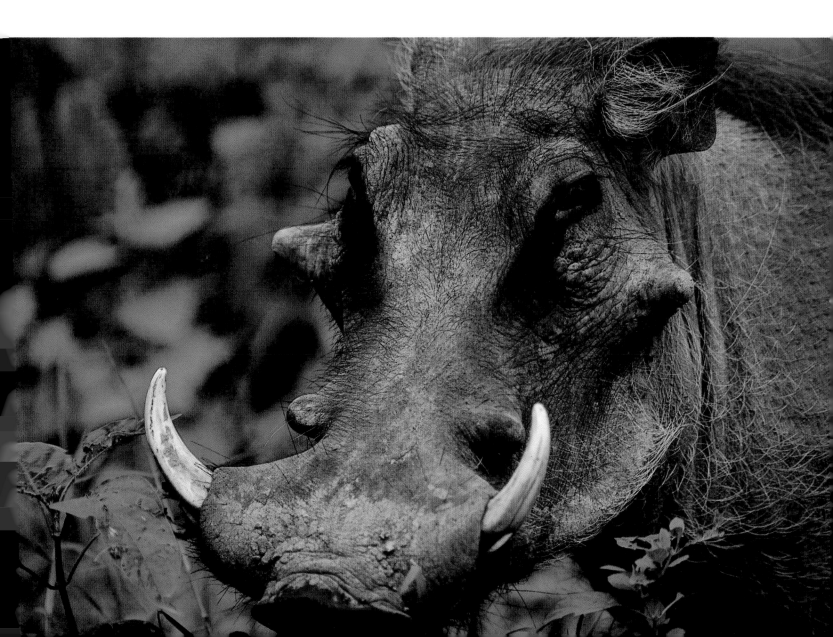

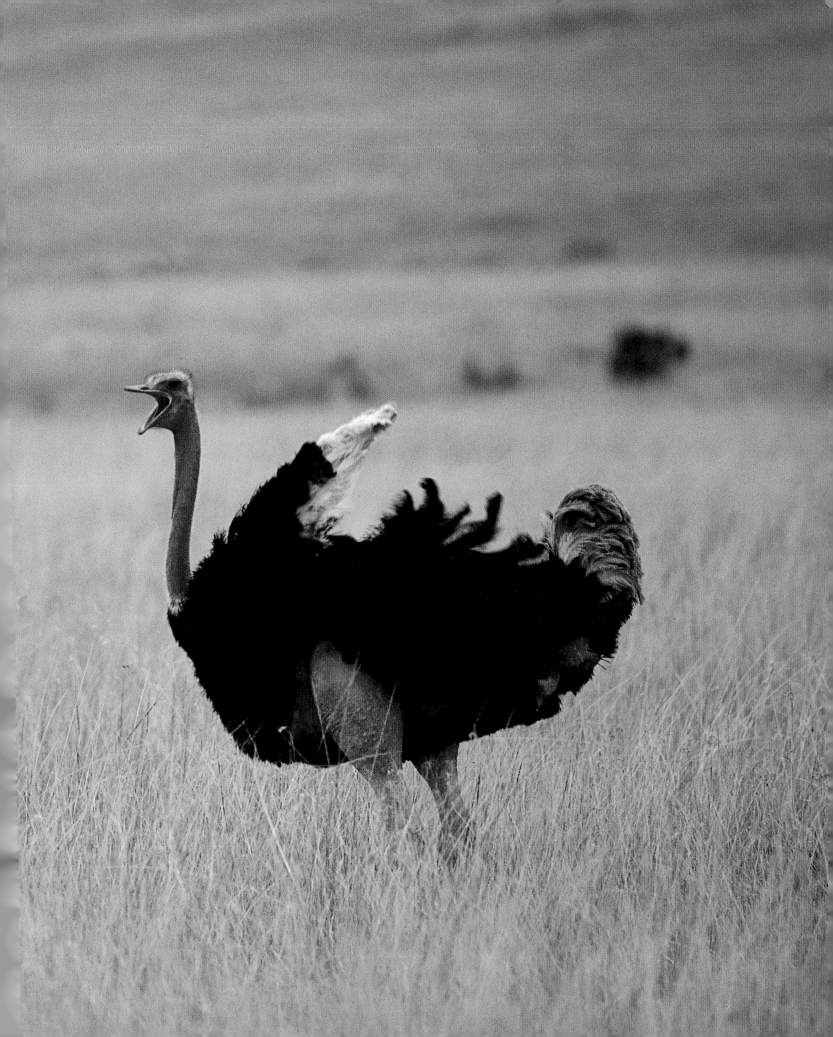

The Samburu people. The Samburu live in northern Kenya, in the areas around the Samburu national park. To the uninitiated they can easily be mistaken for Masai, as the two peoples belong to the same ethnic group and share the same language. Even the two cultures are very similar. As with the Masai, the Samburu people's life is centred on their cattle, which provide for most of their needs. The Samburu love to adorn themselves. The young warriors – or morans – like to dye their hair red and wear colourful bracelets, necklaces and feathers in their hair.

The ostrich – the giant of the bird kingdom. An adult ostrich is no easy prey for a predator. Admittedly it cannot fly, but it runs fast, at speeds of up to 30 miles (50 km) an hour. With its strong leg muscles it can also place well-directed, karate-style kicks.

The ostrich is most vulnerable to attack when it lowers its head to feed, so when a flock of ostriches are grazing one always keeps a watch and warns the others if a predator approaches. However, for many centuries human beings, rather than animal predators, have posed the greatest threat to the ostrich. Ostrich feathers were long a prized fashion accessory in the West, and the trade in feathers took a heavy toll on African ostrich populations.

The ostrich is an unusual bird in many ways. For example, the male mates with up to six or more females, each of which lays between six and eight eggs in a common nest. When all the hens have laid their eggs, the "clutch" may consist of up to fifty eggs. Although the thick-shelled ostrich egg weighs, on average, almost 3.5 pounds (1.5 kg), it is actually very small in proportion to the size of the female bird's body.

The male ostrich's favourite mate – known as the alpha hen – is the only female who stays and sits on the eggs together with him: the female sits during the day, the male at night. Ostrich chicks hatch after forty-two days. They are already well developed on hatching and are soon able to follow their parents, who protect them from predators.

PREVIOUS PAGE: *At 8 feet (2.5 m) tall with a weight of 250 pounds (115 kg), the ostrich is the world's largest living bird. This is a male. Masai Mara, Kenya.*

RIGHT: *An unmarried Samburu girl knows how to adorn herself to attract admiring glances. Samburu, Kenya.*

NEXT PAGE: *A bedecked Samburu warrior contrasts starkly with the dry, monochrome savanna. Samburu, Kenya.*

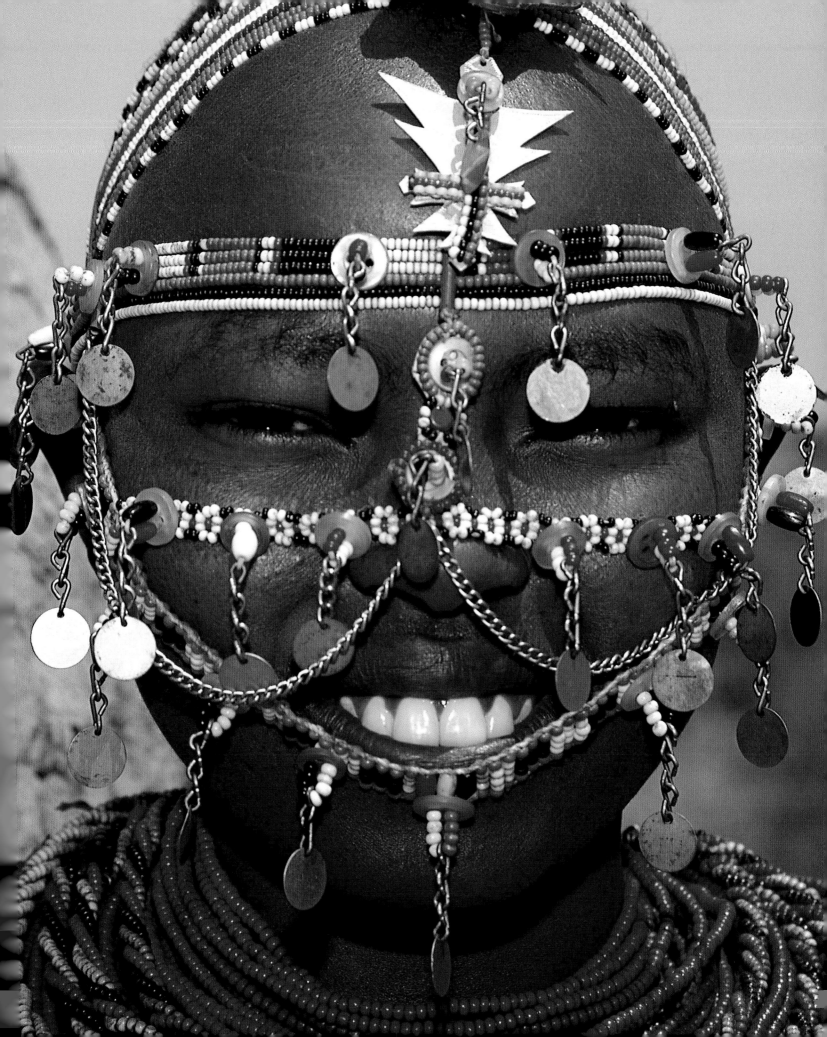

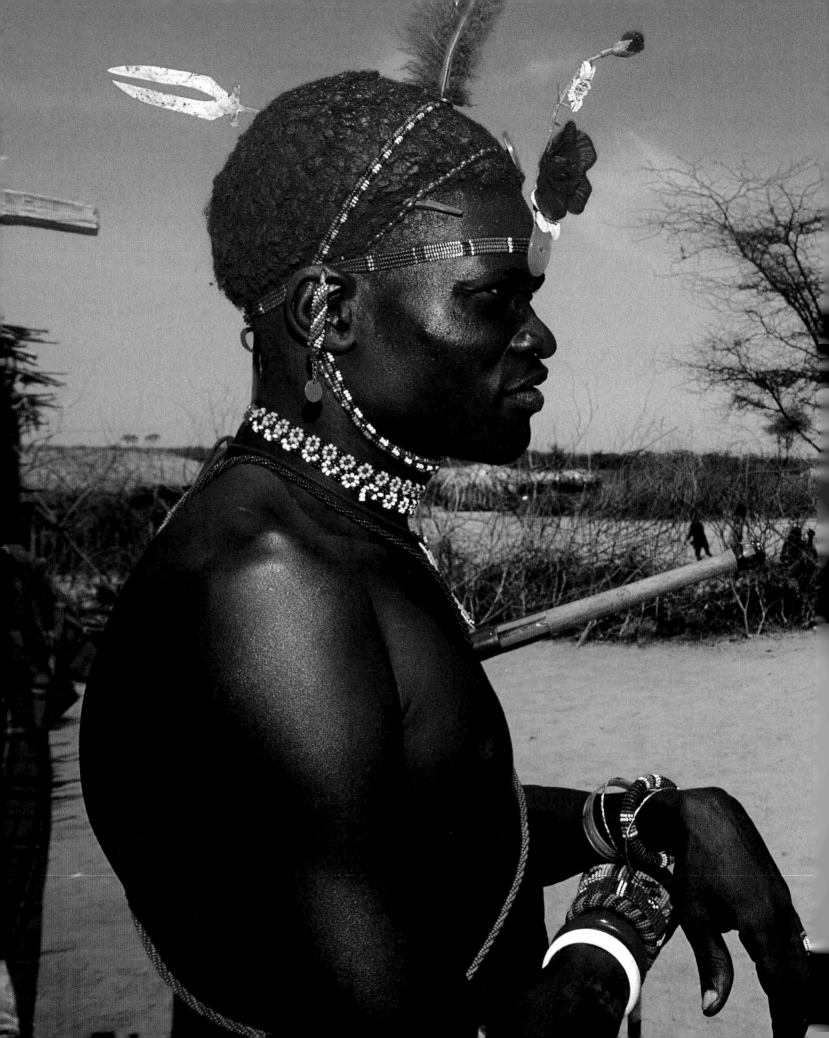

A guinea fowl with a vulture's head. In the Samburu national park in Kenya – and in other dry areas – the splendid vulturine guinea fowl thrives. It has long legs, a long tail and a slender, elongated neck, the lower part of which is adorned with long, pointed black, white and blue feathers. The guinea fowl's head looks as if it has been borrowed from a vulture, hence the bird's name. Like other guinea fowl, the vulturine guinea fowl is not particularly fond of flying. It prefers to run – quickly and preferably surrounded by lots of other birds. A flock of up to twenty vulturine guinea fowl bowling through the savanna's scrubland makes an entertaining spectacle.

BELOW: *The vulturine guinea fowl thrives in the dry areas in northern Kenya where it runs through brush and bush. Samburu, Kenya.*

RIGHT: *Just like a vulture, the vulturine guinea fowl's head and the upper part of its neck are sparsely covered with feathers.*

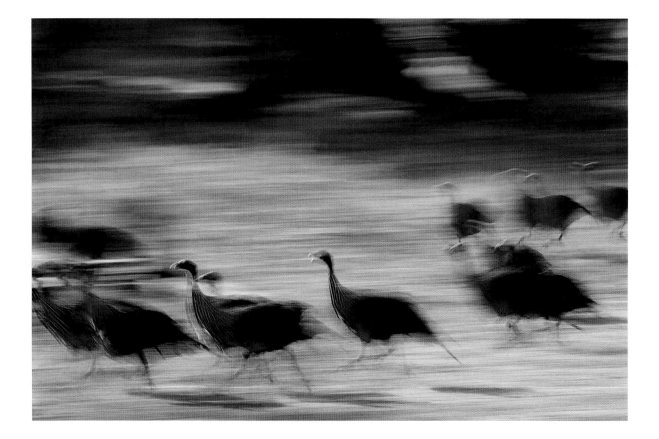

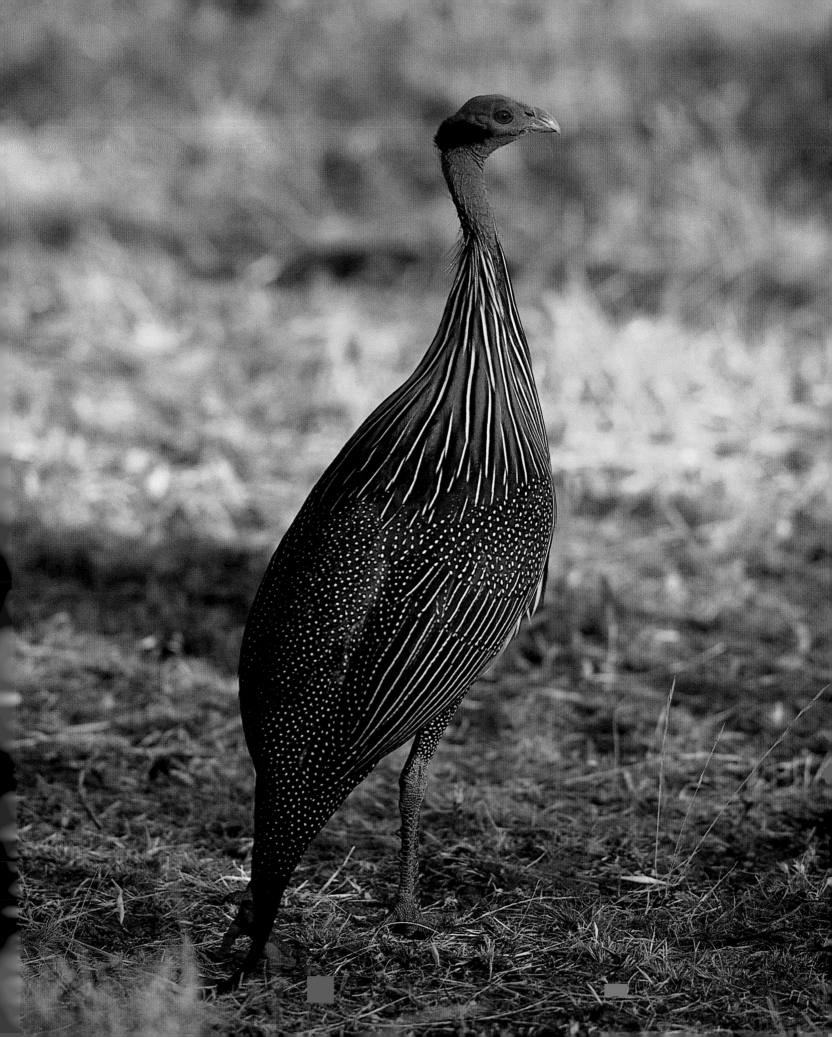

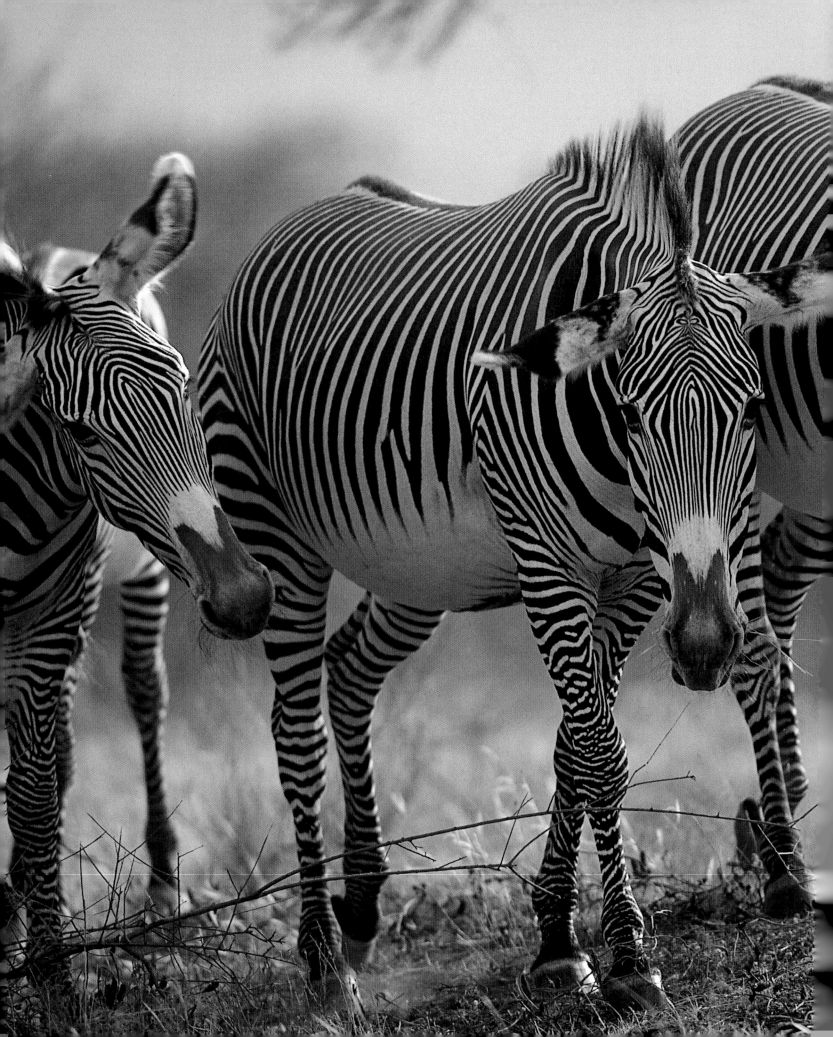

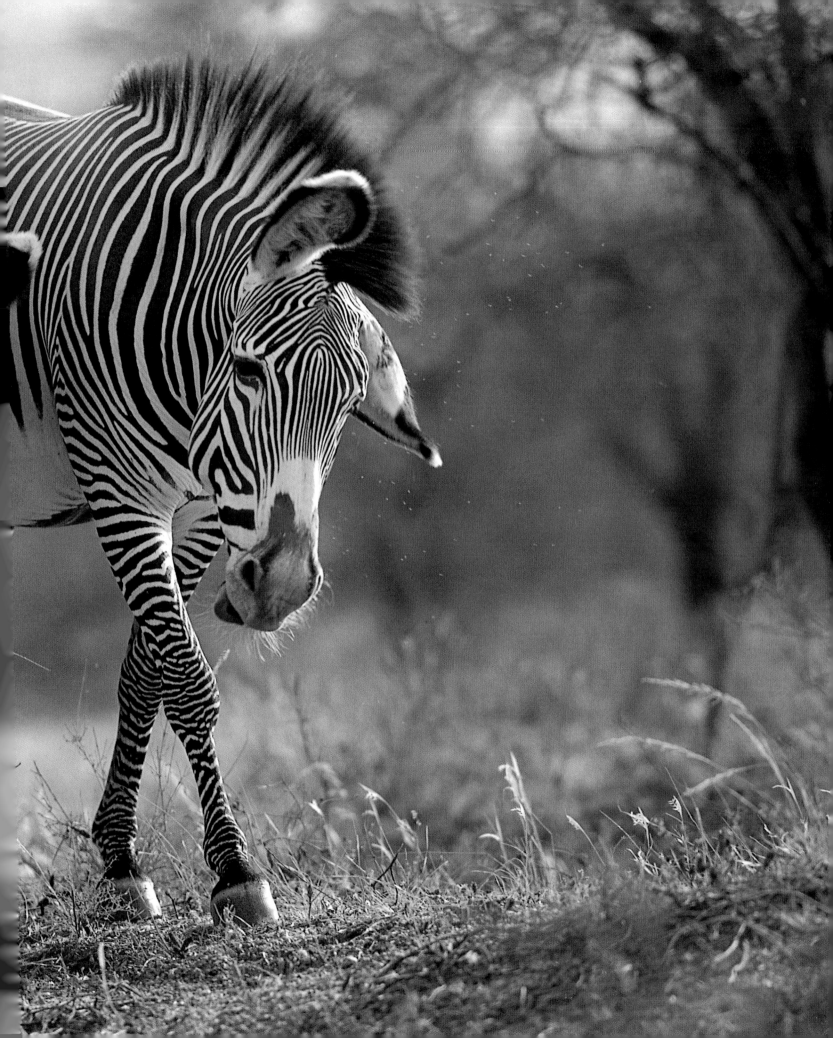

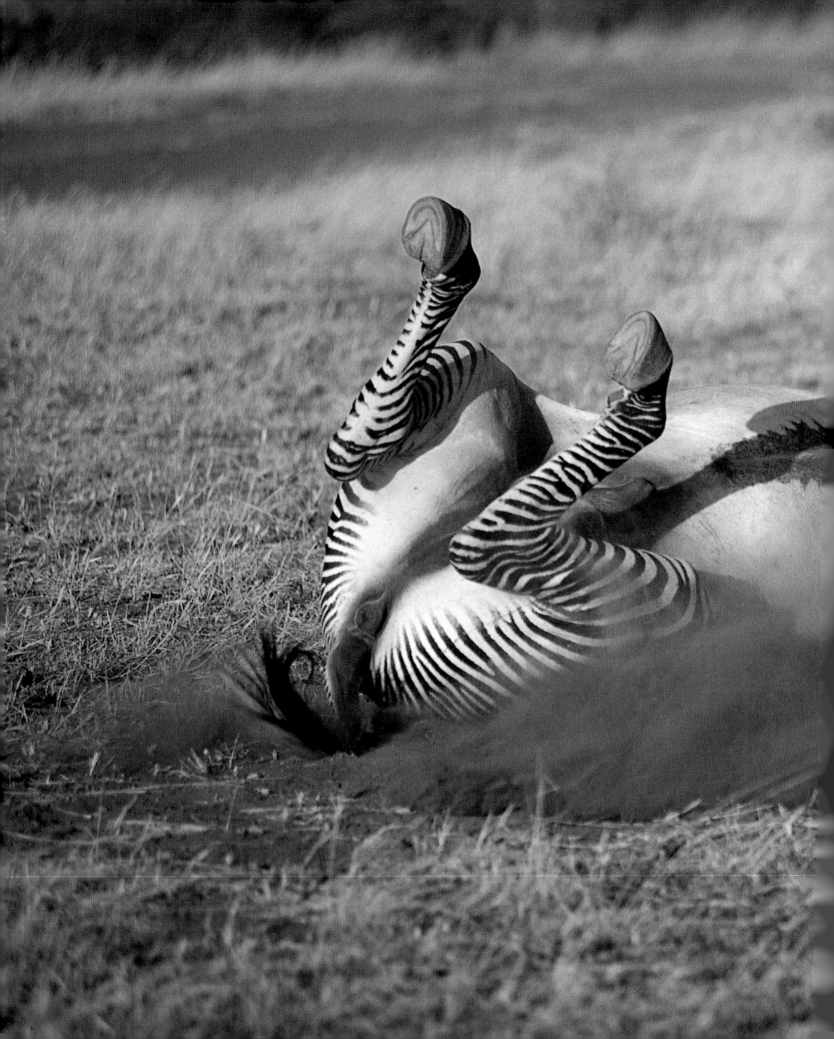

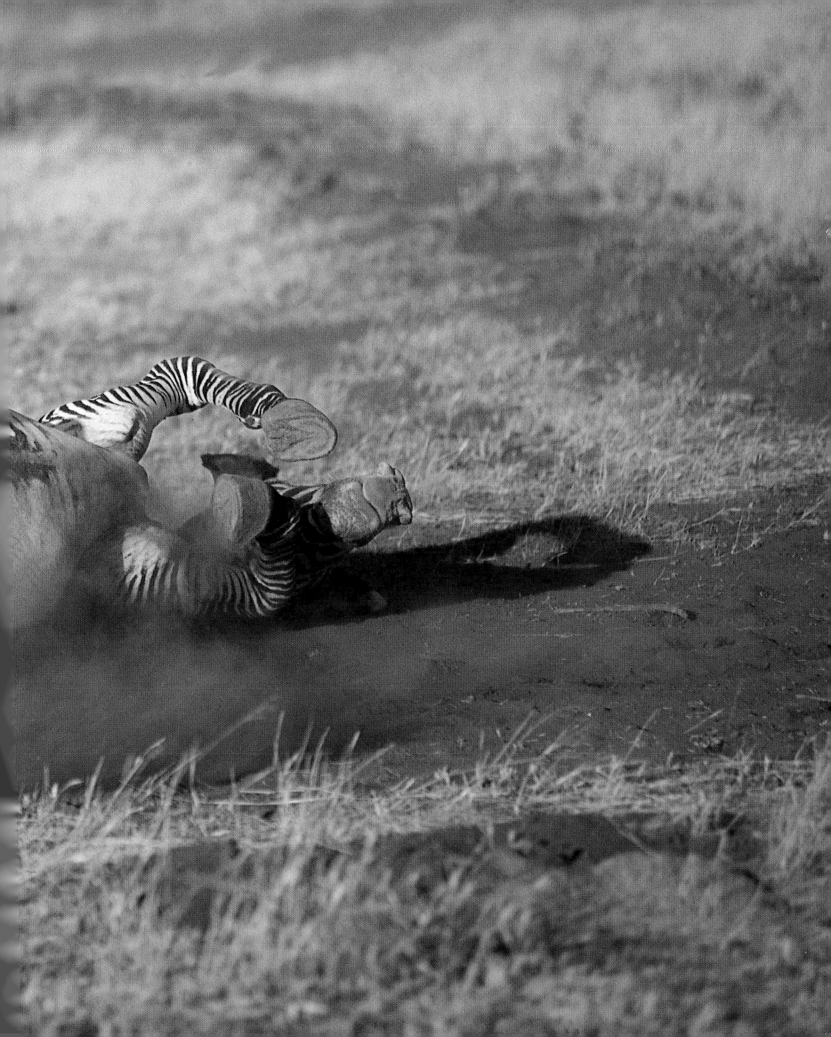

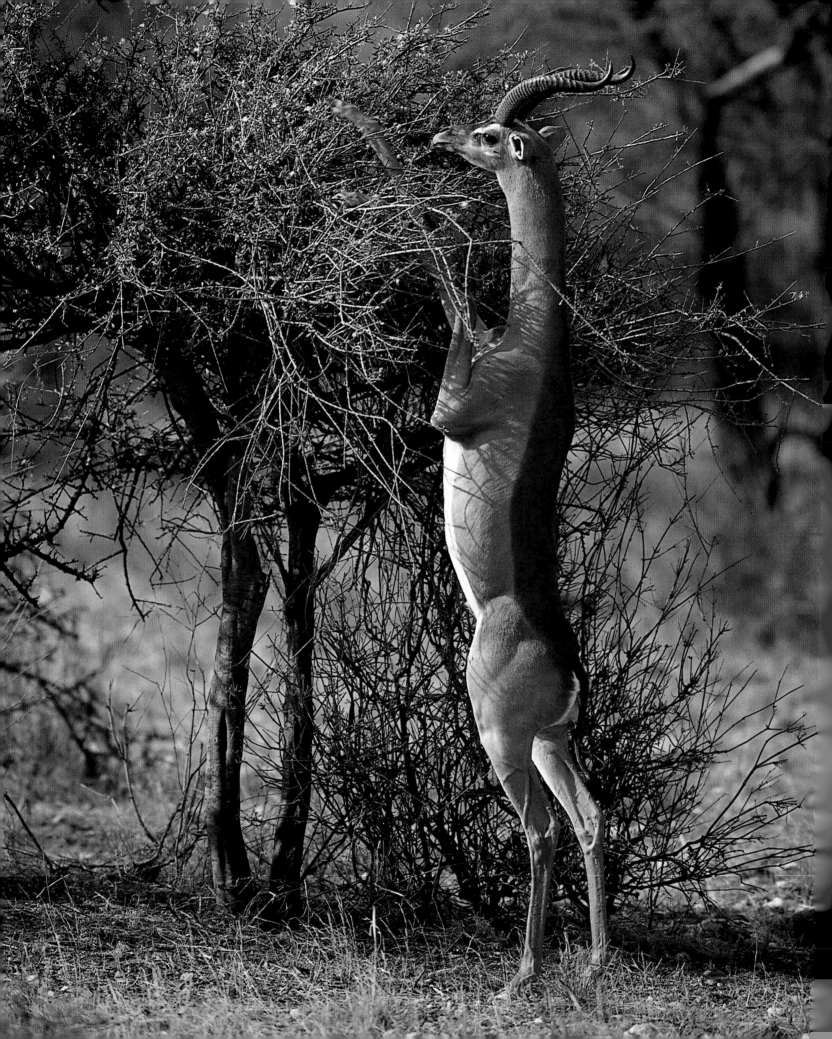

Grevy's zebra. There are three species of zebra. The common zebra, as its name suggests, is the most widespread. It is also known as the plains zebra. The mountain zebra lives in southwestern Africa, while the Grevy's zebra (pictured on the previous page) is found mainly in northern Kenya, Somalia and Ethiopia, where it inhabits areas of semi-desert and bushy steppes. One of the best places to see this zebra is in the Samburu national park in Kenya.

The narrow, vertical black-and-white stripes that curve up over its thighs clearly differentiate the Grevy's zebra from the common zebra. The Grevy's zebra's characteristic mane grows vertically, and its long, narrow head and broad ears make it look rather like a mule.

The giraffe-necked antelope on two legs. The gerenuk – or giraffe-necked antelope as it is also known – is incredibly striking. This slender antelope is happy in very dry environments, such as Samburu in northern Kenya. It has been able to carve out its own special niche thanks to its unusual anatomy – with the help of its long neck it can get hold of food other animals cannot reach, picking the juiciest leaves from bushes and trees. But the gerenuk also has another advantage: it can suddenly rear up on its hind legs to reach even higher acacia leaves – up to about 6 feet, 6 inches (2 m) or more above the ground – and can stand at full height on two legs for up to 15 minutes without difficulty. This position allows the gerenuk to use its front legs to bring any twigs bearing tempting-looking leaves to within reach.

PAGES 76–77: *The beautiful Grevy's zebras are found in northern Kenya. Samburu, Kenya.*

PREVIOUS PAGE: *A Grevy's zebra rolls on its back until the dust whirls around it. Samburu, Kenya.*

LEFT: *The gerenuk, or giraffe-necked antelope, can reach the leaves at the very top of a bush or small tree by standing upright on its hind legs. Samburu, Kenya.*

A richness of birds. More than 2,200 species of bird have been observed in sub-Saharan Africa. This is more than twenty per cent of all known species, and of these about 1,850 breed here. Around thirty-five per cent of Europe's breeding birds migrate to tropical Africa, including storks, raptors, waders and a long list of small birds, such as swallows, thrushes, warblers and flycatchers. There is a general tendency for birds that breed in western Europe to fly to West Africa, while species from eastern Europe migrate to eastern and southern Africa.

Many of these migratory birds are often thought of as being European, but in fact they spend more time in Africa than in Europe. An alternative to the traditional view is that they undertake a "breeding migration" to the north to take advantage of the abundant insect populations there.

The birds in these pictures, however, are as African as can be. The hornbill's large but light beak is an excellent tool for plucking fruits and handling large insects and other delicacies. There are more than twenty species of hornbill in Africa – the red-billed hornbill is one of the most common. The glossy starling can be seen everywhere and it loves to take a bath in the nearest puddle. The beautiful rosy-breasted longclaw is often spotted in small bushes out on the savanna.

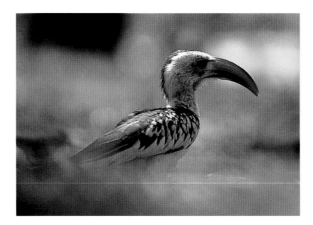
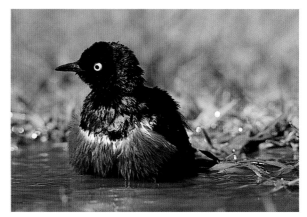

FAR LEFT: *A red-billed hornbill. The long bill is very handy when the male has to supply the female and her chicks with food. During breeding the hen shuts herself into her nesting hole and walls up the opening, but leaves a small crack as a "food hatch". Samburu, Kenya.*

LEFT: The glossy starling loves to bathe and like so many other members of the starling family is often seen close to people. The one shown here is a species known as the superb starling. Samburu, Kenya.

BELOW: The rosy-breasted longclaw is a common sight on the savannas of the Masai Mara and the Serengeti. Masai Mara, Kenya.

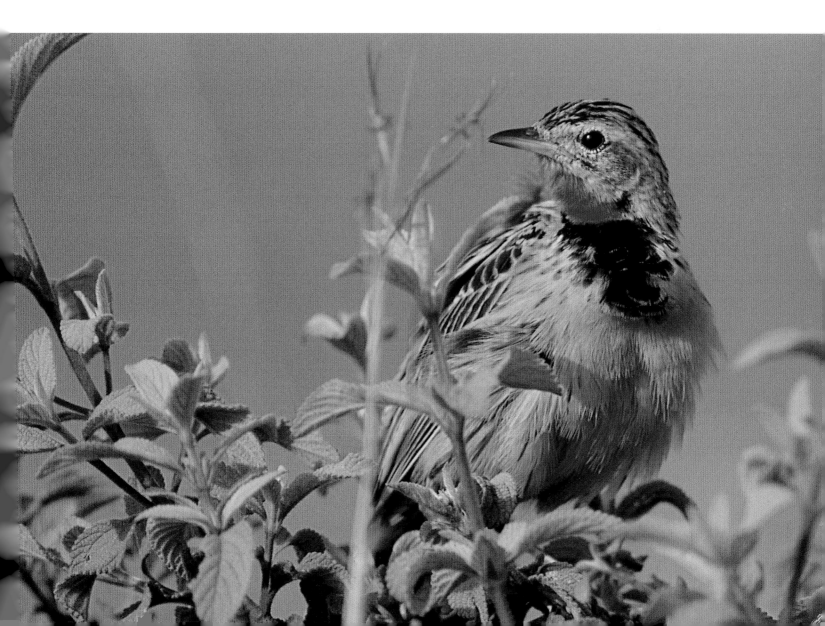

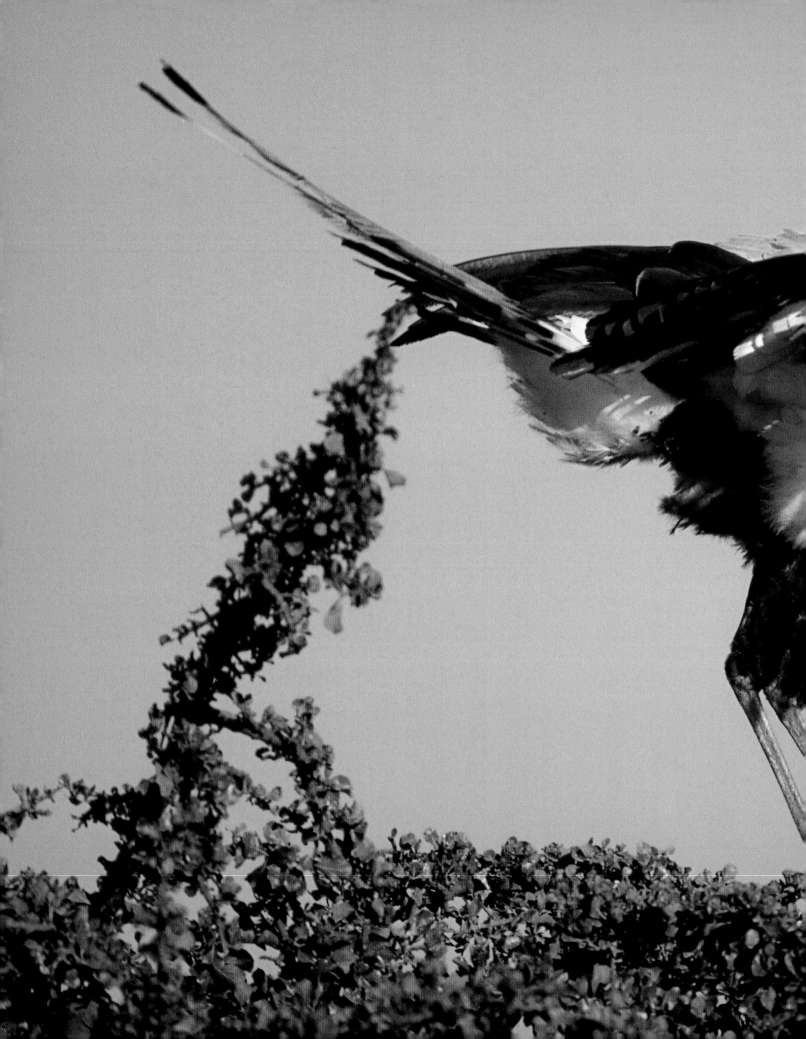

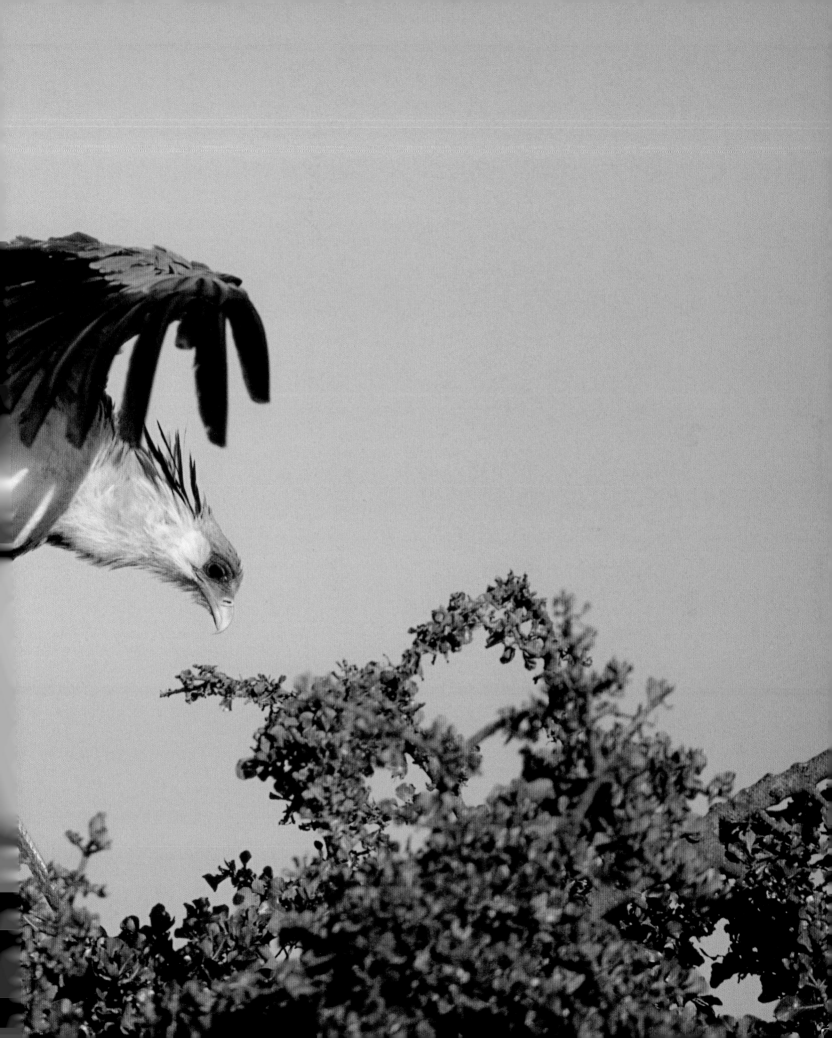

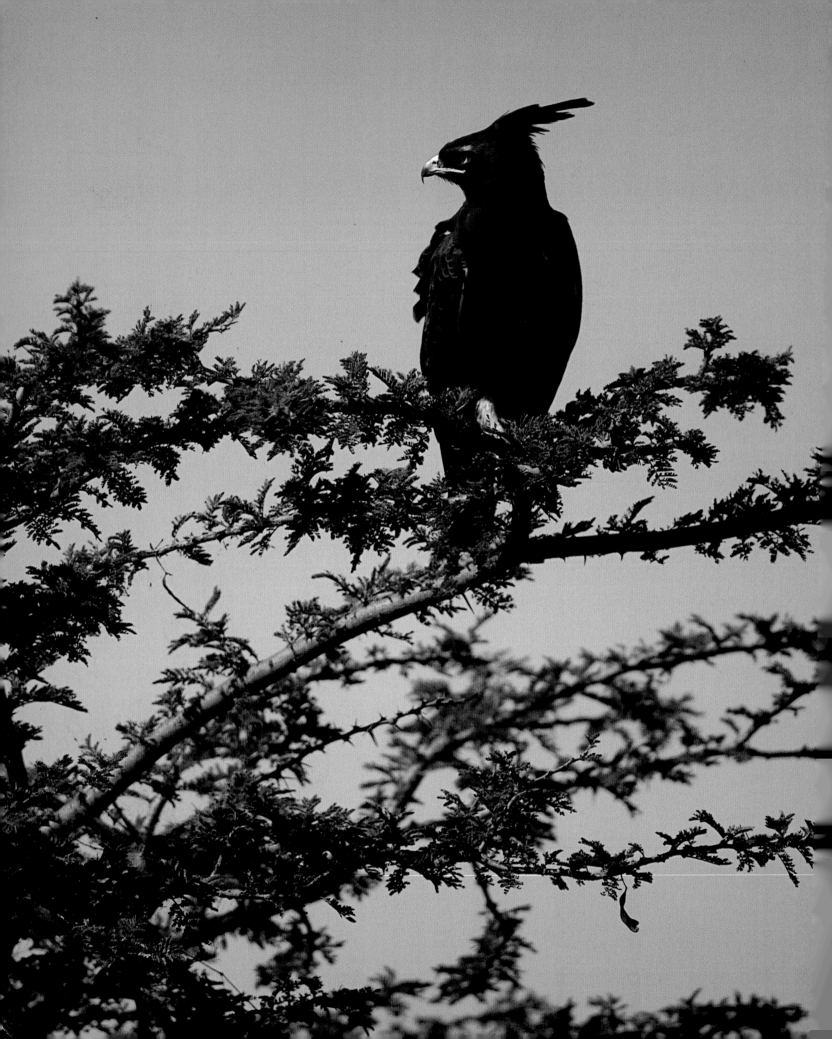

The long-crested eagle and the secretary bird. Africa is the place for anyone with a preference for birds with curved beaks and sharp claws. At the top of an acacia sits the long-crested eagle on the look-out for prey. Easily recognizable thanks to its characteristic tuft, which often stands straight up like a wimple, the long-crested eagle can sit like this for hours until it spots a suitable quarry on the ground. Then it dives and hopefully catches a rodent, a small chicken or a reptile.

Where reptiles are concerned, however, the most skilled hunter of all is the secretary bird, which is an expert on creeping creatures such as lizards, frogs and snakes (it even hunts poisonous snakes such as cobras). Chickens, rats, shrews and hedgehogs are also easy prey. With the exception of the very biggest, the secretary bird swallows most of its victims whole. When it is targeting a potentially dangerous prey it prances around nervously and tries to get in a kick or two before grabbing the creature with its powerful toes and suffocating it.

The secretary bird, like the one shown on the previous page, may occasionally rest in a tree, but it spends most of the day strutting around on its strong, stilt-like legs searching for food. At more than 3 feet (1 m) tall, it has a good view of the surrounding terrain. This odd, stork-like bird is actually a raptor.

PREVIOUS PAGE: *The secretary bird's name is derived from the special feathers on its neck — they resemble the old quill pens that secretaries often had tucked behind their ears in former times. Masai Mara, Kenya.*

LEFT: *The long-crested eagle can sit for hours scanning the ground for prey. Masai Mara, Kenya.*

Welcome visitors. There is a reason why the oxpecker is allowed to creep around and pick the buffalo's nose, scale the giraffe's neck and climb on the back of the impala's head – the little bird feeds on irritating insects and parasites such as horseflies, ticks and lice. But these small creatures are not the only things on the oxpecker's menu – a quarter of what it eats comprises wax and skin from the host animal's ears. What is more, the oxpecker loves blood, which it consumes when it swallows blood-filled parasites. It also helps itself to blood from any wounds on the host's skin. If the wound has begun to heal, the oxpecker will happily pick a hole in it again.

As these pictures show, there are two different species of oxpecker – the yellow-billed and the red-billed. Both are specially adapted to their unusual lifestyle, with long, pointed toes and claws which enable them to hold on tight when the host animal moves.

BELOW LEFT: *An oxpecker will look anywhere for food, even on the muzzle of the kaffir buffalo. Masai Mara, Kenya.*

BELOW RIGHT: *Just like woodpeckers, oxpeckers have short tails that work as a support. This is useful when riding on the long neck of a giraffe. Masai Mara, Kenya.*

RIGHT: *A red-billed oxpecker helps an impala to keep its hide free of various insect pests. Samburu, Kenya.*

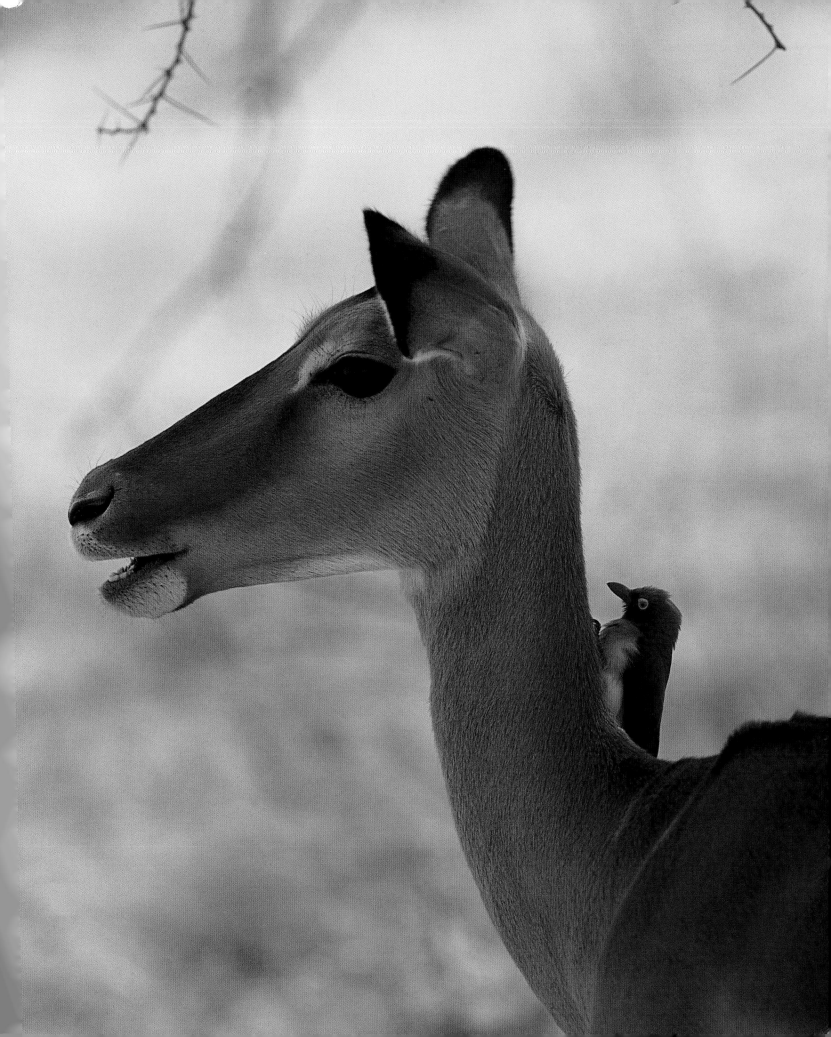

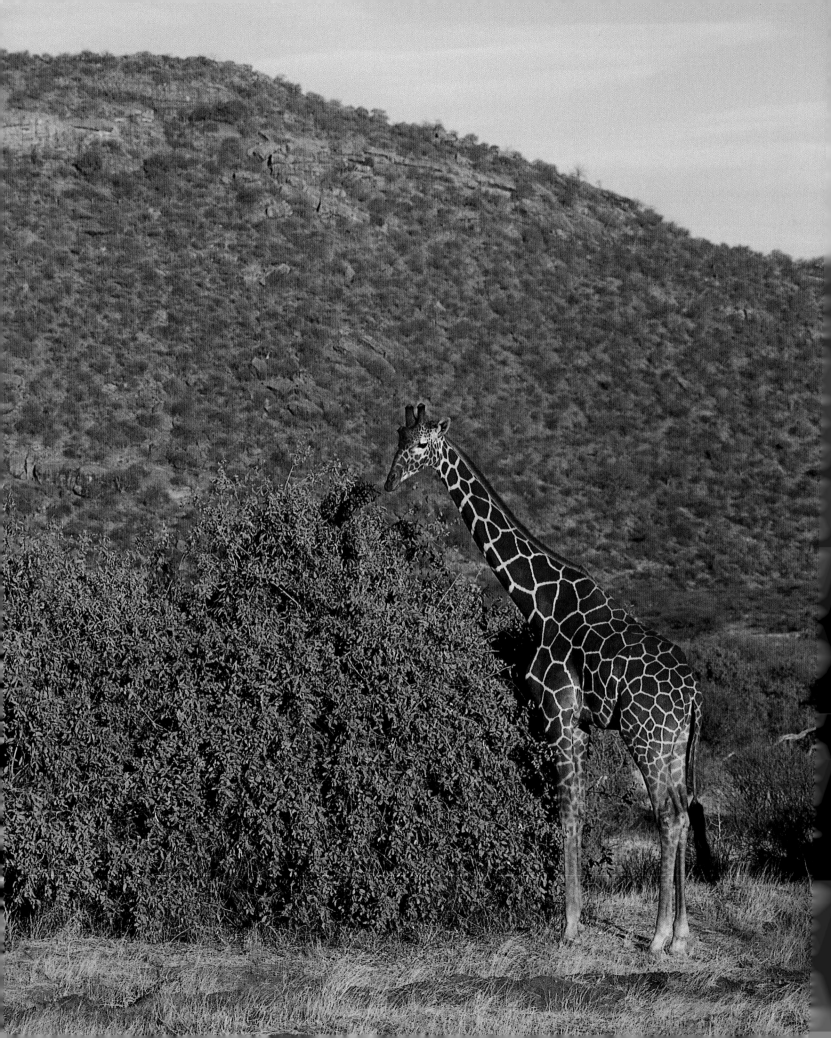

Food is everything. The giraffe spends most of its life eating. It often grazes on acacia trees, which have long thorns and small, hook-shaped prickles. With the help of its tongue, which is almost 20 inches (0.5 m) long, the giraffe devours leaves and prickles alike. Broad grooves in the roof of the animal's mouth help it to compress this spiky food.

The advantage of being so tall is that the giraffe can reach up to graze on the highest bushes. Its height also gives it a good view over the surrounding terrain, making it easy to spot an approaching lion. However, an adult giraffe becomes vulnerable to attack from predators when it is drinking water. Unable to actually reach the ground when it is standing normally, the giraffe has to splay its forelegs wide apart in order to drink – this rather awkward pose allows it to just get its mouth down into the water.

LEFT: *A grazing giraffe in the dry bush savanna of northern Kenya. Samburu, Kenya.*

BELOW: *The giraffe is most vulnerable when it is drinking. Etosha, Namibia.*

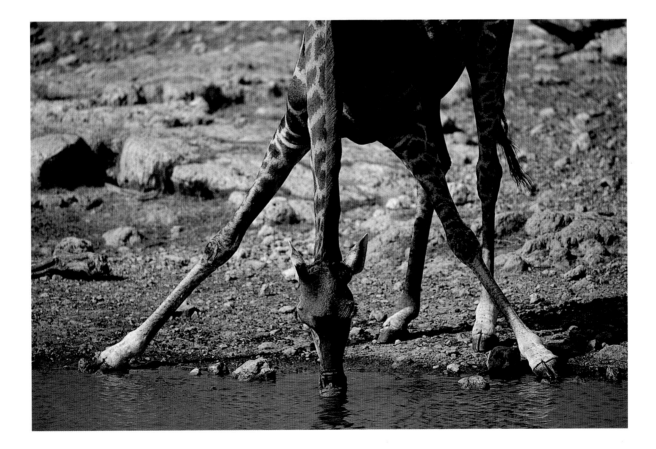

Tough hunters. While most other monkeys are content with their greens for lunch, certain baboons are not averse to a good steak, and they will not make do with rotten meat left over from the lion's feast. Instead they actually hunt for themselves, preferably in groups. They can catch small herbivorous mammals, such as gazelle calves or hares, which together they flush out of their hiding places. However, the individual baboon who finally manages to kill the prey is often only reluctantly prepared to share the spoils with his hunting companions.

Baboons can be enormously self-centred, but they are also very sociable. Happiest in each other's company, they are capable of developing close and long-lasting ties. The troop may comprise anything from thirty to 150 animals who spend most of their time together – whether they are on the move, eating or sleeping.

It is the females – most of whom are related to one another – who form the heart of the baboon community, while the large adult males may come and go. Female baboons are skilled at taking care of their young and protecting them from dangerous predators. In order to defend an infant, an adult baboon, with its strong canine teeth, will even tackle a leopard if necessary.

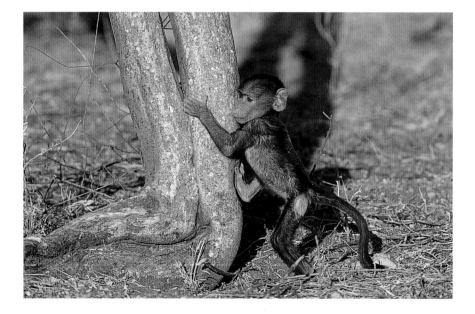

LEFT: *A baby baboon attempts to climb a tree for the first time. Savanna baboons mostly seek their food on the ground but they can also climb to the tops of the trees to feed on acacia flowers. Samburu, Kenya.*

BELOW: *A female baboon keeps her baby close to her and out of danger. Samburu, Kenya.*

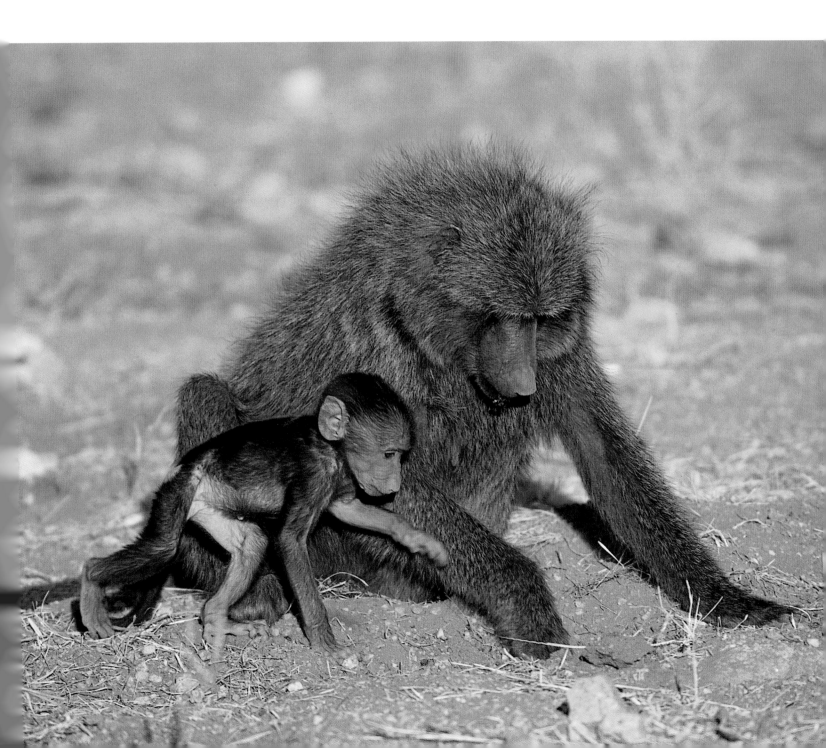

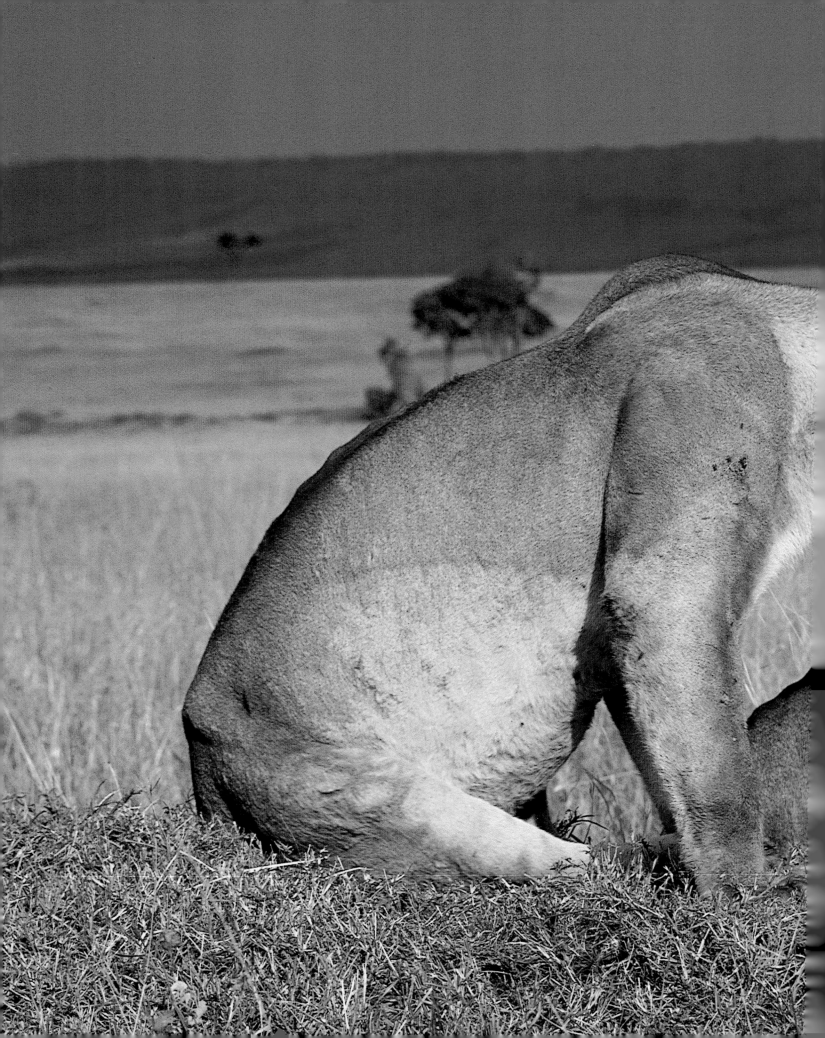

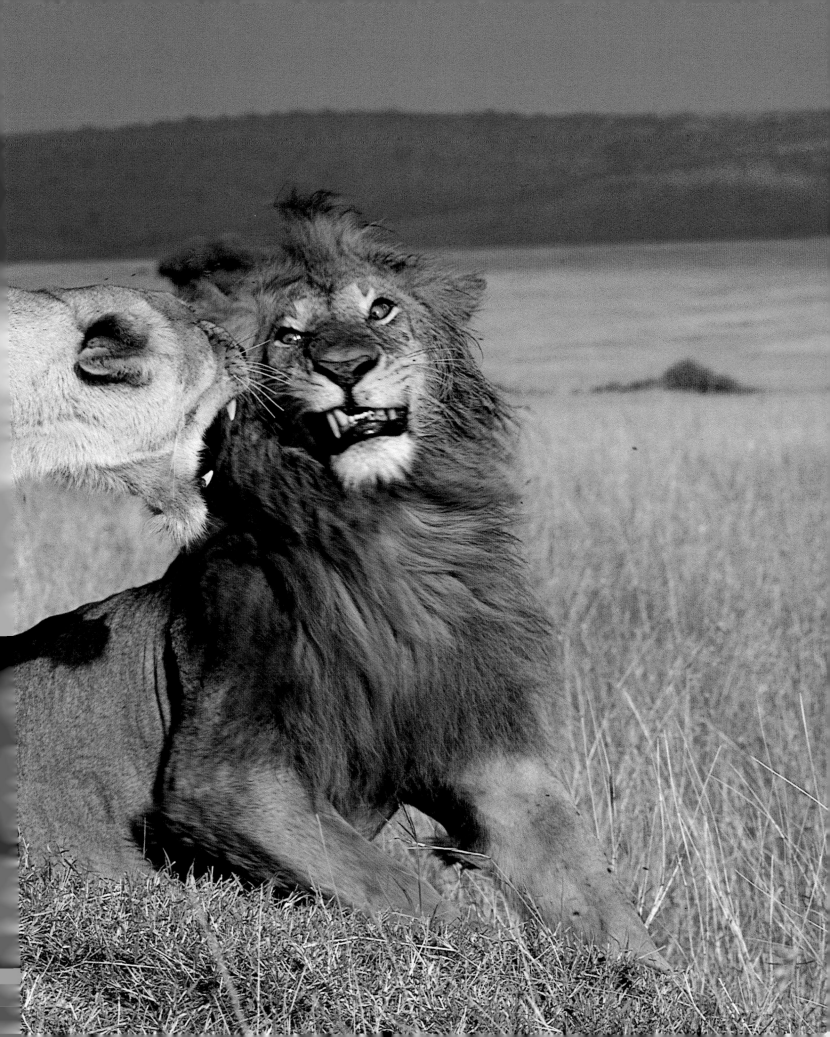

The great mating week. The lioness gets up and comes closer. She lies down. The male looks up drowsily. He stretches and trots over to the lioness. She turns and spits and growls at him. He growls back and then takes up position on the lioness's back. The act doesn't last long – barely twenty seconds. Then there's a pause. The male bites the female on the back of the neck a little and she responds by rolling over and baring her teeth. He takes the hint.

After just fifteen minutes' rest, the male rouses himself for a fresh coupling and the same ritual of growling and yelping. The lion can keep up this routine without a break (and without food) for the week during which the lioness is on heat, perhaps mating with her as many as 150 times. If, after a week, fertilization has still not occurred, the female comes on heat again about two weeks later, and this cycle continues until she conceives. According to research, only one in five attempts to reproduce is successful on average, which means that a pair of lions may need to mate several hundred times during the mating season in order to achieve fertilization.

PREVIOUS PAGE: *Here the lioness is spitting to keep the male away but he will soon try again. Masai Mara, Kenya.*

BELOW: *The lions' coupling often lasts as little as twenty seconds. Masai Mara, Kenya.*

RIGHT: *The lioness is pregnant for about three and a half to four months. She usually gives birth to two or three cubs. Masai Mara, Kenya.*

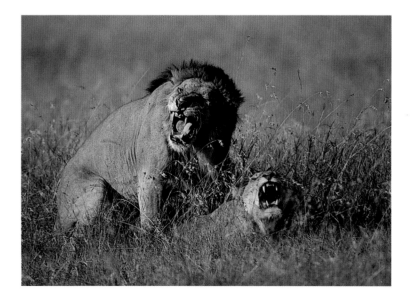

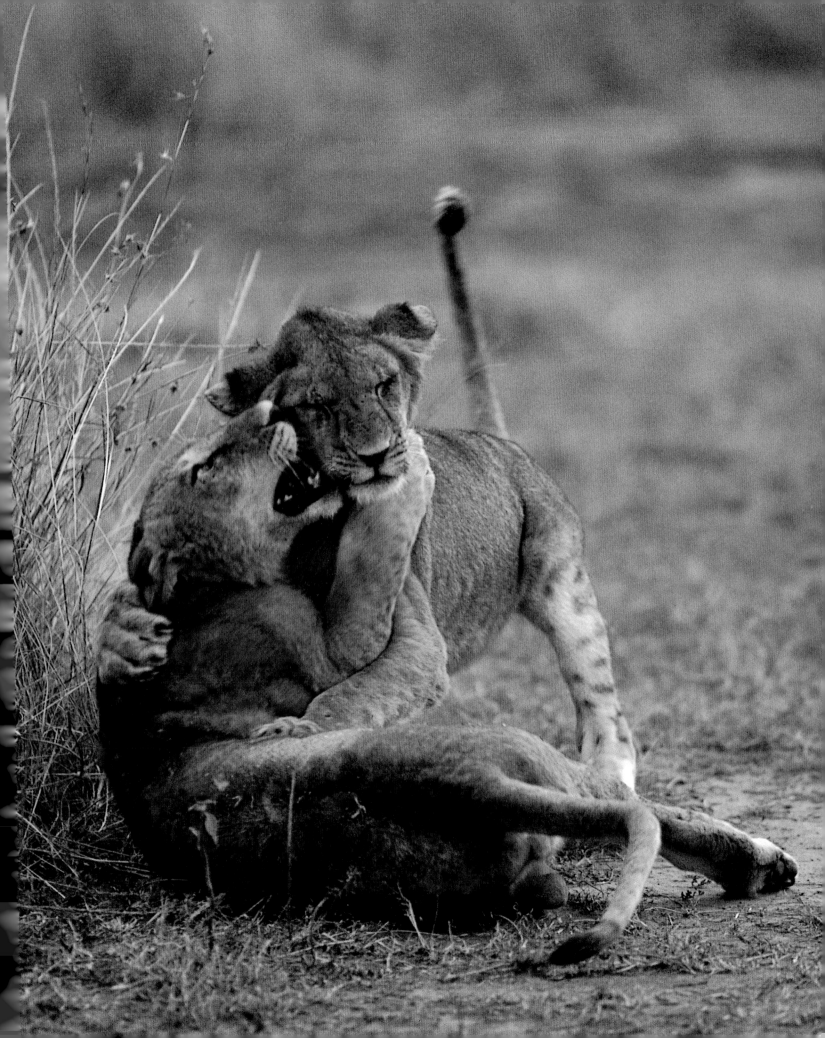

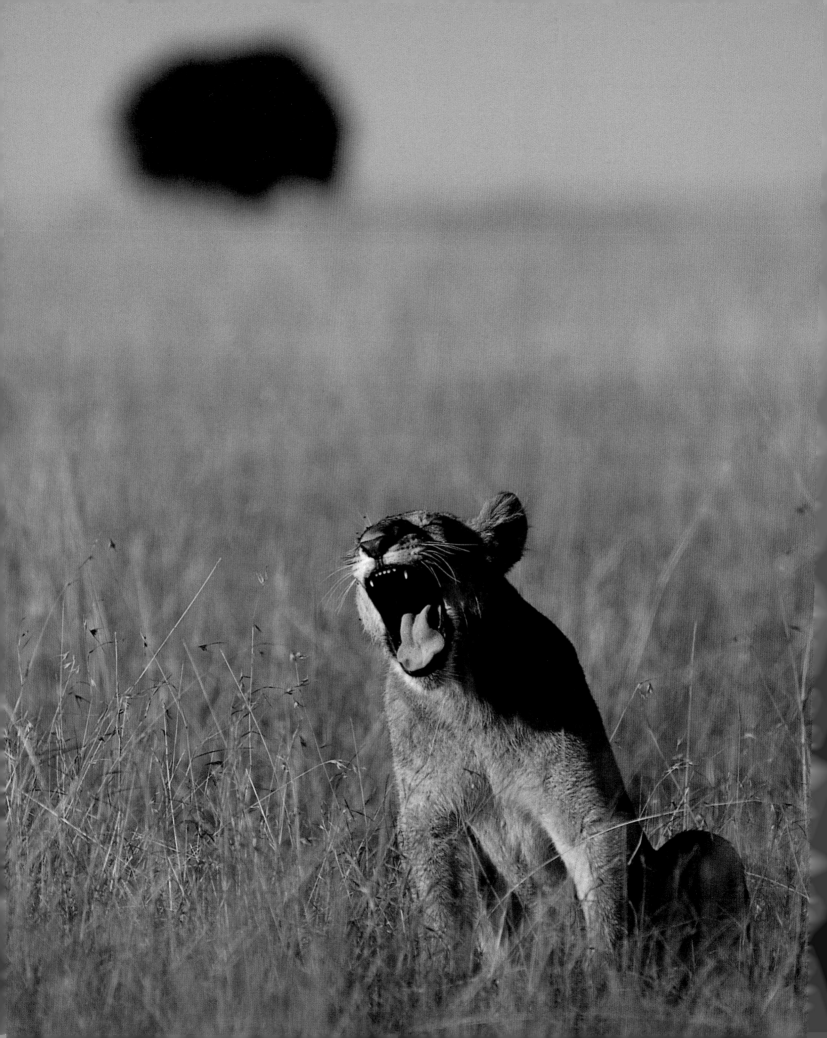

Games and danger. Lion cubs' games are a preparation for adult life. Like the pair pictured on page 97, cubs scrap and pounce on one another, and in this way they also begin to hone their hunting skills. Before too long they will be pouncing on wildebeest, zebras and other prey.

If a new male takes over the pride he usually rejects the role of stepfather and kills the younger cubs. With their cubs dead, the females will come on heat again and then the new leader can mate with them in the hope of fathering offspring of his own. Such infanticide may seem cruel to us, but such is the nature of the lions' world. Each adult male seeks to spread his own genes.

LEFT AND BELOW: *Like most cats, the lion rests for the greater part of the day, since on the open savanna hunting is most effective under cover of darkness. Masai Mara, Kenya.*

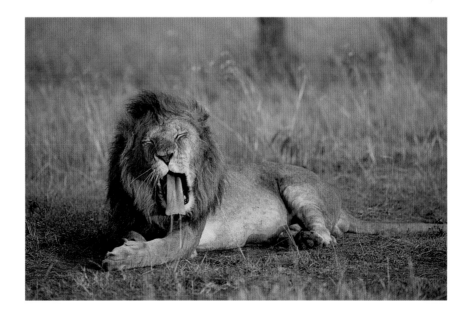

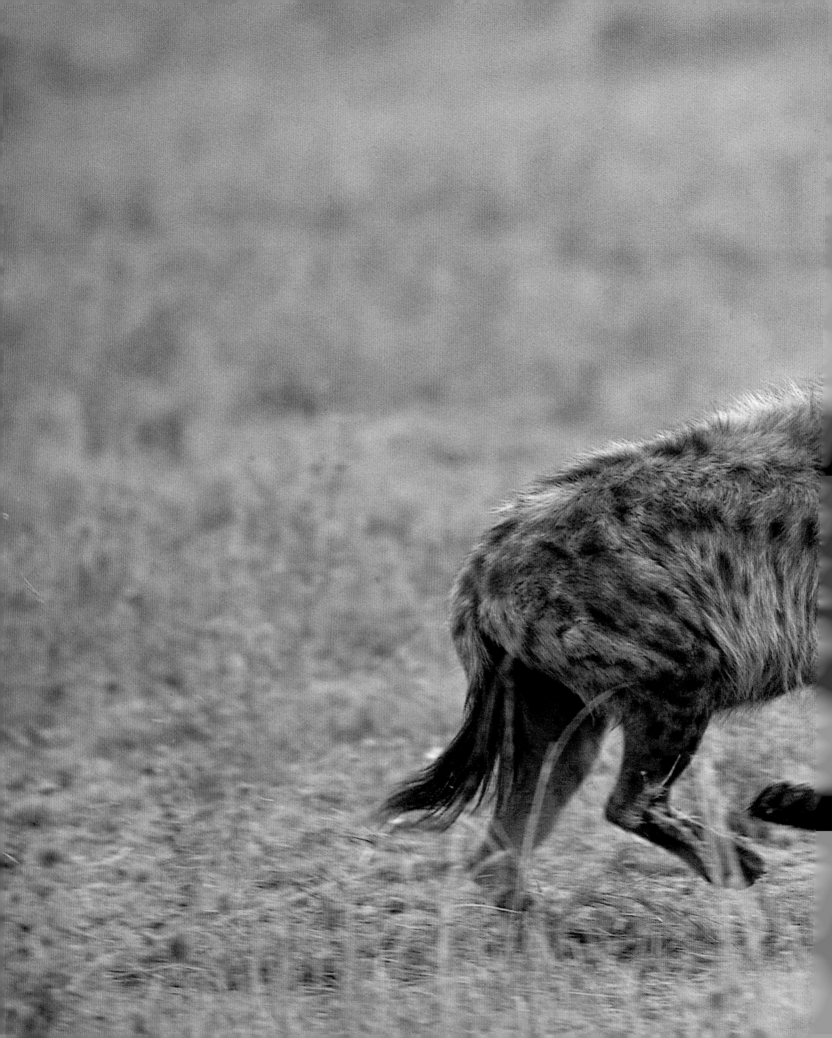

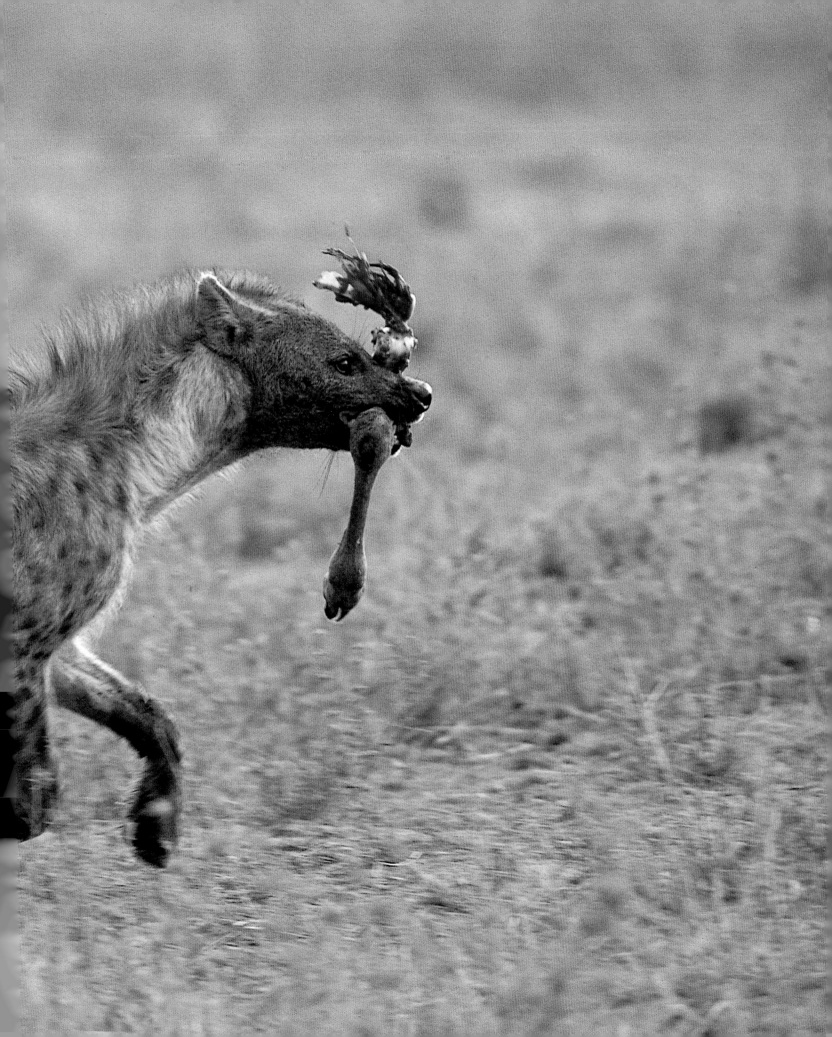

Africa's iron jaws. Spotted hyenas have the strongest jaws of all the savanna's inhabitants. They can bite through both marrow and bone – a useful attribute when devouring an animal carcass. Without hyenas, vultures and other such scavengers, the savanna could be poisoned by dead animals.

However, hyenas do not just eat carrion – they are also excellent and indefatigable hunters. While the cheetah cannot run for more than a few hundred yards, spotted hyenas are capable of pursuing a wildebeest for up to 3 miles (5 km), sometimes at speeds of 38 miles (60 km) an hour. However, even after such exertion, it has been known for a lion to purloin the whole meal.

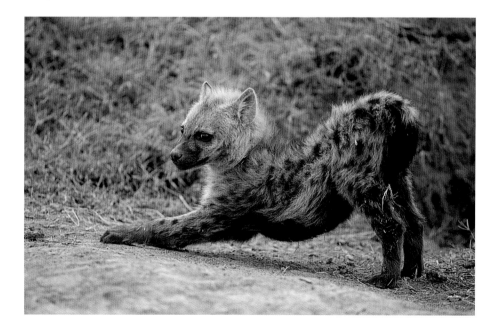

PREVIOUS PAGE: *A hyena runs away with a torn-off antelope leg. Masai Mara, Kenya.*

LEFT: *A hyena cub which has not yet learned to hunt. Masai Mara, Kenya.*

BELOW: The jackal (see page 105) likes to follow the big predators as they hunt for food. Ngorongoro crater, Tanzania.

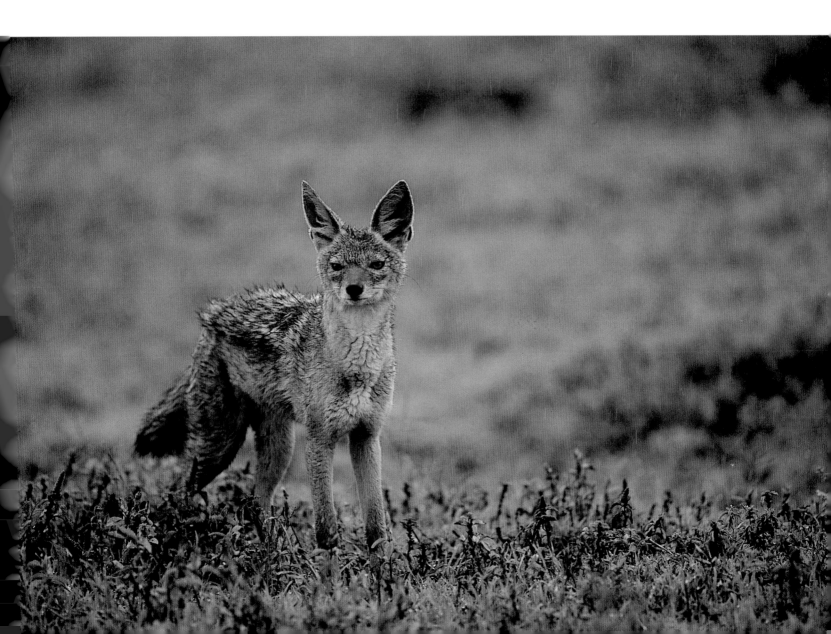

Small hunters. Bat-eared foxes and jackals do not draw much attention to themselves. They don't run as fast as the leopard; unlike the lion they don't fell big animals; and they don't outwit anyone in the dark. They still manage pretty well, however, as they patter about on the savanna.

The bat-eared fox specializes in catching insects such as termites, beetles and grasshoppers, although it also eats scorpions, mice, lizards, spiders and centipedes. When it is hunting it uses both sight and smell, as well as its remarkable sense of hearing. The bat-eared fox's large ears come into their own when it needs to locate its favourite food – termites, dung beetles and other grubs – moving around under the ground.

The golden (or common) jackal has proportionately smaller ears but is a little bigger, standing up to 20 inches (0.5 m) tall and weighing about 22 pounds (10 kg). Although it can be highly effective when chasing the newborn kid of a Thomson's gazelle, the jackal is perhaps best known as a scavenger which simply waits for lions and hyenas to finish their dinner.

The mongoose, and in particular the dwarf mongoose, is an even smaller hunter. These fearless creatures are not afraid to pounce on scorpions, spiders, snakes and rats.

LEFT: *The bat-eared fox's oversized ears help to regulate the animal's body temperature. Masai Mara, Kenya.*

BELOW: *The dwarf mongoose is a social animal which likes to live in groups in holes in the ground or, as here, in an abandoned termite stack. Serengeti, Tanzania.*

Cloaked in darkness. Many of Africa's mammals operate under cover of darkness, and as we drive around with a strong halogen lamp in Sweetwater's game reserve in Kenya we are lucky enough to see some of the continent's most extraordinary creatures. An aardvark runs past and we follow it for a few minutes before it disappears into a hole in the ground. The aardvark feeds on termites and ants – when it has found a termite mound it adopts a sitting position and makes a V-shaped opening in the mound with the help of its snout. It probably catches the termites by poking its long, sticky tongue into the stack. It often digs so deep that almost half its body disappears. Since this animal is nocturnal and extremely shy, not much is known about it.

Another remarkable creature is the African porcupine, whose name derives from the word pig but which is in fact a 20-inch (0.5-m) long rodent. The porcupine in the picture was lured out with the help of the remains of our dinner and some fruit on a private reserve in Namibia. It pounced on the titbits and slurped them noisily.

Related to the mongoose, the genet is a small, cat-like animal with a long tail. In the picture below a genet is shown waiting for its dinner in its customary place up a tree close to a tourist centre in Kenya's Samburu national park. The genet knows that when the guests have finished their meal it will be treated to the left-overs.

BELOW LEFT: *African porcupine. Okonjima, Namibia.*

BELOW RIGHT: *The genet is a small, nocturnal animal. Samburu, Kenya.*

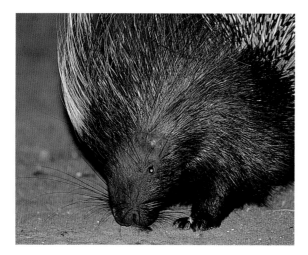

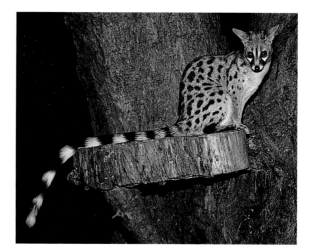

BELOW: The aardvark, with its large ears and long, tubular snout, looks a bit like an elongated pig. It is the only member of the aardvark family. Sweetwaters, Kenya.

NEXT PAGE: The night is black as pitch, except when the occasional flash of lightning illuminates the savanna. Masai Mara, Kenya.

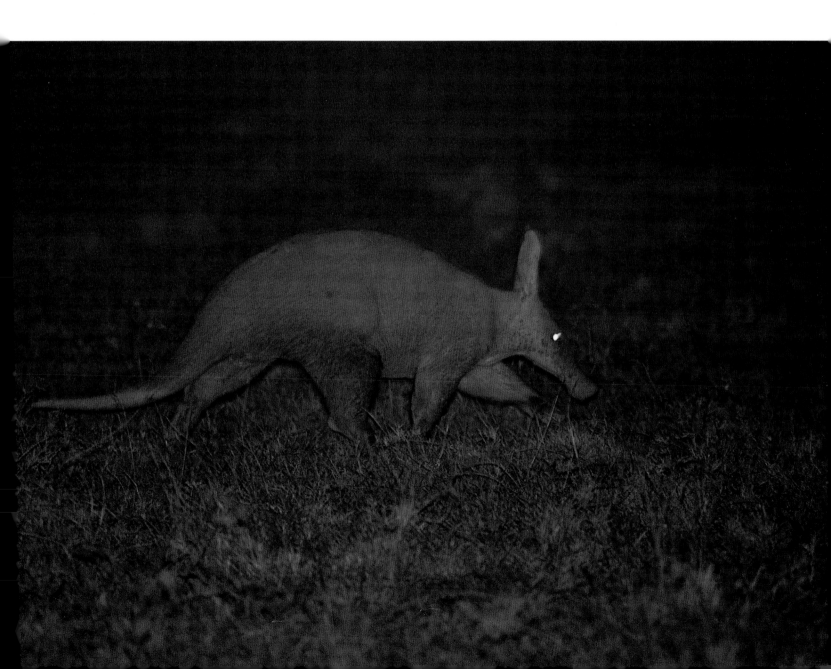

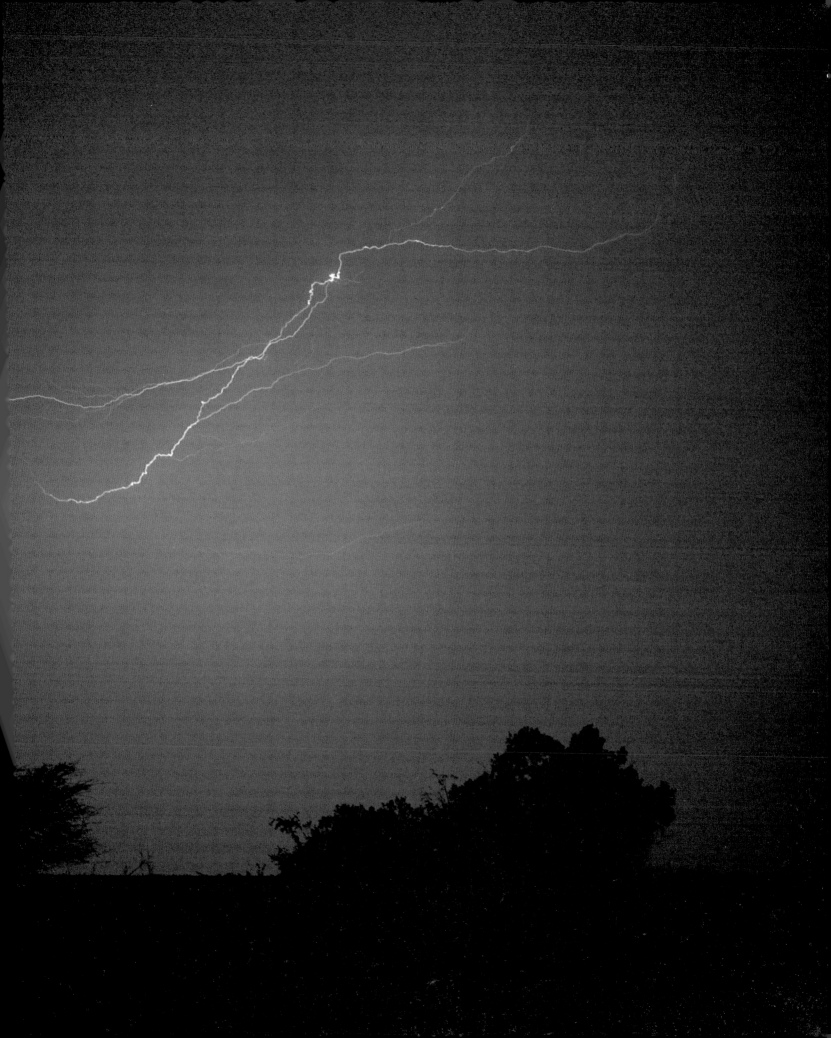

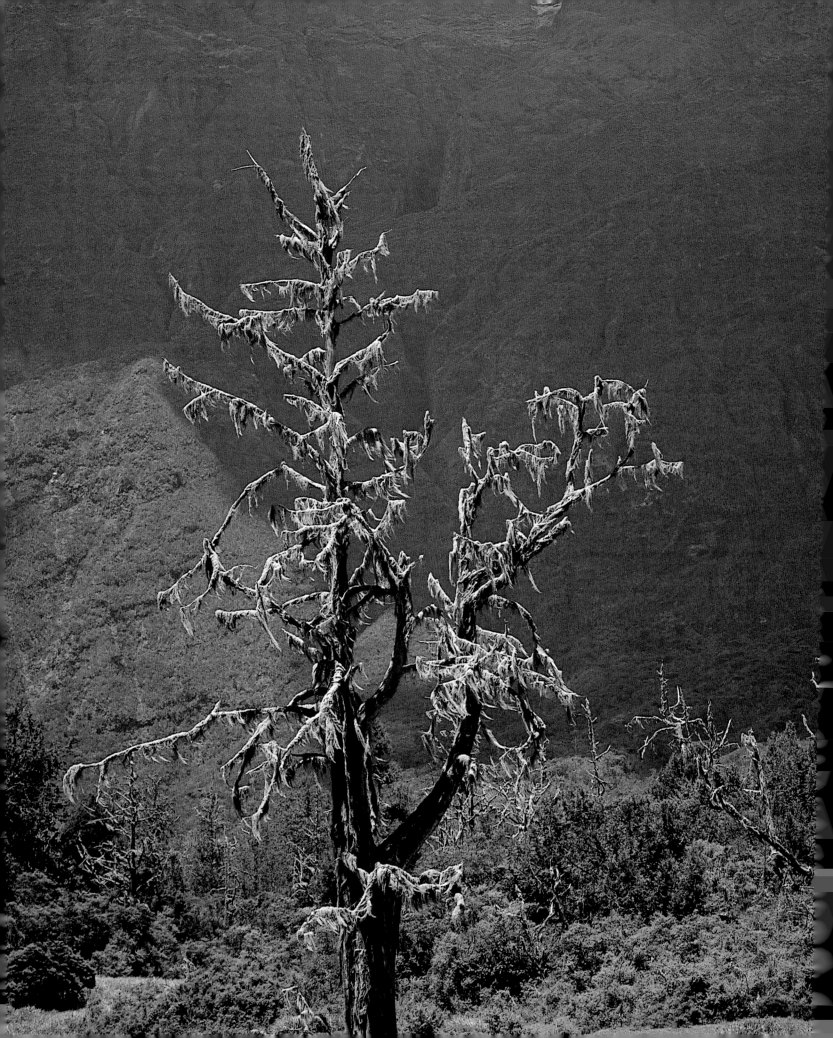

MOUNTAINS AND FORESTS

In addition to the flat, hot savanna, the continent of Africa also features forests and snowy mountain peaks, including Ruwenzori, Mount Kenya, Mount Elgon, the Aberdare mountains and Kilimanjaro – the highest of them all – which rises to 19,340 feet (5,895 m) above sea level. The composition of the flora and fauna on the mountainside varies according to altitude. Between 5,000 and 10,000 feet (1,500 and 3,000 m) the mountain is clad in rainforest – this is where the mountain gorillas live. The occasional leopard also prowls around in the darkness at night. Higher up, the alpine heath resumes, with rock hyrax, ericaceous plants and the giant senecio. In the Indian Ocean lies the world's fourth-largest island, Madagascar, with its singular animal and plant life. There are species here which are found nowhere else on earth.

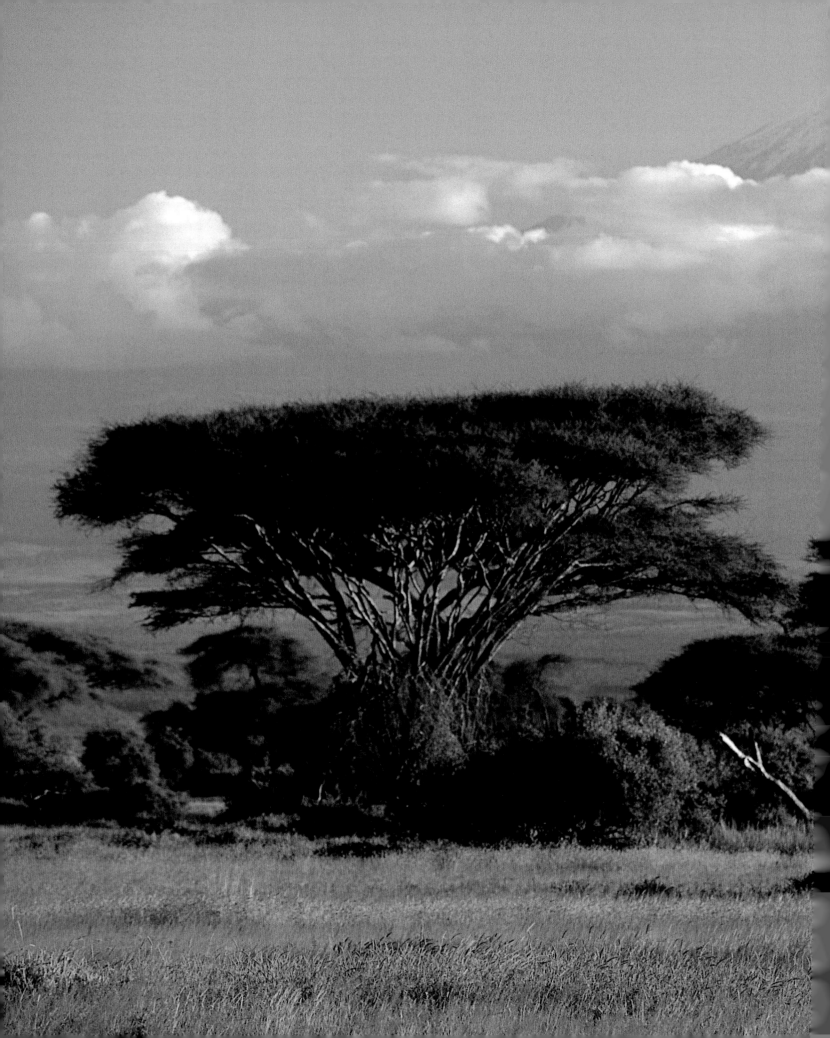

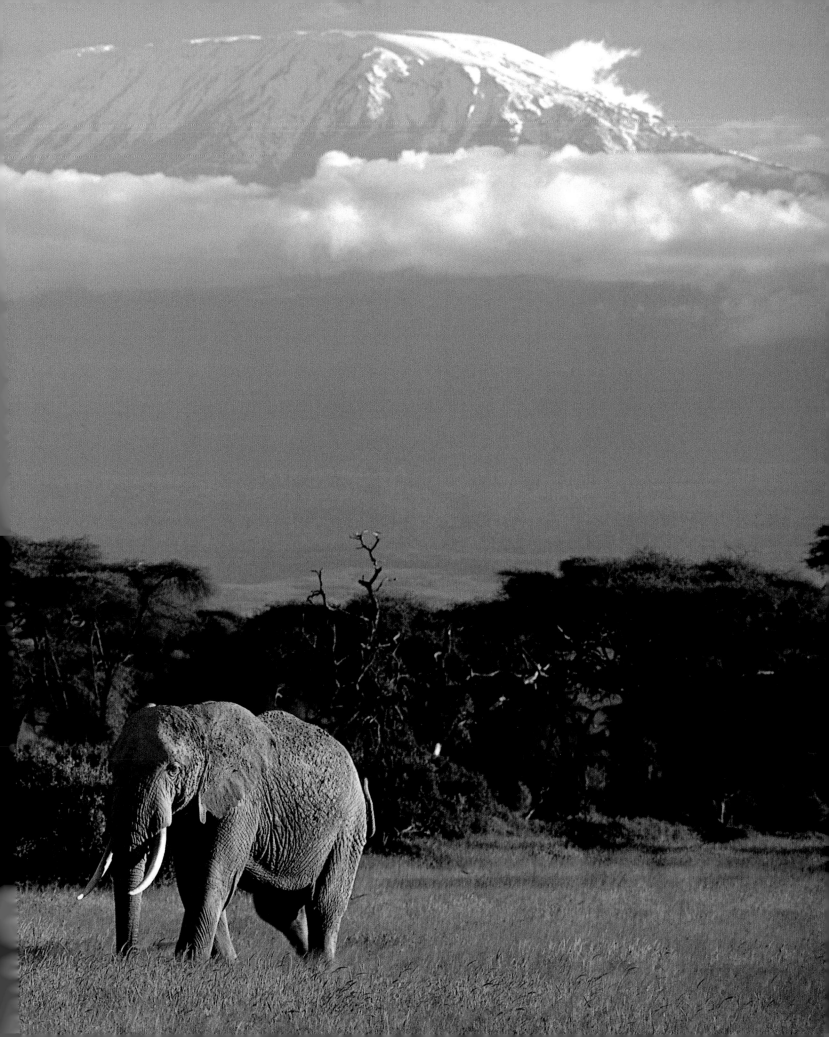

The roof of Africa. Sometimes, when the clouds are so inclined, they reveal Kilimanjaro, Africa's highest mountain. At 19,340 feet (5,895 m) above sea level, this extinct volcano has become a symbol for Africa, almost as well known as Mount Everest.

It is uncertain where the name Kilimanjaro actually comes from. "Kilima" means mountain in Swahili, while "njaro" has several different meanings. One of them is caravan, so that the name might simply mean the "the mountain of the caravans". "Njaro" can also refer to the demon Njaro who created cold and frost – which would make it "Demon Njaro's mountain". In the Masai language "njaro" means water – thus "the water mountain".

From the savannas in Amboseli in southern Kenya there is a fine view of Kilimanjaro. The first European to report seeing the mountain was the Swiss missionary Johann Rebmann. On 11 May, 1848 he wrote: "I saw something white at the top of the mountain by the village of Chagga. My guides did not know its name but used the word cold. It was snow." However, Rebmann's observation was described as "absurd and fanciful" by the famous geographer William D. Cooley in London and the matter was debated for years. A German nobleman, Klaus von Decken, put an end to all the discussion in 1861 when he made the first attempt to climb the peak. Even though he reached a height of only 10,000 feet (3,000 m), he was able to bring back a precise description of Kilimanjaro's slopes.

In 1886 Queen Victoria presented the mountain as a gift to her son-in-law, the future Kaiser Wilhelm II. The peak was conquered for the first time on 5 October, 1889 by the Germans Hans Ludwig Meyer and Ludwig Purtscheller. They placed the German flag on the top and named the site Kibo – the highest point on Kilimanjaro. For its height, Kilimanjaro is the most accessible mountain in the world. It requires no climbing, simply walking. For most people attempting to reach the summit, the main obstacle is altitude sickness.

PAGE 110: *A lone tree festooned with lava in the mountain rainforest. Arusha, Tanzania.*

PREVIOUS PAGE: *A picture of Africa rich in symbolism: Kibo, Kilimanjaro's snow-covered peak, appears to hang suspended over the savanna. Amboseli, Kenya.*

RIGHT: *Kibo is the highest peak in the Kilimanjaro massif. Kilimanjaro, Tanzania.*

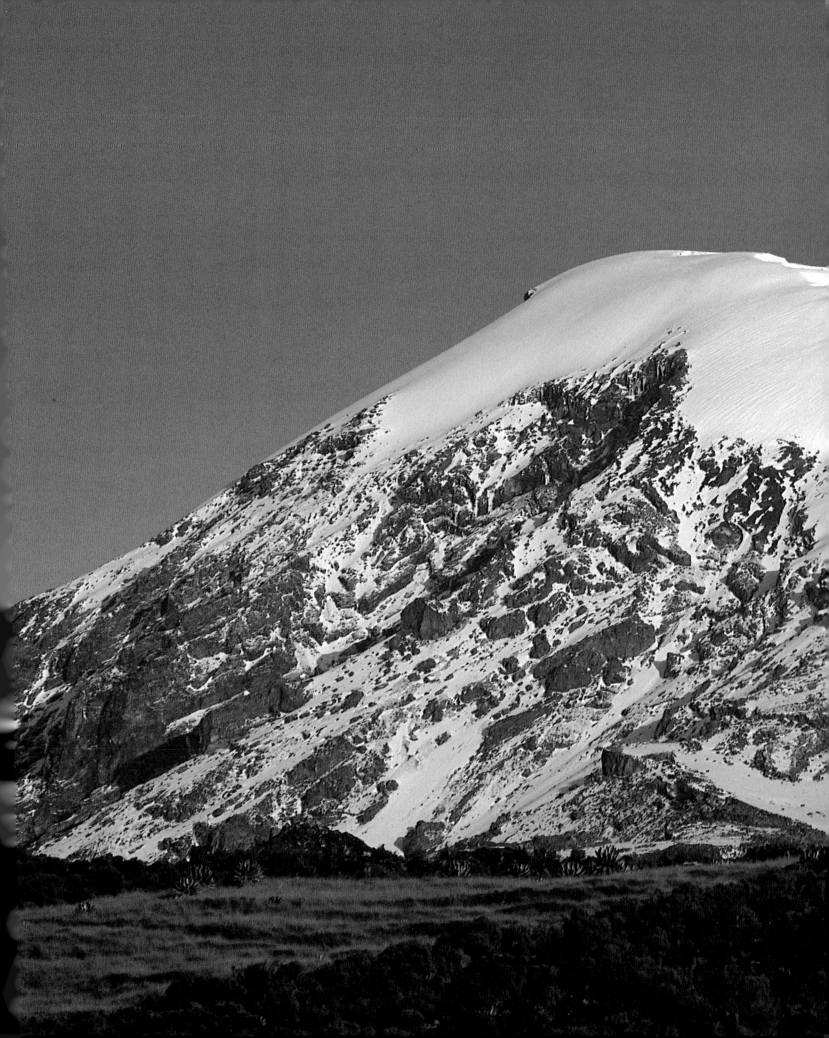

The enchanted forest. In Africa's mountain ranges, at altitudes of about 5,000 to 10,000 feet (1,500 to 3,000 m), a dense and luxuriant rainforest grows. Lichen hangs in long swathes from the trees and the trunks are covered with green moss. The 100- to 130-foot (30- to 40-m) tall trees are intertwined in a single, huge tangle. As a rule it rains heavily and frequently here. Mist forms readily, making the forest seem even more mysterious.

In Africa mountain climbers usually take at least a day to get through the enchanted forest. If they are lucky they may catch glimpses of birds and animals that are unique to this habitat, such as various species of brilliant, nectar-feeding sunbirds, bigger, fruit-eating turacos – or perhaps a family of black-and-white guereza monkeys, with their long bushy tails and big beards. One may also come across a bad-tempered buffalo, elephant or bushbuck. There are also leopards in the mountain forests; sometimes they even stray on to the alpine heaths above forest level.

RIGHT: *Moss- and lichen-clad enchanted forest is found on Kilimanjaro and Mount Kenya, and on Virunga, on the border between Rwanda, Uganda and the Democratic Republic of the Congo (formerly Zaire). Such forest also grows on the slopes of mounts Elgon and Aberdare in Kenya and on the Ruwenzori range on the border between Uganda and the Democratic Republic of the Congo. Kilimanjaro, Tanzania.*

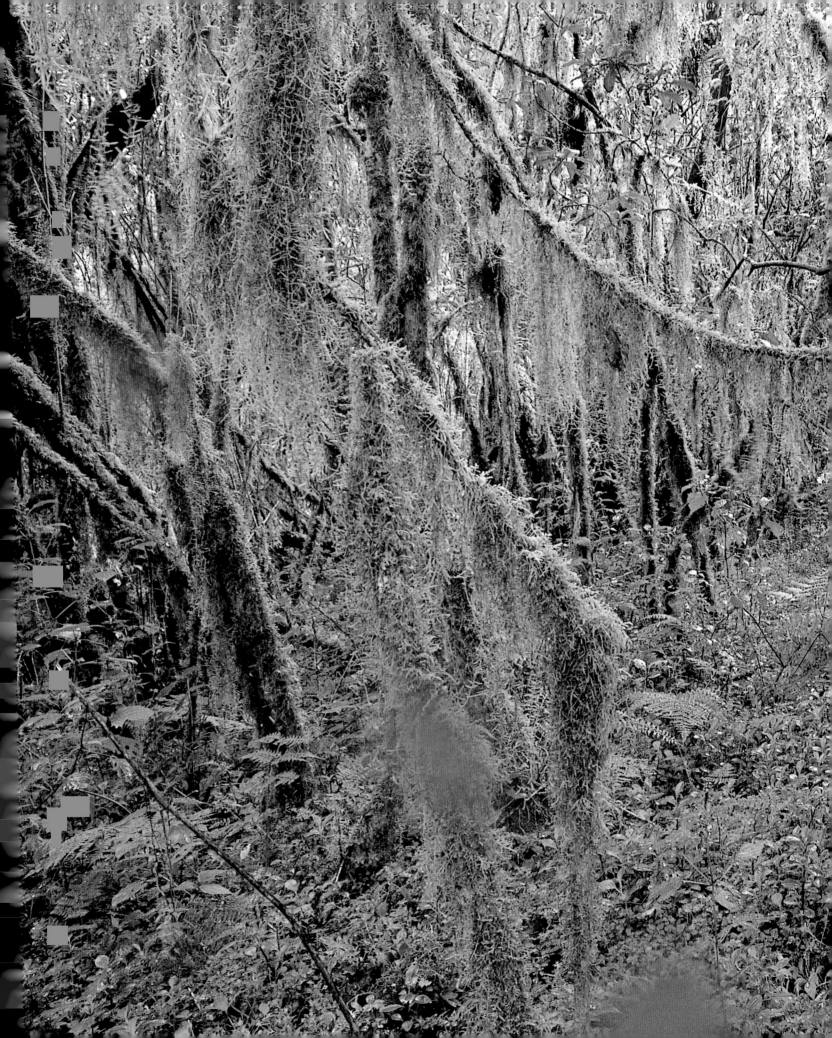

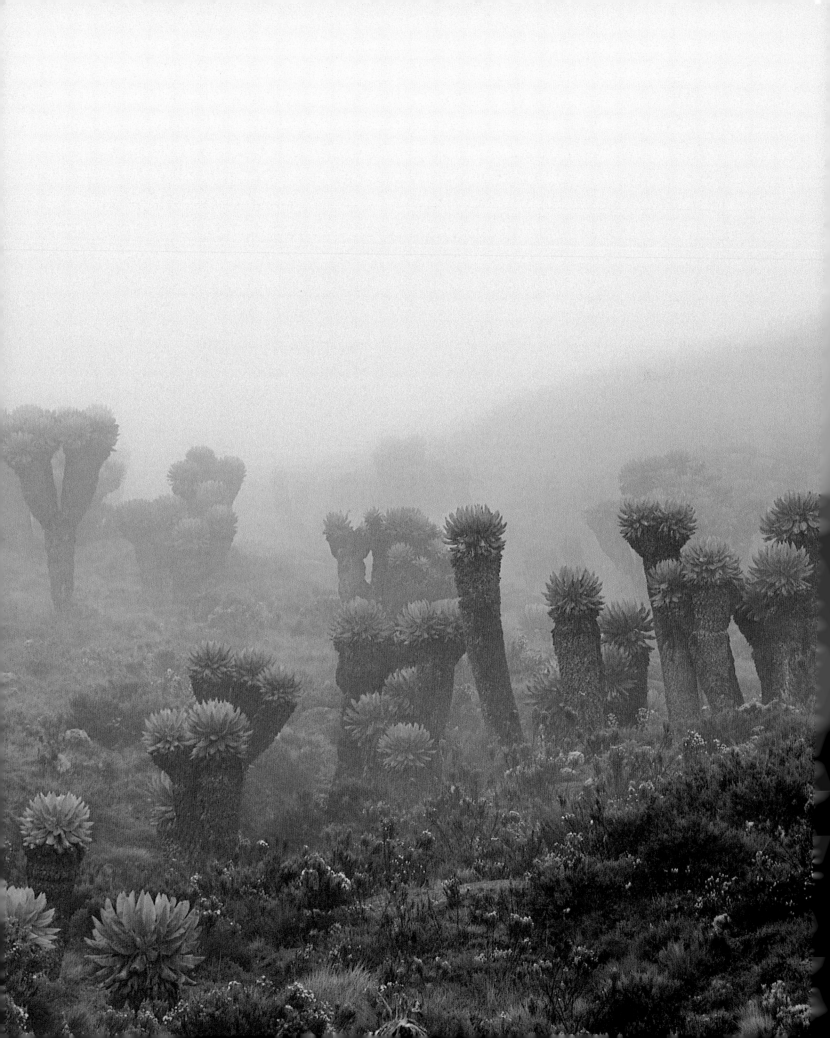

Alpine flora. At a height of about 10,000 feet (3,000 m) the mountain rainforest ends and first a sub-alpine heath zone and then, immediately below the snowy tops, an afro-alpine zone take over. When you reach 13,000 feet (4,000 m) you are in the land of the giant senecios and lobelias. These enormous, high-altitude plants grow slowly and can live for up to 200 years. At 16,500 feet (5,000 m) the giant senecio is at its largest, and is very common around Kilimanjaro and Mount Kenya. At Horombo Hut on Kilimanjaro, there is a whole miniature forest of these palm-like plants. On Mount Kenya one species can grow up to 30 feet (10 m) tall.

Mountain plants growing at such heights have to be able to tolerate wide variations in temperature. They use various methods to do so: dead leaves insulate the stems; the plants have small, protected flowers and produce a fluid in the leaves which protects against frost. Above the senecio zone nothing grows and the mineral kingdom takes over, stone upon stone, forming a seemingly endless, lifeless desert.

LEFT: *A forest of giant senecios at 13,000 feet (4,000 m). Kilimanjaro, Tanzania.*

BELOW: *The giant lobelia opens out its 1.6-foot (0.5-m) wide rosette of leaves during the day and closes up again at night when the temperature falls below freezing. Mount Kenya, Kenya.*

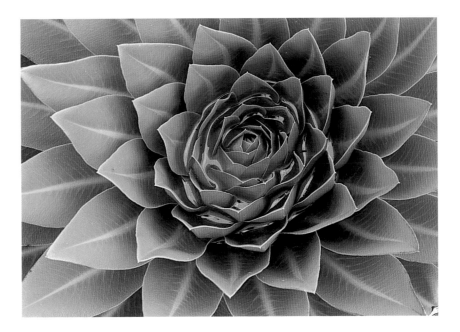

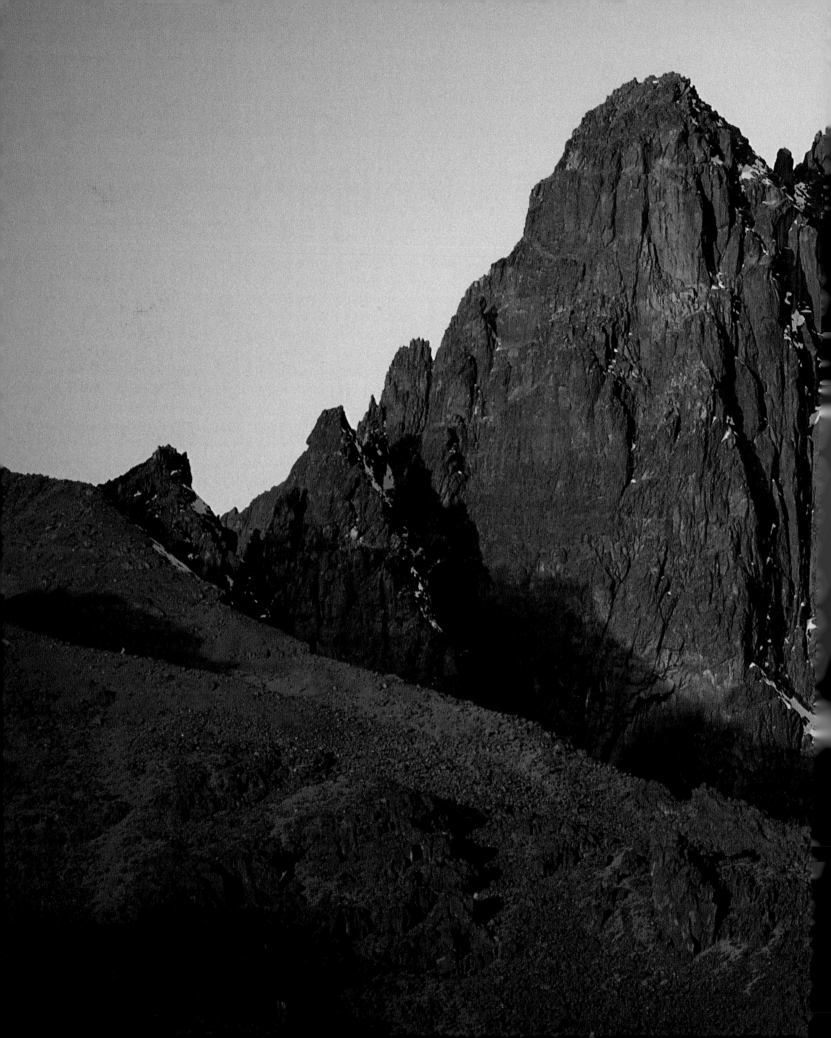

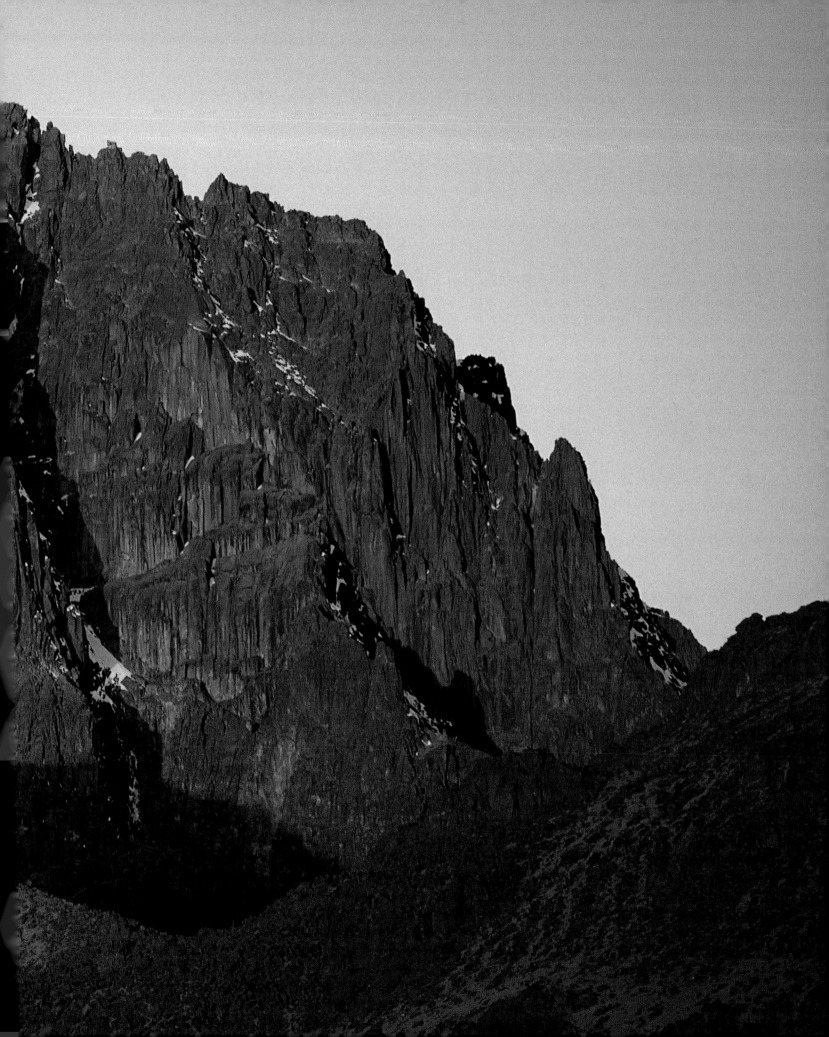

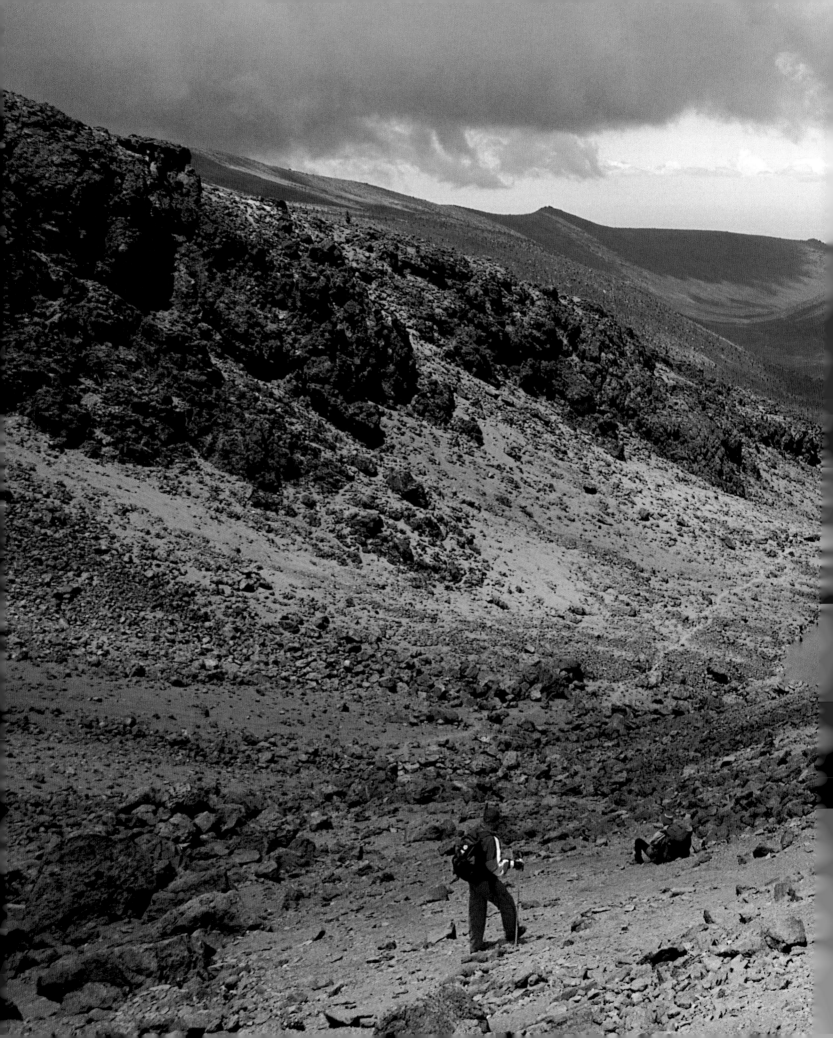

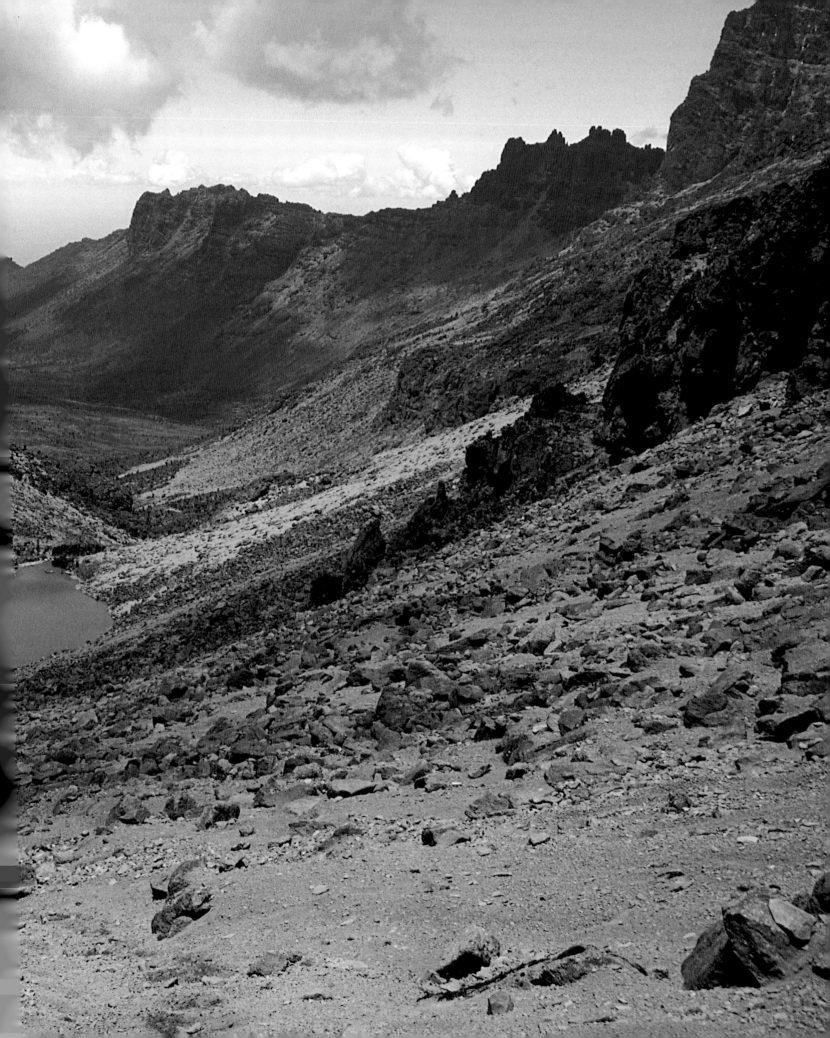

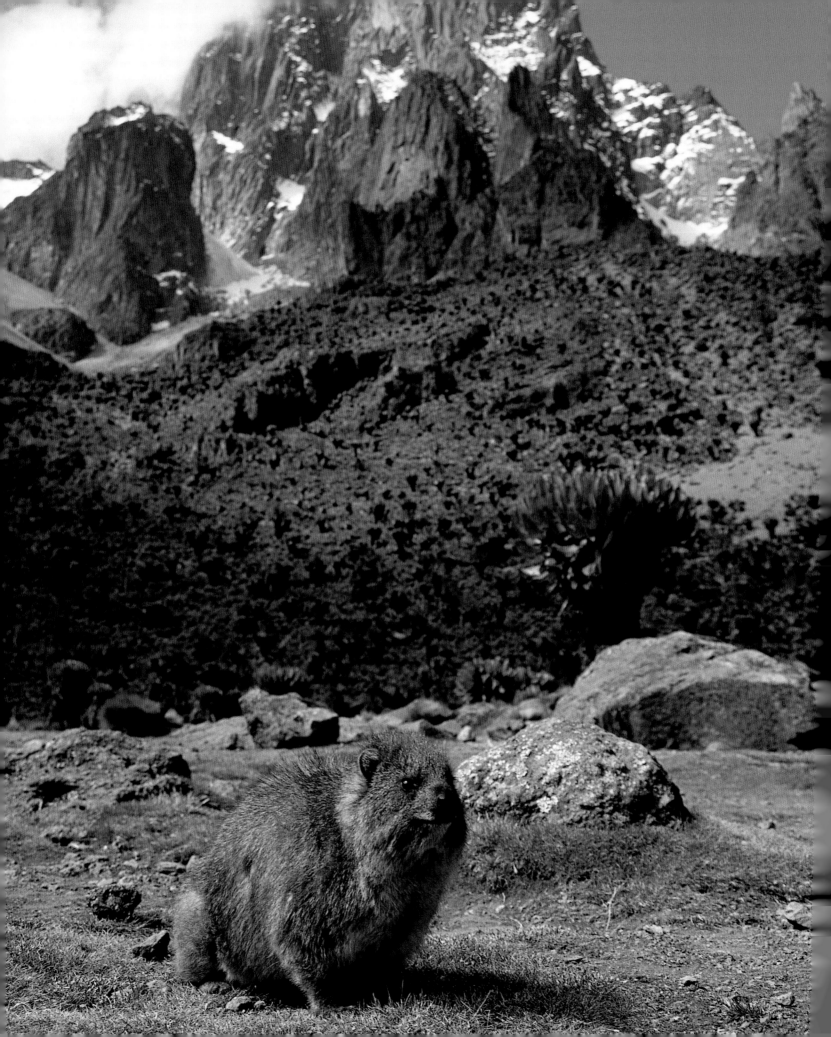

Mount Kenya. It is early in the morning. Outside the weather is fine and clear and the sun is about to rise. For a few minutes everything is fiery red. The view towards Batian and Nelion, the two volcanoes that form the highest peaks on Mount Kenya, at 17,057 feet (5,199 m) and 17,025 feet (5,189 m) respectively, is unparalleled. This is the second-highest mountain massif in Africa – only Kilimanjaro is higher. Just like its neighbour in Tanzania this peak is a once-active volcano. The experts claim that it was once 24,985 feet (7,615 m) high and exactly the same shape as Kilimanjaro, but the teeth of time have gnawed away at the mountain and only the most resistant rocks are left.

The Kikuyu people called Mount Kenya Kirinyaga. "Kiri" means mountain and "nyaga" ostrich – hence "the ostrich mountain". It is certainly true that the contrast between the white snow and the black rock recalls the male ostrich's black-and-white plumage. This name was probably also the origin of the word "Kenya". Because the mountain provides rain, the people also long believed that the rain god Ngai resided up among its jagged peaks.

Mount Kenya is both wilder and, overall, more barren than Kilimanjaro. If you want to ascend Batian and Nelion you have to climb – with ropes and proper equipment. The highest you can get without climbing gear is Point Lenana, at 16,345 feet (4,982 m).

From hut to hut. In the Mount Kenya national park one can walk from hut to hut in the thin air, surrounded by dramatic mountain peaks, glaciers and steep ravines. All around the massif, from an altitude of 13,100 feet (4,000 m), huts stand huddled quite close together. The highest is the Austrian Hut at 15,715 feet (4,790 m), from which most climbing expeditions set out. Down by the huts you may spot a rock hyrax, a member of a small family of mammals thought to be the elephant's closest living relatives – although that fact does not immediately spring to mind when you first see these little creatures approaching to beg for food.

PAGES 120–121: *The early morning sun on Africa's second-highest mountain, Mount Kenya.*

PREVIOUS PAGE: *A stony landscape in Mount Kenya national park.*

LEFT: *A rock hyrax in its home environment, with Mount Kenya in the background.*

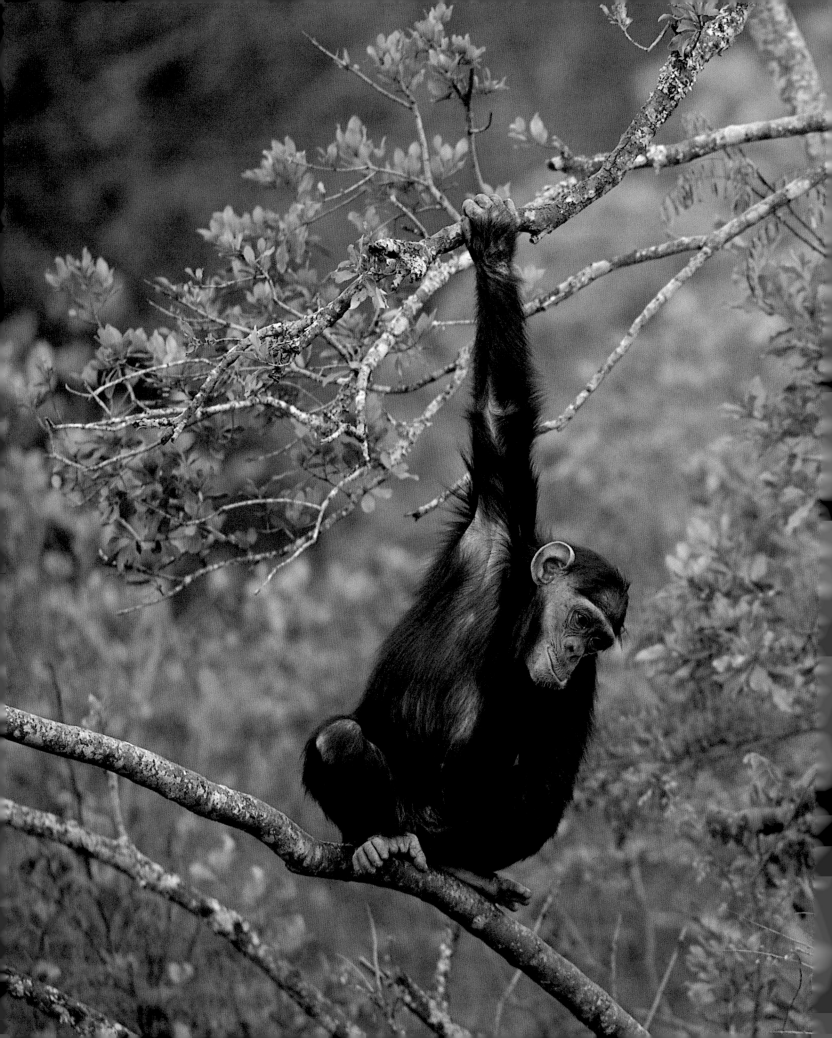

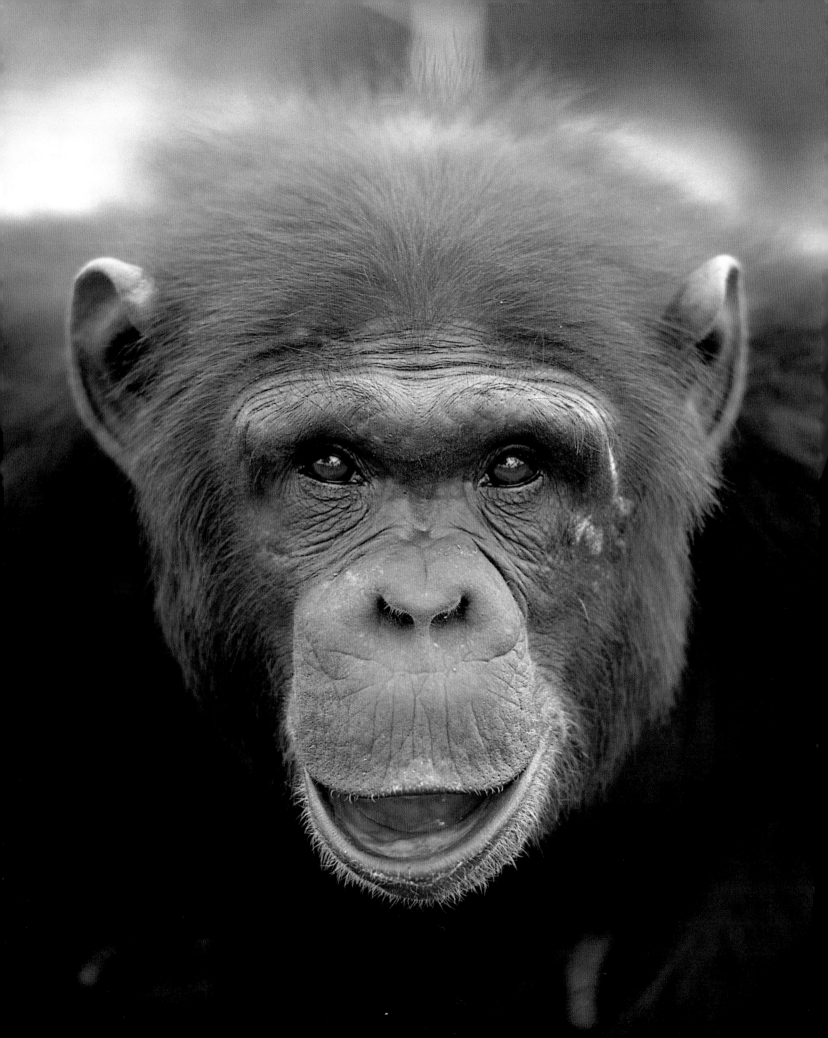

Ninety-nine per cent the same. Judy (left) and the other chimpanzees in Kenya's Sweetwaters game reserve live in captivity. They share an unhappy history – all, as babies or adults, have been freed from imprisonment in the Congo. They would probably prefer to live in the forest, but once they have lived in captivity chimpanzees cannot cope in the wild, so instead they have been given a refuge in Sweetwaters' huge enclosure.

With two kindly eyes Judy peeps through the mesh fence. She looks very human. Recent research has revealed that there is only a one per cent difference between our DNA material – our genetic building blocks – and that of chimpanzees. This means that the chimpanzee is so like us that its blood could be used to save a human through blood transfusion – and vice versa. Our immune systems are also similar, which is why so many chimpanzees have been used in medical research.

However, it is undeniable that the one per cent of genetic material that separates us from chimpanzees renders our two species very different. We humans have language. We have the ability to think in the abstract, to plan, to compose music, to write and to create cultures. We also have another, less desirable trait – we are capable of annihilating other species.

This latter human characteristic has had dire consequences for chimpanzees. At the beginning of the twentieth century there were between one and two million chimpanzees in Africa – today there are probably not many more than 100,000 of them left. Previously they were found in more than twenty-five countries, but now they have been completely wiped out in four of those and almost entirely lost in a whole series of others. Only in the heart of their territory – deep in the forests of the Congo, the Democratic Republic of the Congo (formerly Zaire), Gabon and Cameroon – do large chimpanzee populations still survive. But even there stocks are dwindling, chiefly due to the trade in so-called "bush-meat". This product is not sold to feed hungry people, but as an expensive delicacy to be served in big-city restaurants – chimpanzee meat has even been exported as far as Belgium. Chimpanzees are also sold to be kept as pets, for entertainment and for medical research.

PREVIOUS PAGE: *Chimpanzees are consummate climbers. Sweetwaters, Kenya.*

LEFT: *This chimpanzee, who is called Judy, likes to be photographed. Sweetwaters, Kenya.*

Six hundred mountain gorillas. We are right in the middle of Africa, hiking through mountain rainforest in Rwanda. A few miles to the west is the Democratic Republic of the Congo, the vast country previously called Zaire. To the north lies Uganda and to the east the savannas of Tanzania, rich in wildlife. We are hoping to catch a glimpse of mountain gorillas in the Parc National des Volcans, which, together with the Virunga national park in the eastern part of the Democratic Republic of the Congo, and gorilla reserves in southwestern Uganda, constitutes a huge protected area in the Virunga mountain range. The mountains are dominated by eight great volcanoes, the highest of which, Karisimbe, is 14,787 feet (4,507 m) high. We can just make out a couple of them through the mist that drifts through the rainforest.

Face to face. We are on the right track. After just an hour of searching we find black gorilla droppings. A few broken twigs indicate that a large animal has recently passed through the forest. Then finally we hear the drumming of a male gorilla close by. So as not to suddenly take the group unawares, our guide Jean starts to hum softly. We creep on and there stands the male gorilla, just 16 feet (5 m) away, cramming leaves and plants into his mouth with two huge fists.

Suddenly a young male dashes out from the undergrowth on two legs. With strong hands he beats his chest before darting back into the bushes again. Another young bachelor is busy testing his tree-climbing skills, but the feeble trunk breaks under the weight of the heavy gorilla, who falls to the ground with a crash.

There are twenty-three gorillas in this group. The male leader – known as a silverback because his back has turned silvery grey with age – is the most impressive. This giant, who is at least ten years old, is the only male allowed to mate with the ten or so females who belong to the group. A few young males are also members, but in time they will leave and roam around alone until they manage to collect their own group of females – a so-called harem. Female gorillas are impressed by size and strength. Weaker males may never manage to acquire a harem.

After an hour the visit ends. We pack up our photographic equipment and take a last look at the mountain gorilla chieftain before heading back into the jungle.

BELOW: There are only about six hundred mountain gorillas left in Africa. About half of them have their home in the Virunga mountains; almost all the rest live in the Bwindi Impenetrable National Park in Uganda. These lords of the jungle can weigh up to 400 pounds (180 kg). Parc National des Volcans, Rwanda.

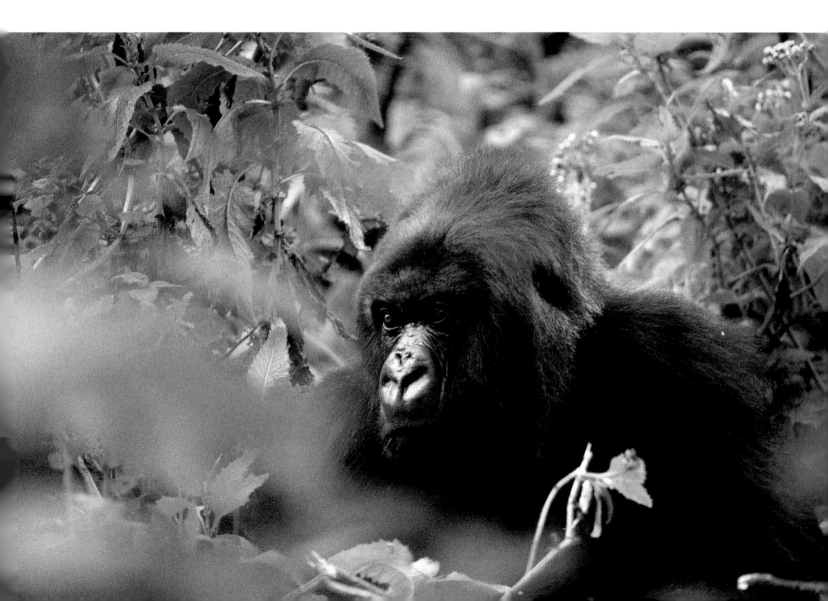

The dappled shade of the acacia tree. In contrast to the lion and the cheetah, which like to be out on the open savanna, the leopard prefers to live and hunt in dense forest, close to rivers and other sources of water. The leopard is one of the "big five" – the African animals that it is most difficult to get a sighting of (the other four are the elephant, buffalo, rhinoceros and lion).

One of the biggest leopard populations in Africa is to be found on the shores of Kenya's Lake Nakuru. Around this large, flamingo-inhabited lake runs a belt of thick acacia forest bordered by open savanna. The area abounds in wildlife, and provides an excellent hunting ground for leopards. However, although there are many leopards here, they are very hard to find.

Only when daylight is fading fast does a leopard finally appear. It comes running across the ground, jumps up onto a strong branch and climbs swiftly up the acacia tree. Soon the big cat, barely more visible than a shadow, takes up position at a vantage point from which it can survey the forest floor. Within a few minutes it will be swallowed up by the darkness and will be able to begin its stealthy hunt for antelopes in peace, out of sight of photographers and tourists.

PREVIOUS PAGE: *The leopard's spotted coat provides the perfect camouflage among the foliage. Lake Nakuru, Kenya.*

BELOW: *The leopard – considered by many to be the most beautiful of all the predators. Samburu, Kenya.*

RIGHT: *Its long whiskers betray the fact that the leopard is a nocturnal animal. Lake Nakuru, Kenya.*

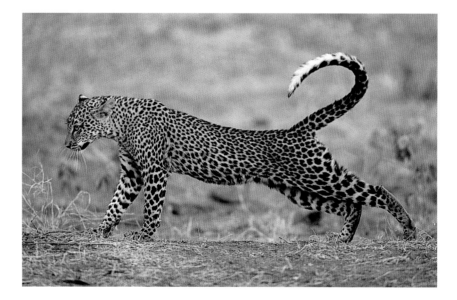

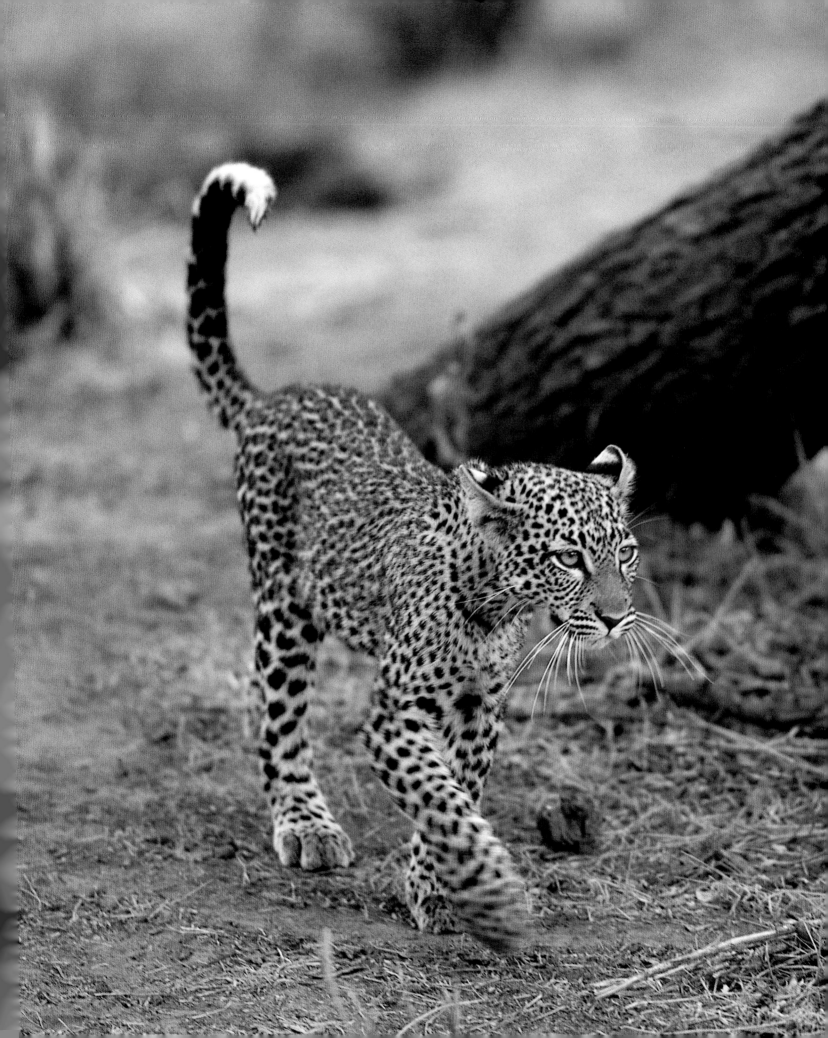

BELOW: *The silhouette of a leopard at dusk. Lake Nakuru, Kenya.*

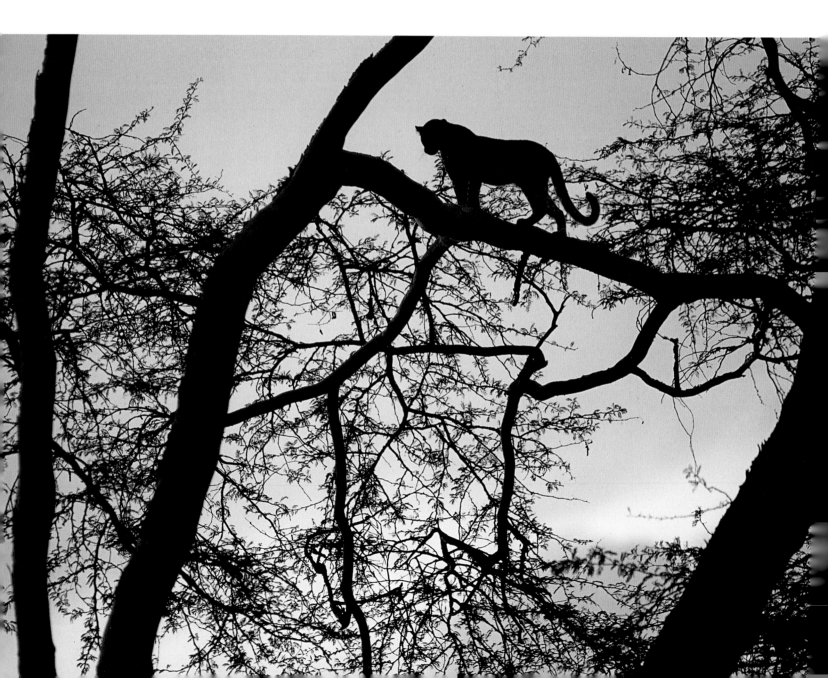

The wily hunter. Apart from Lake Nakuru, Samburu is one of the best places to catch a glimpse of a leopard. In the course of two days we manage to see five of these great African cats. The first time is at sunset and the leopard is lying right at the top of a tall tree and gazing superciliously down at us as we stand in our safari jeep. Through our binoculars we can admire the animal which many consider to be the most magnificent and beautiful of all the predators. While the cheetah is the long-legged supercat which can outrun its prey on the savanna, the leopard is the strong, muscular hunter which creeps up on its victims and catches them off guard in the darkness of the night.

The next morning, out in the jeep again, we are treated to yet another wonderful experience. Two amorous leopards are lying on a large stone slab by a dry precipice. They are about 500 feet (150 m) away; through the binoculars we watch the male courting the female and then suddenly the pair mate. This is a rare sight indeed – very few people ever see these big cats mating. Leopards are happiest alone and it is only hormonal urges that drive the two sexes to come together during the mating season.

That very evening we hit the jackpot while following a track along a river bank. We have already seen crocodiles and a big group of baboons, and have stopped the car when suddenly one of our party spots a leopard straight ahead. Not quite a baby, but not fully grown either, the young leopard comes toward us, passes by the car and continues along the bank. Soon another leopard comes into view – the mother. The two of them walk calmly over to a large tree in which park rangers have hung the carcass of a dead animal to attract predators such as these. The female leopard and her cub climb up into the tree, where the cub spends a few minutes biting his mother's tail while she eats, before jumping down to the ground to play in the fading light.

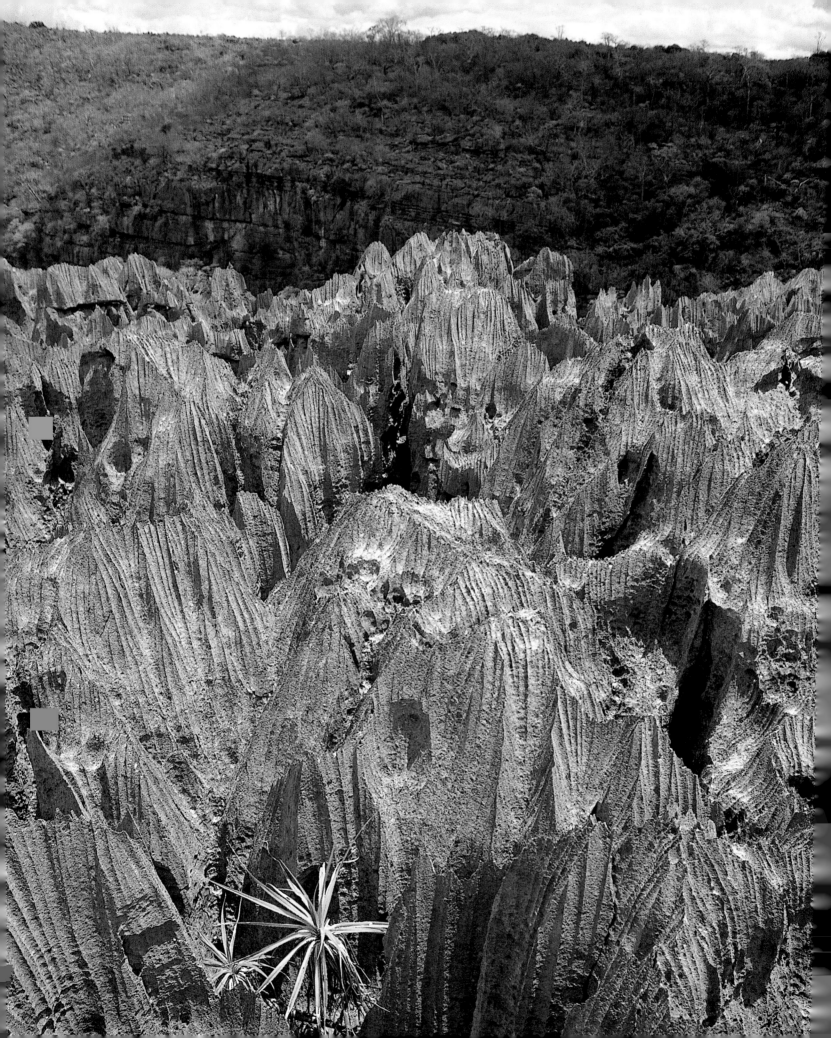

The island of surprises. Madagascar, which lies in the Indian Ocean off the southeastern coast of Africa, has neither lions nor elephants – nor will the visitor see giraffes or graceful antelopes. Yet Madagascar is a complete world of its own, with a very varied climate. Among the primates that live here all but two are endemic – in other words, unique to the island. Almost half of Madagascar's birds are also endemic. In botanical terms this is one of the richest places on earth, and home to many important medicinal plants.

LEFT: *Jagged, inaccessible limestone formations are intersected by numerous ravines and caves. Ankarana, Madagascar.*

BELOW: *At the island's southernmost end there is an extraordinary prickly forest of cactus-like trees, the long, thorny branches of which stretch up toward the sky. Spiny forest, Berenty, Madagascar.*

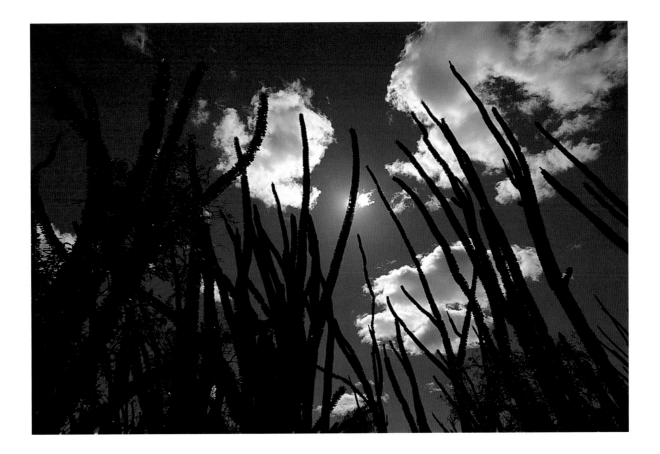

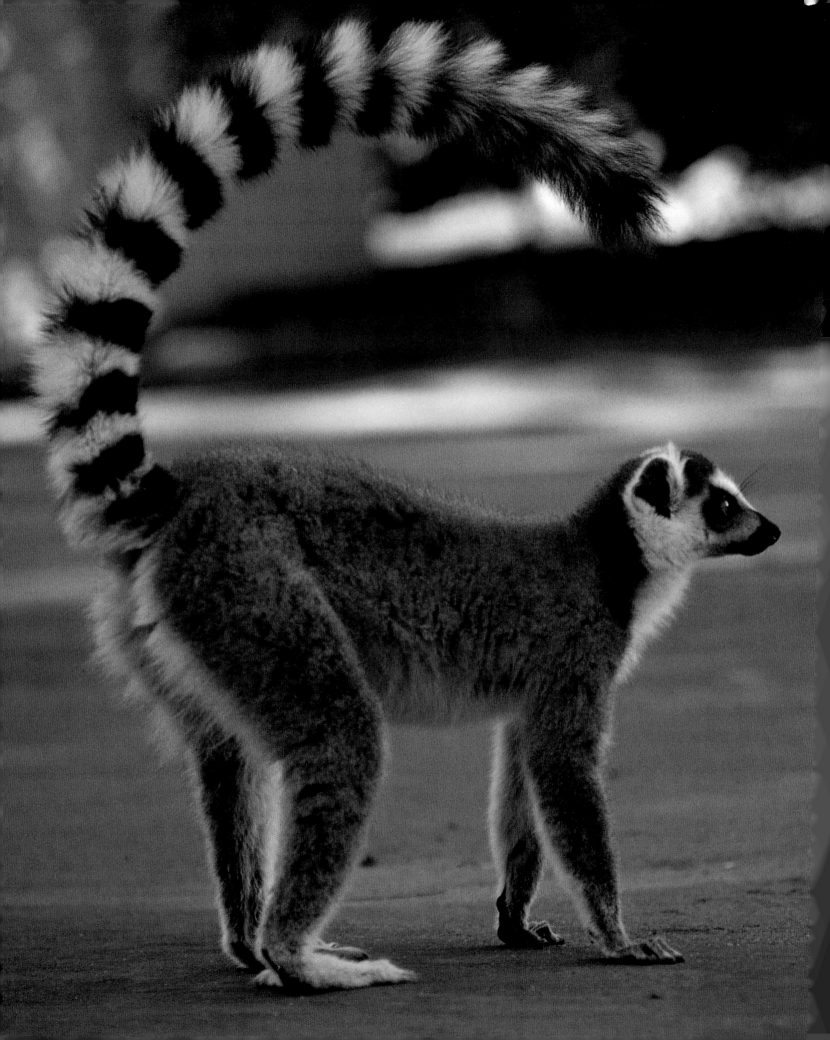

Unique to Madagascar. Of the thirty-seven species of lemur known in the world, all but a couple live only on the island of Madagascar. There is enormous variation among these prosimians, from the pygmy mouse lemur, which can be as little as 3.6 inches (9 cm) in length and 1.75 ounces (50 g) in weight, to the indri, which can be up to 28 inches (70 cm) long and weigh 15 pounds (7 kg).

The ring-tailed lemur with its black-and-white striped tail, lives almost exclusively on the ground, while the endangered sifakas inhabit the treetops. However, the sifakas sometimes have to come down to the ground in order to cross a clearing, which they do in the style of a ballerina: on tiptoe, sideways and with their arms raised they dance over the open ground until they reach safety again in the trees. The large, virtually tail-less indri have a different distinguishing characteristic: they sing polyphonically, and their voices, which sound rather like saxophones, can be heard for miles around.

The most remarkable of all the lemurs is the aye-aye. It looks like a strange hybrid creature, appearing to have the teeth of a rabbit, the ears of a bat, the hide of a wild boar and the tail of a squirrel, as well as a long, skeletal index finger which it uses to examine cracks in tree bark in search of insect larvae. Many Malagasy people are afraid of these wraith-like little creatures and kill them whenever they get the chance. However, some regard aye-ayes as spirits of their dead ancestors and think that they bring good luck.

Human beings have long been the lemurs' enemy. When people first reached the island 1,500 to 2,000 years ago they soon discovered that many of the lemurs tasted delicious. About fifteen species of lemur, the largest of which was bigger than a male gorilla and weighed more than 440 pounds (200 kg), were quickly wiped out. People also began to cut down trees and burn the earth in order to cultivate it. Of the vast forest that once covered large areas of Madagascar, only ten per cent remains today. Deforestation has been a disaster for the lemurs, as for many other species now threatened with extinction.

LEFT: *A ring-tailed lemur. Berenty, Madagascar.*

BELOW: The northern sportive lemur is a nocturnal animal which likes to sleep in hollow tree trunks or dense tangles of vines during the day. It feeds on leaves and breaks down the cellulose in two stages — like a rabbit, it eats its first droppings in order to digest the food more completely the second time. *Ankarana, Madagascar.*

RIGHT: *A female sifaka with her baby. Beza-Mahafaly, Madagascar.*

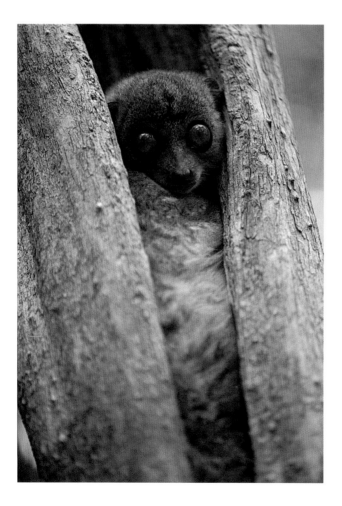

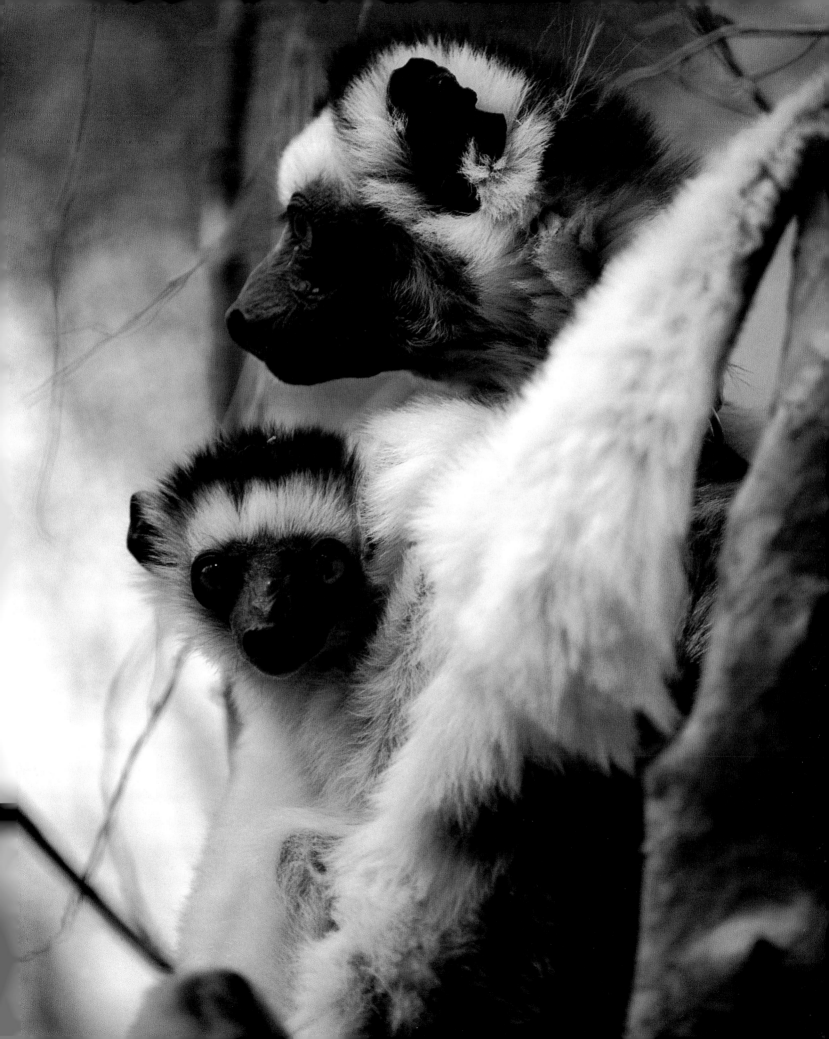

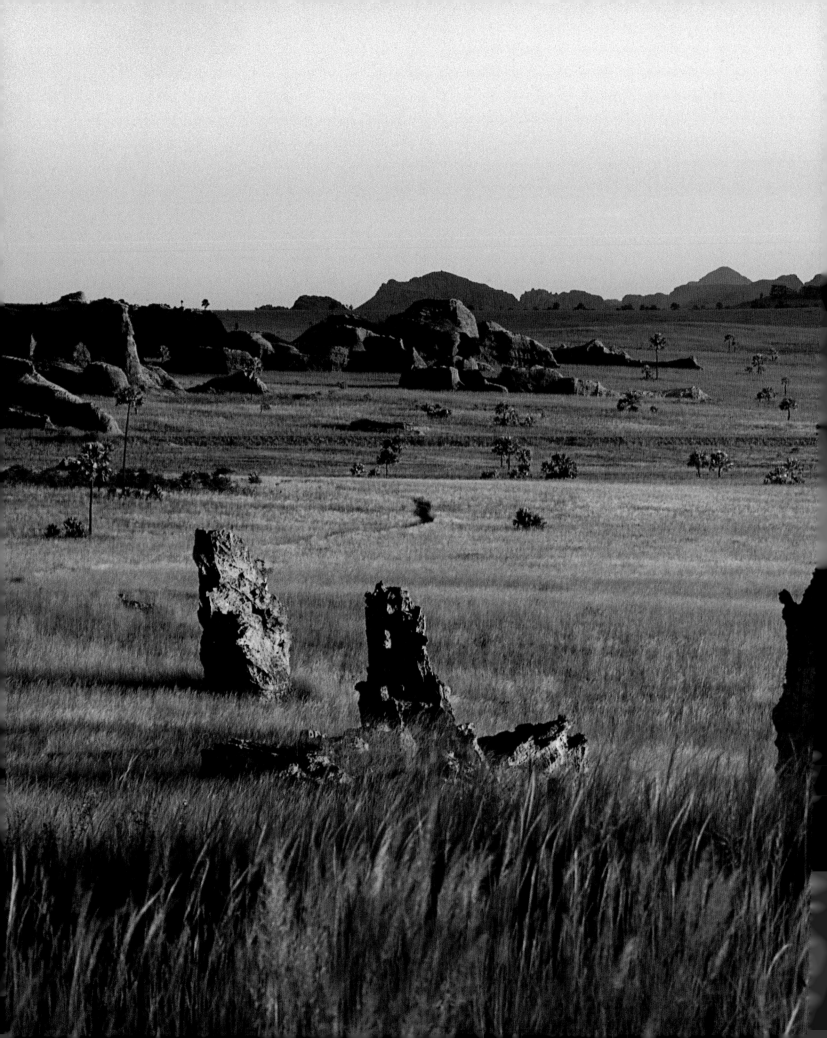

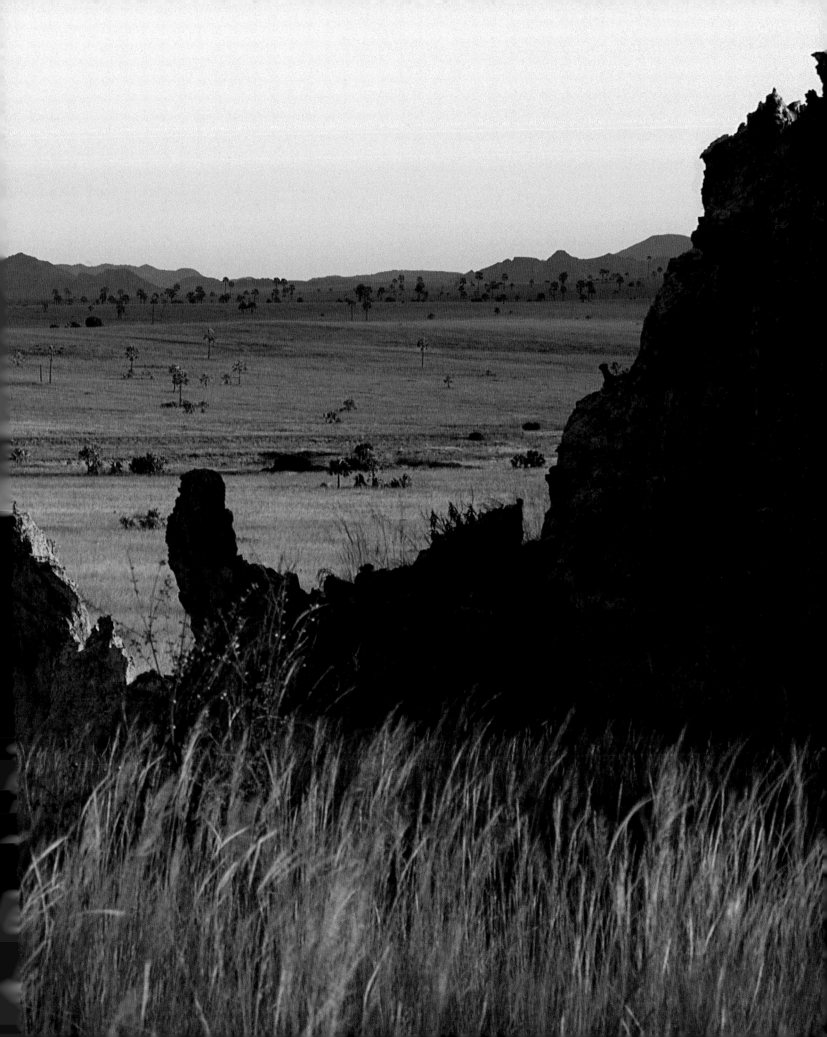

PREVIOUS PAGE: Isalo national park in Madagascar.

BELOW: Large stalactite formations hang from the ceiling in huge caverns inside the rocks, and in the entrance to the cave where we have set up camp. Ankarana, Madagascar.

RIGHT: Inside the caves there are both snakes and spiders, together with Nile crocodiles which enter via the watercourses that flow through the cave system. Ankarana, Madagascar.

A stone landscape. Isalo national park is Madagascar's answer to Utah and Arizona in the southwest USA. Thousands of years of erosion have created a remarkable sandstone landscape. Year round, crystal-clear rivers run through many of the small ravines that crisscross the area. Yet there is no rain in this part of Madagascar during the dry season; between June and August the sky is usually completely devoid of cloud.

In spite of its status as a national park, many illegally started bush fires rage through this area every year, set by peasant farmers clearing land for farming. One tree in particular survives – the fire-resistant Uapaca bojeri. Animal life here is limited. Most of the eighty-one identified species of bird live along the river banks and around the cliffs. The park is particularly famous for the Benson's rock thrush, a species found only in the Isalo region.

Cave safari. In the Ankarana Special Reserve in northern Madagascar a unique cave system lies hidden under a large limestone mountain. One of the caves is almost 7 miles (11 km) long, and more than 62 miles (100 km) of corridors have been recorded. Watercourses flow through the caves and they are home to several Nile crocodiles which have migrated up the subterranean rivers from the outside.

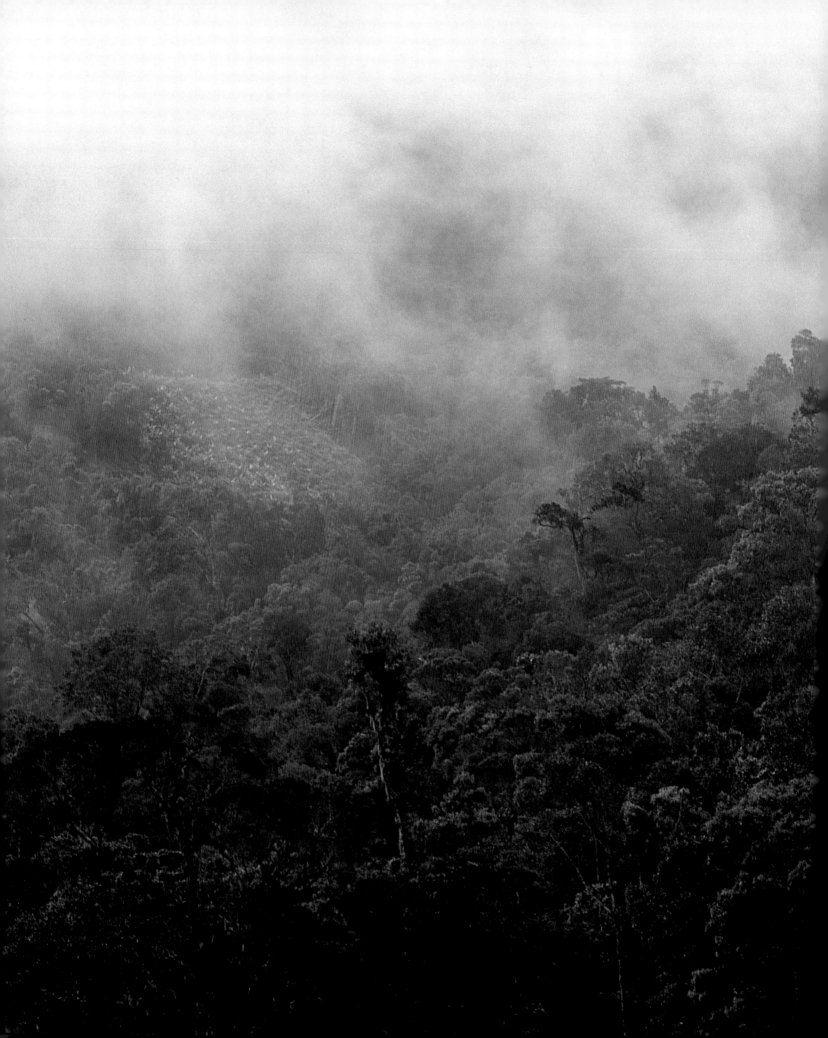

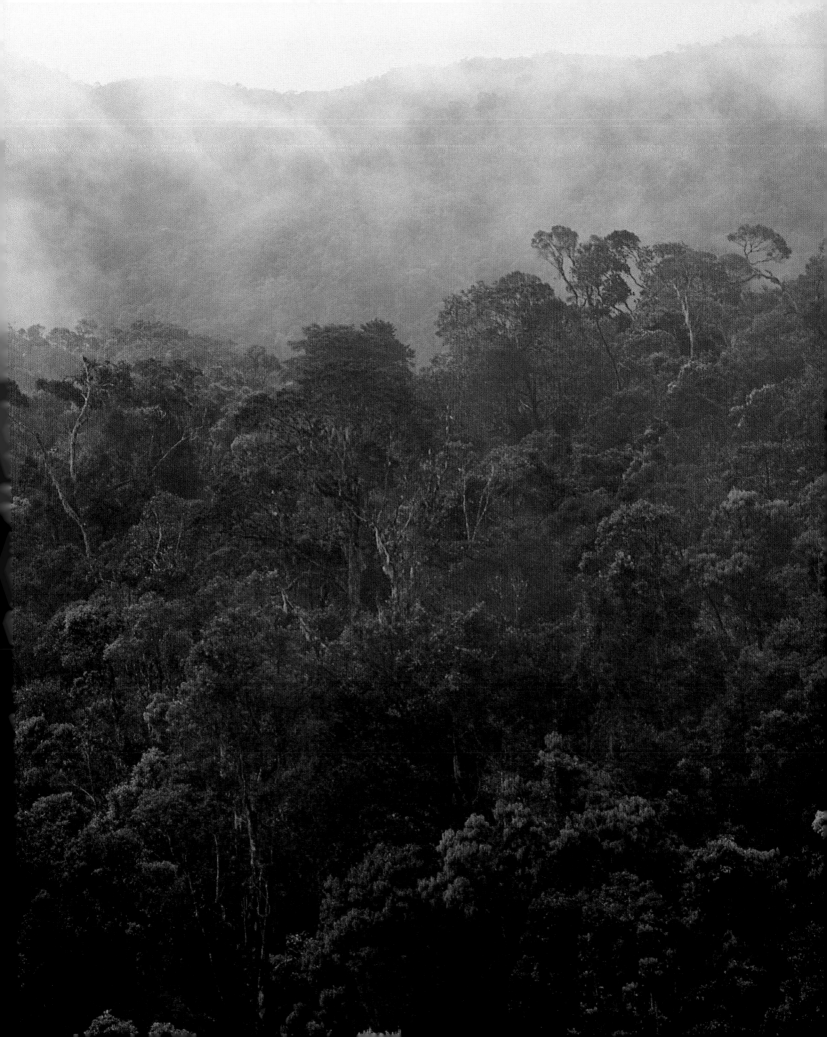

Rainforest. Africa has vast areas of rainforest. The largest are in the Congo Basin in central Africa, but civil war, riots and corruption have made this breathtakingly beautiful region a virtual no-go area for tourists. Madagascar's rainforest, which borders the island's east coast, is considerably more accessible. One of the finest areas is Ranomafana national park, home to many natural treasures. As recently as 1986 a new species of lemur was discovered here – the golden bamboo lemur.

The Malagasy rainforest is extremely humid. In Ranomafana an average of 102 inches (2,600 mm) of precipitation falls annually over a period of about 200 days. The park lies at an altitude of 2,100 to 4,600 feet (650 to 1,400 m) above sea level, and on rainy days it can be remarkably cold here. Countless small rivers and streams flow into the Namorona river which tumbles down the valley in a series of miniature falls and rapids.

Apart from the rare golden bamboo lemur, there are many other species of lemur and other mammals in the rainforest. Most visitors negotiating the forest paths also encounter leeches, which cling to your feet, especially the parts where the skin is thinnest. Even if you are on your guard, one or other of them always manages to find its way into your shoes and socks and attach itself between your toes. Leeches give off an anti-coagulant substance which means that you don't stop bleeding for a while; the whole experience is uncomfortable but not dangerous, according to the experts.

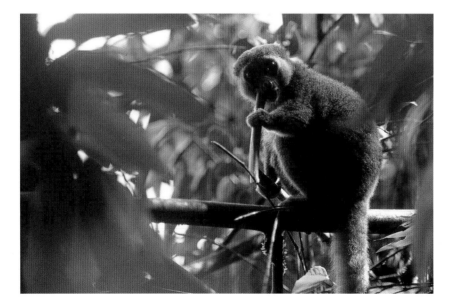

PREVIOUS PAGE: Mist hovers over the rainforest. Ranomafana, Madagascar.

LEFT: The rare golden bamboo lemur. Ranomafana, Madagascar.

BELOW: The Namorona river runs through the rainforest in the Ranomafana national park on Madagascar.

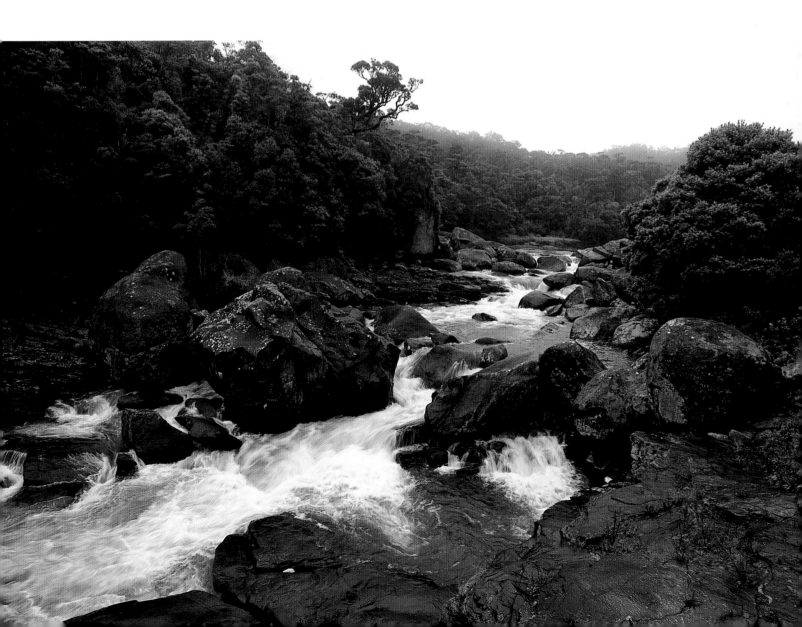

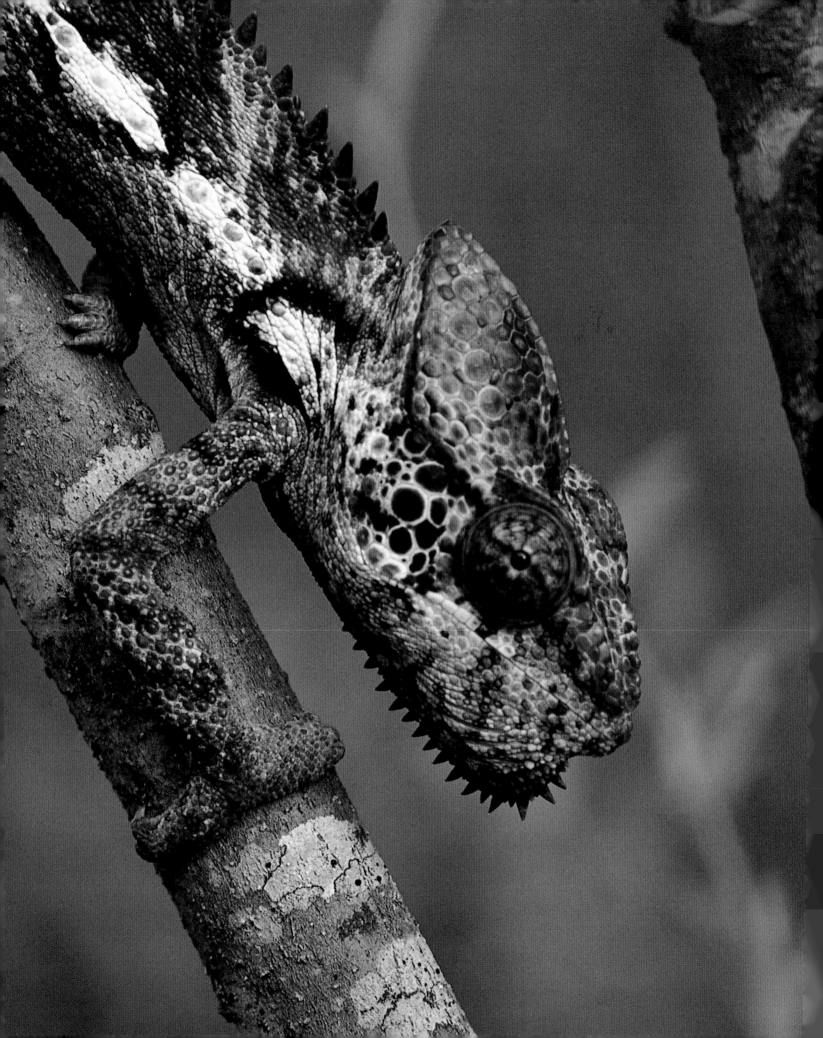

One eye forward and one back. More than half of all the species of chameleon in the world are found on Madagascar. Most of them are 6 to 12 inches (15 to 30 cm) long. But there are also some whoppers which can reach 27 inches (68 cm) – and a number of dwarfs which only grow to less than an inch.

Most chameleons live in trees and bushes. They climb hesitantly, holding on tight to twigs with the help of specially shaped claws and a long, coiling tail, which provides extra support. Their progress is often so slow that it is almost imperceptible. Chameleons are masters of disguise. Seen from the side, they appear to be flat, and resemble a large, thick leaf – when disturbed some species begin to sway back and forth, like a leaf in a gentle breeze. Chameleons can also change their colour to match that of their background, making them virtually invisible.

A chameleon's tongue is almost as long as its body. Usually rolled up against the jawbone inside the creature's mouth, the tongue shoots out with fantastic precision to grab any insect unlucky enough to pass within reach. The tip of the tongue is so sticky the prey has no chance of getting away. The larger chameleons can also catch other lizards, birds and even small mammals.

LEFT AND BELOW: *The chameleon's protruding eyes can swivel independently, allowing it to look both forward and backward at the same time without moving its head. Beza-Mahafaly, Madagascar.*

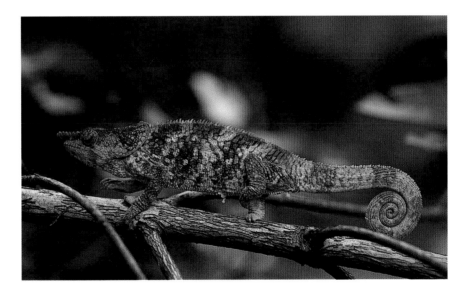

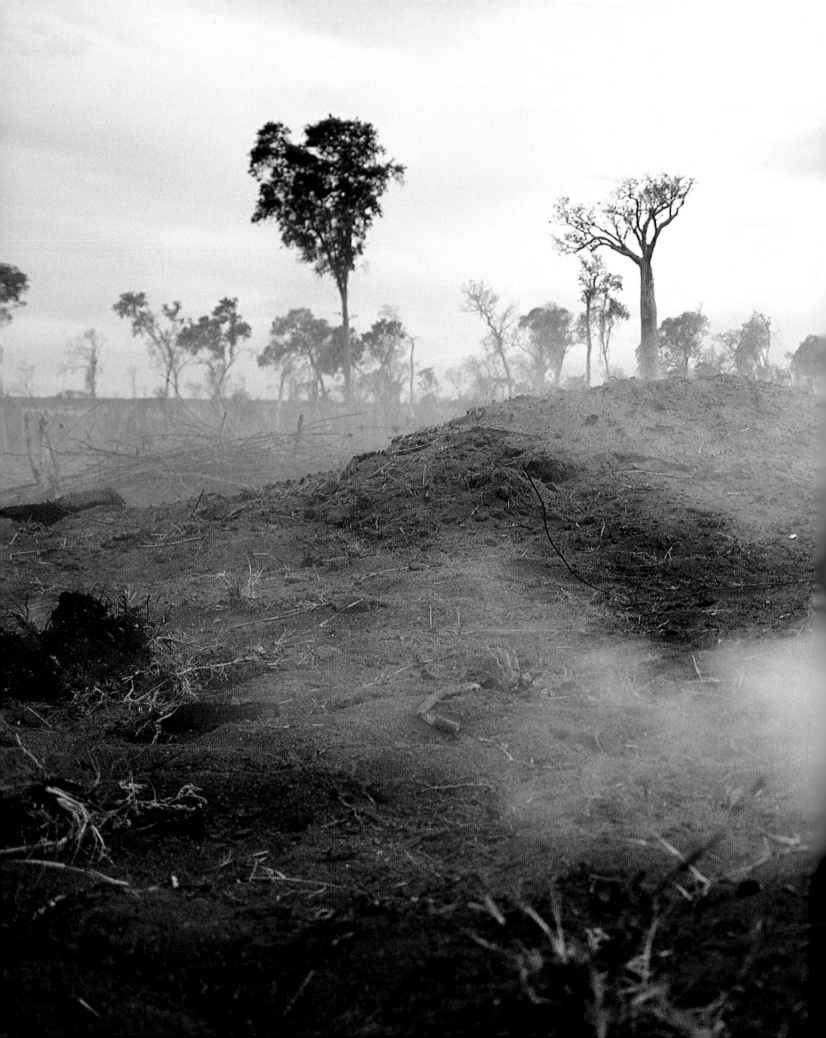

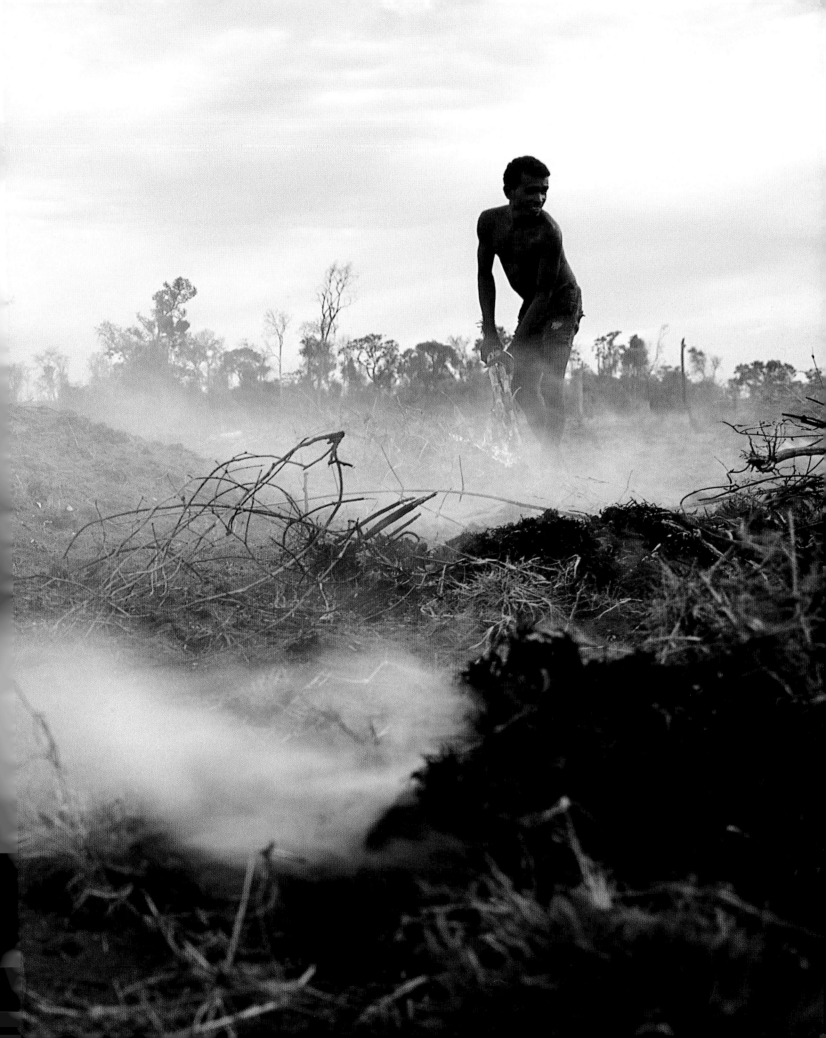

An endangered treasure trove. Time is running out for Madagascar. The island is facing an ecological disaster and its unique biodiversity is in danger of disappearing.

Once a lush, green island, today large parts of Madagascar have been left brown by man-made erosion. Almost ninety per cent of the island's original forest is gone, burned to create grazing for cattle and provide land for cultivation.

As everywhere in tropical forest areas, slash-and-burn farming – or *tavy* in Malagasy – is widespread. Poor peasant farmers fell trees and burn off bushes and undergrowth. The cleared earth is cultivated for three years, after which it is completely devoid of nutrients, forcing the farmers to move on and repeat the process. Land that has been subjected to such farming methods takes up to fifteen or twenty years to recover and even then may be smothered by alien vegetation.

Every year Malagasy farmers burn a quarter of the island's area to encourage the growth of grass as grazing for their cattle. The ground is irrigated, and when the rain comes it washes the red, ferrous laterite earth into rivers which eventually carry it out to sea.

From the air you can see how the island has been ruined. For mile after mile you fly over lifeless ridges covered only with dry grass. There may be a few miles between individual trees and many more between wooded areas. Since most of the deforestation has occurred relatively recently very few of Madagascar's animals have managed to adapt to life in these barren areas.

Many of the island's species have already disappeared. Fifteen lemurs are extinct. Two giant turtles have also died out, as have the pygmy hippopotamus and the 10-foot (3.2-m) tall great elephant bird, which may have weighed 1,000 pounds (450 kg). The elephant bird vanished about 500 years ago, but fossilized elephant-bird eggs are occasionally found in dried-up river beds and areas where people dig. Elephant-bird eggs are 180 times larger than hens' eggs and are sold all over the country – a symbol of the human plundering of Madagascar.

PREVIOUS PAGE: *Forest is burned to create farmland. Zombitse, Madagascar.*

RIGHT: *A Malagasy man holds the fossilized egg of the giant elephant bird, which became extinct about 500 years ago. Tolanaro, Madagascar.*

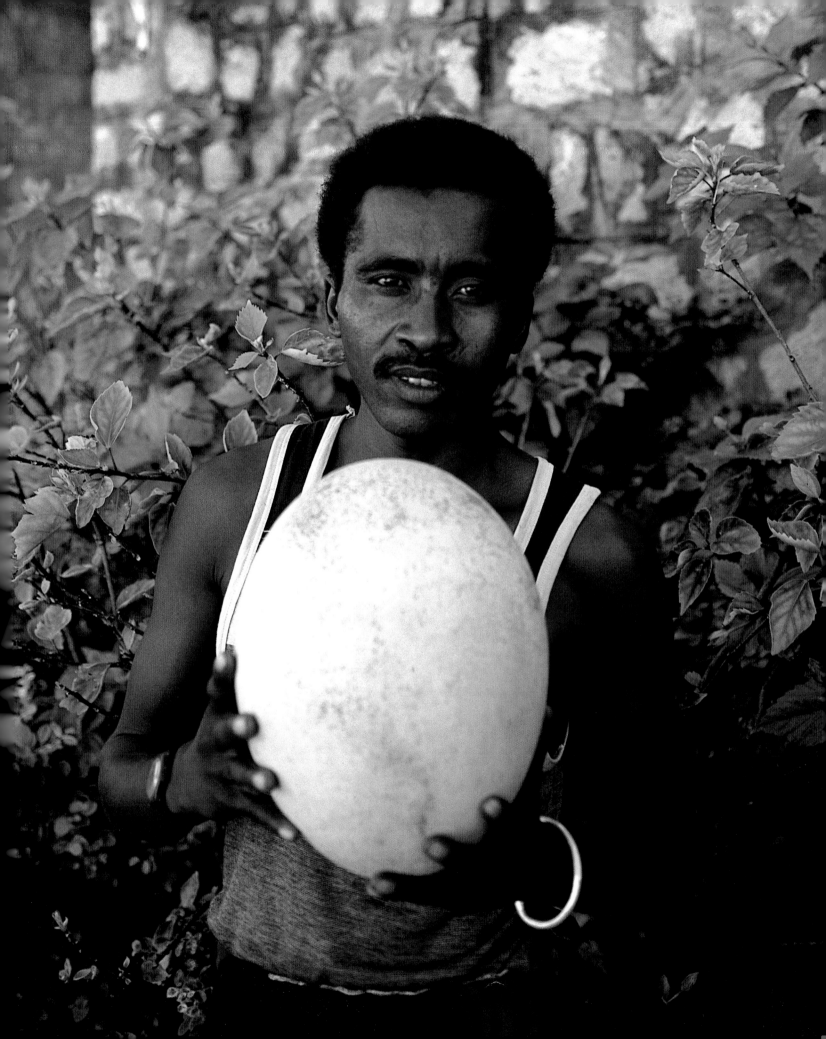

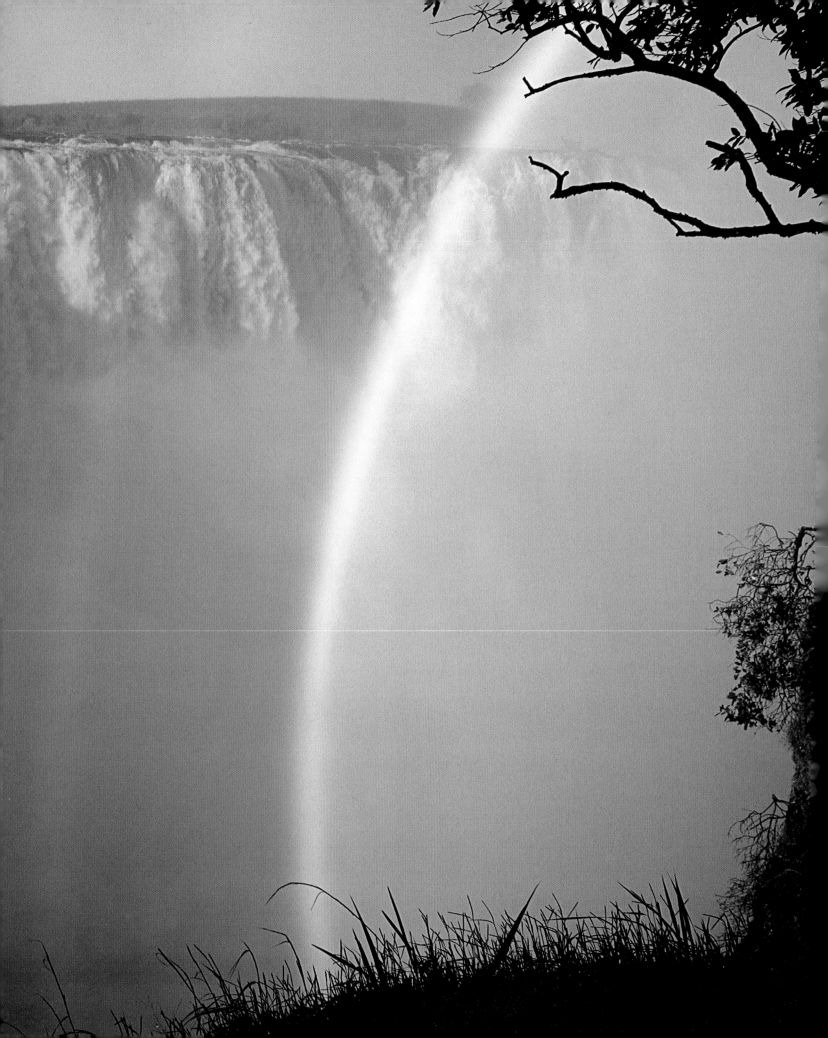

RIVERS AND LAKES

Even though dry areas make up one third of the surface of Africa, the continent's rivers and lakes are home to some of its most magnificent natural treasures. The Zambezi river, with the Victoria Falls on the border between Zambia and Zimbabwe, and Kenya's lakes Naivasha and Nakuru offer unique spectacles. Okavango in Botswana is the world's largest inland delta, and is rich in plant and animal life. Here there are lakes full of water-lilies, antelopes whose hooves are equipped with pads that enable them to flee their enemies by water instead of on land, and the rare African wild dog, the only species in its genus. Animals more typical of savanna regions, such as lions, cheetahs and leopards, also inhabit these watery areas.

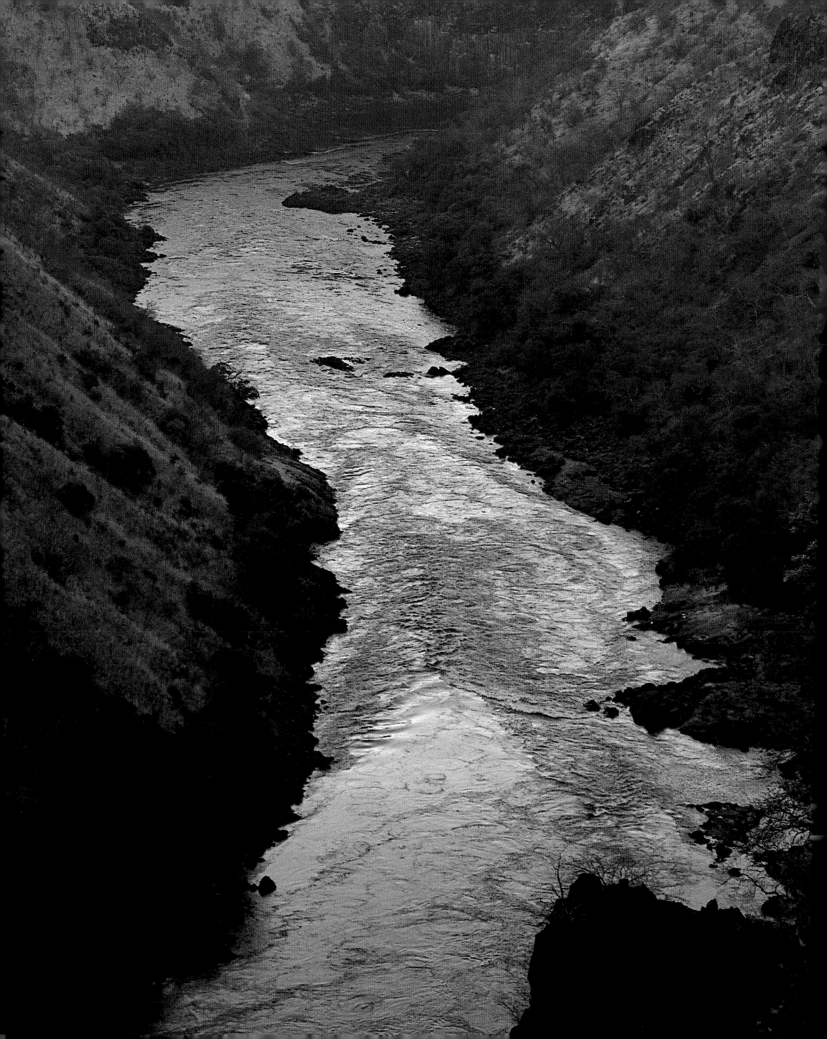

A magnificent spectacle. The Victoria Falls, which lie on the border between Zambia and Zimbabwe, are one of Africa's most impressive sights. On average around 17 million cubic feet (500,000 cubic m) of water flows over the edge every minute, except during the rainy season (March to May), when up to 170 million cubic feet (5 million cubic m) of water a minute tumbles down into the deep chasm. Huge clouds of steam rise constantly from the falls, accompanied by a deafening roar. The indigenous people call the falls "Mosi-oa-Tunya" – the smoke that thunders. An apt description for an overwhelming spectacle.

A long journey. The Zambezi is the longest river in southern Africa. It rises in northwest Zambia and flows first south and then east until it finally runs out into the Mozambique Channel. Part of the Zambezi's 2,200-mile (3,500-km) course forms the border between Zambia and Zimbabwe, where the Victoria Falls are situated.

PAGE 158: *The Victoria Falls measure 5,580 feet (1,700 m) across and drop between 295 and 350 feet (90 and 107 m) into the Zambezi Gorge. Victoria Falls, Zimbabwe.*

LEFT: *The Zambezi river runs through a deep gorge between Zimbabwe and Zambia.*

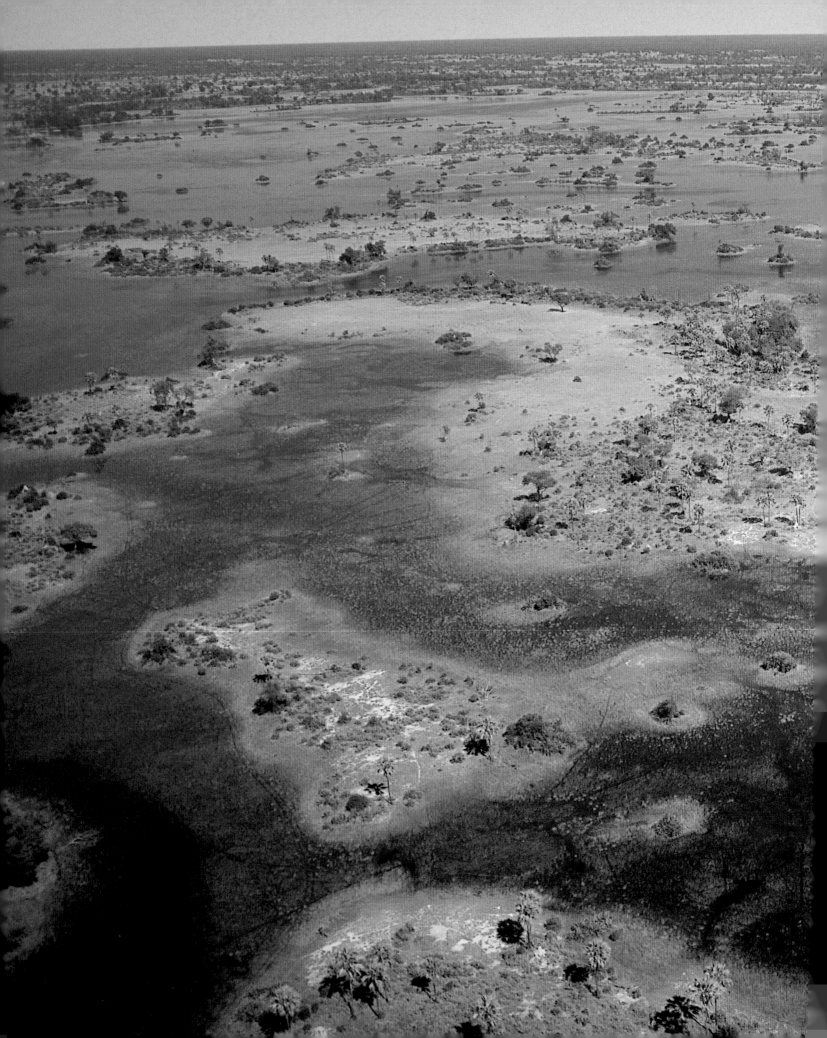

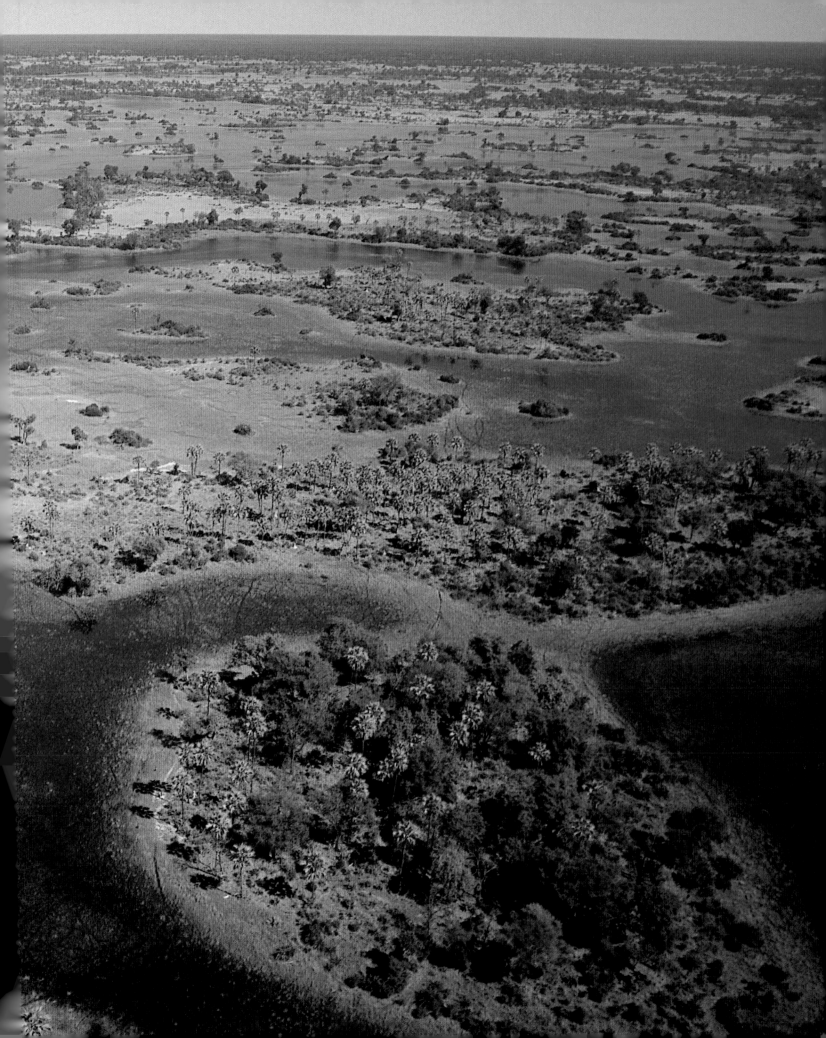

The world's largest inland delta. After a thirty-minute flight over a dry and parched-looking brown landscape, green foliage and water suddenly come into view and we wonder whether we are seeing a mirage. We seem to be flying from desert dryness into the Garden of Eden. Soon we are right over Okavango in Botswana – the largest inland delta on earth. Beneath us for as far as the eye can see lie islands covered with palm trees, lakes festooned with water-lilies and lagoons with forests of papyrus. The Okavango delta consists of up to 7,000 square miles (18,000 sq km) of watery landscape.

The river that disappears. The 900-mile (1,450-km) long Okavango river is formed from thousands of streams that are created by the summer rains high up in the highlands of Angola. Instead of running out into the Atlantic Ocean 190 miles (300 km) away, the Okavango flows right across southern Africa, through Namibia and into Botswana. Soon after that the river begins to divide, creating shallow lagoons, lakes and channels. Then, after spreading itself over a huge area, the Okavango simply vanishes. An estimated ninety-five per cent of the water evaporates into the dry air and two per cent is swallowed up by the sand. Just two to three per cent flows on in two branches of the river – and even they eventually dry up.

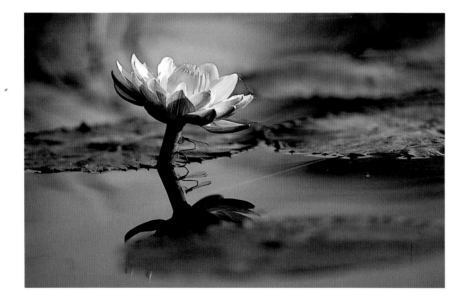

PREVIOUS PAGE: The huge Okavango inland delta, seen from the air. Okavango, Botswana.

LEFT: Water-lily. Okavango, Botswana.

BELOW: The mokoro canoe is used to navigate the shallow waters of Okavango. It is a very strange experience to sit in a canoe and be propelled along through groves of reeds and papyrus. Okavango, Botswana.

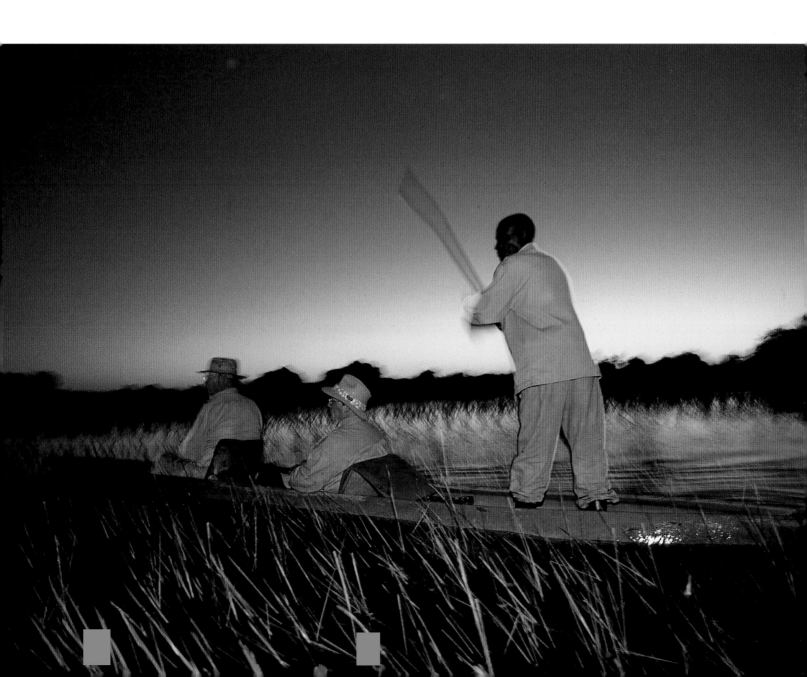

BELOW: Lechwe waterbucks running through water to escape from predators. Okavango, Botswana.

RIGHT: Today Botswana has the largest population of endangered African wild dogs. Okavango, Botswana.

NEXT PAGE: Evening in Okavango. The sun has just disappeared over the horizon and a lone ebony tree is reflected in one of the region's many lakes. Okavango, Botswana.

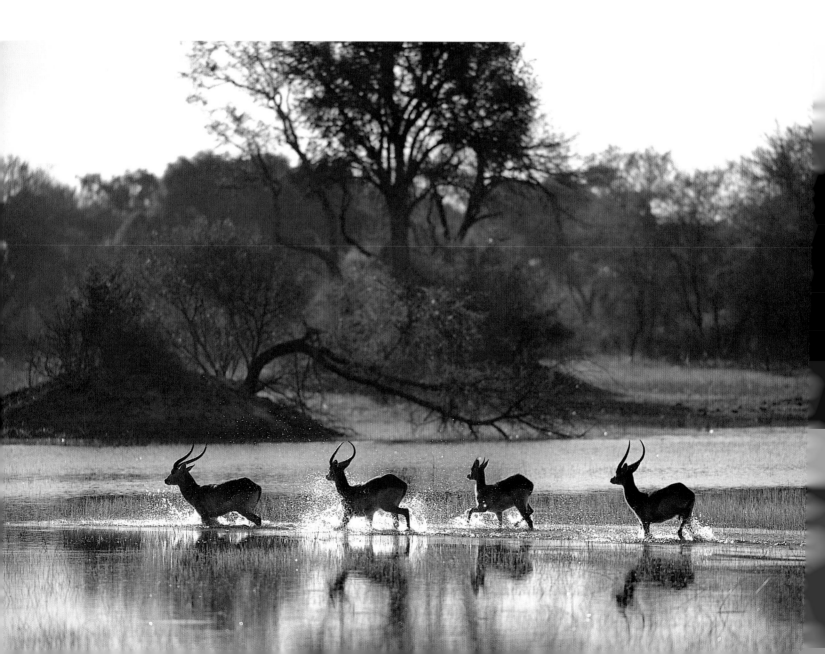

Life in the delta. About 60,000 people, 164 species of mammal, 450 species of bird, 84 species of fish, 157 species of reptile and 38 species of amphibian live in the Okavango delta.

The sitatunga is an antelope that is especially adapted to living in a marshy area – its elongated, splayed and padded hooves prevent it from sinking down into the mud. Another specialized creature is the lechwe waterbuck, of which there are more than 30,000. When they flee their enemies these agile creatures always run through water, moving in graceful leaps with the water splashing up around them. Some of the delta's 50,000 islands are inhabited by the elusive Pel's fishing-owl, which sits waiting for a catch high up in the shadow of the palm leaves.

On some of the larger islands vehicle safaris are available. In a big reserve on the 400-square mile (1,000-sq km) Chief Island in Moremi you can sometimes see traditional savanna animals such as lions, cheetahs and leopards. The lions in Okavango are of the so-called Kalahari type, characterized by the males' extremely dark manes. If there is one thing that lions and most other cats usually avoid it is immersion in water, but in Okavango the lions enjoy taking a swim among the islands out in the delta.

One of the strangest animals in Moremi and Okavango is the African wild dog, the only species in its genus and an endangered one – there are only about 5,000 individuals left. Wild dogs live in packs and hunt together as a group, just like wolves.

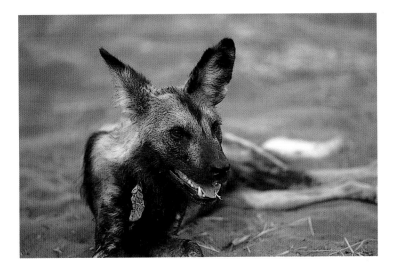

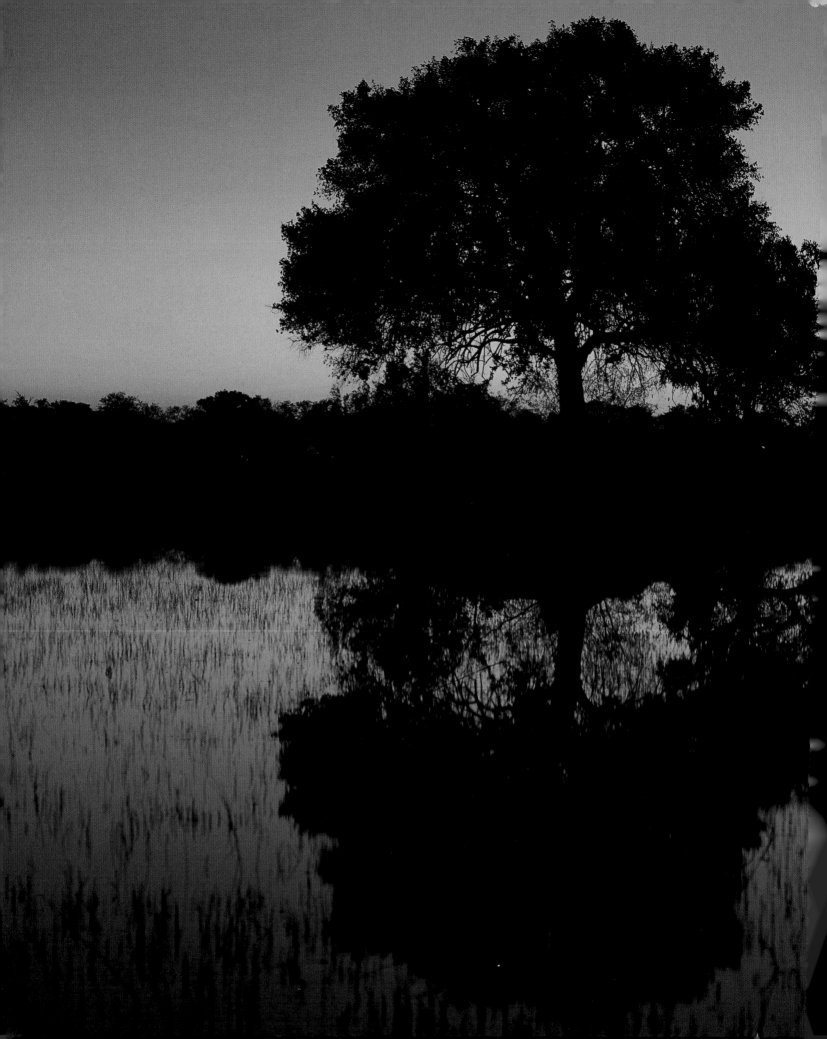

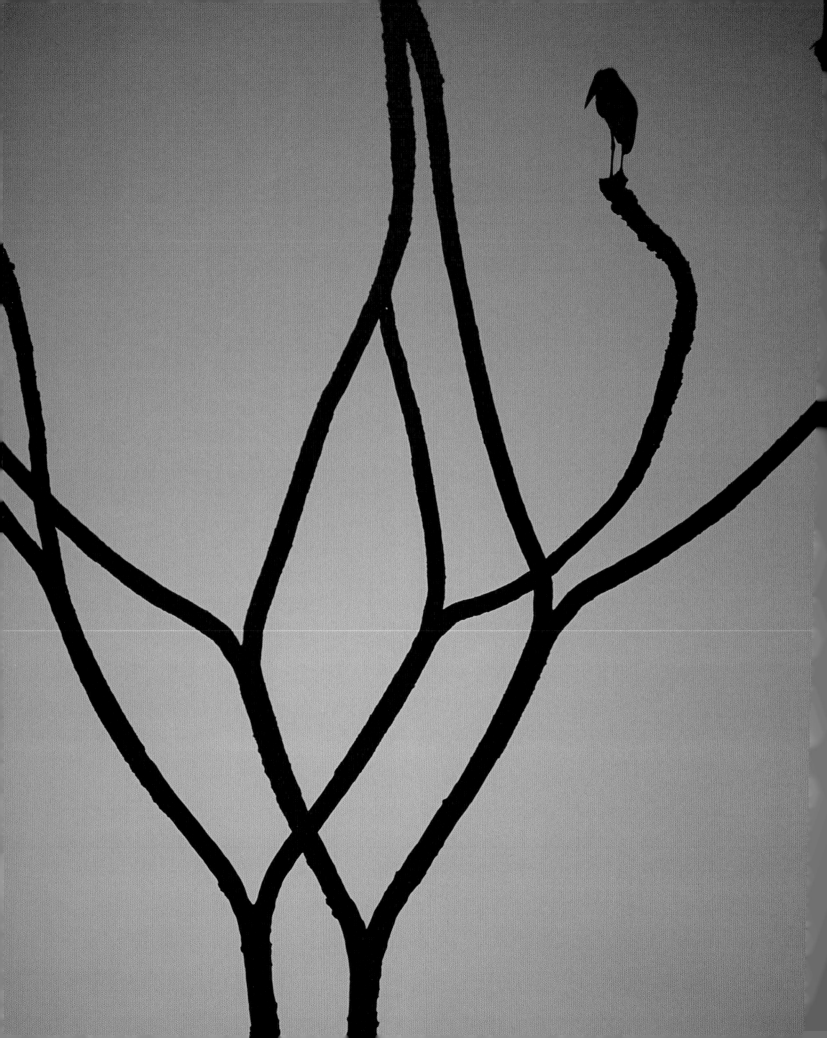

Africa wakes up. Daylight comes quickly in this part of the world – there is no real dawn or twilight hour. The sun disappears rapidly below the horizon in the evening and then rises again just as abruptly the next morning.

At the end of one of a dry tree's long, bare branches sits a marabou stork. For a few short minutes a lovely early-morning mood pervades the air, but soon it is bright daylight and the daily search for sustenance begins. A cormorant stands on top of a post in the water. It has a voracious appetite and dives, sometimes quite deep, to catch its food. After a while the cormorant's plumage becomes waterlogged and the bird finds an airy perch where it can rest for a while with its wings spread out to dry.

LEFT: *A marabou stork wakes up at the top of a dead tree. Samburu, Kenya.*

BELOW: *A cormorant spreads its wings in the sunshine. Lake Naivasha, Kenya.*

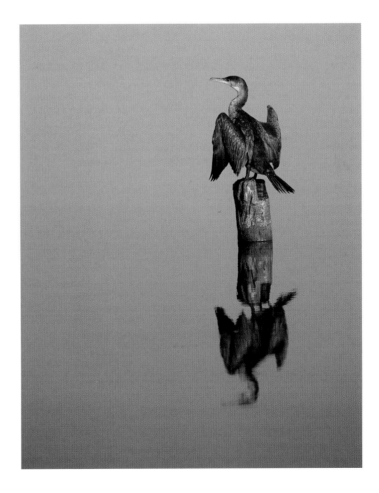

The hippopotamus attacks. Out in the middle of the Mara river in Kenya's Masai Mara a herd of hippopotamuses lies basking. Suddenly one of these massive animals charges toward us, water splashing furiously up around its legs. Then just as suddenly the hippopotamus stops and stands there with the bulk of its body visible above the surface and water pouring out of its huge mouth. Then it turns and waddles back to its friends out in the river; it was a mock attack. It is said that of all Africa's wild animals it is the hippopotamus that kills the most people.

Every night the hippopotamus leaves its river bath to graze on dry land. A hippopotamus can travel over quite large areas during its nocturnal grazing trips, often covering several miles. In the morning, just before sunrise, it returns to the river.

BELOW: *A baby hippopotamus clambers out of the water to ride on its mother's back. Masai Mara, Kenya.*

RIGHT: *Adult hippopotamuses are heavy mammals: females average 1.4 tons and males may grow to as much as 3 tons. The hippopotamus's skin gives off large quantities of water, especially in dry air, which is why the animal has to spend all day immersed in water to prevent it from drying out. Masai Mara, Kenya.*

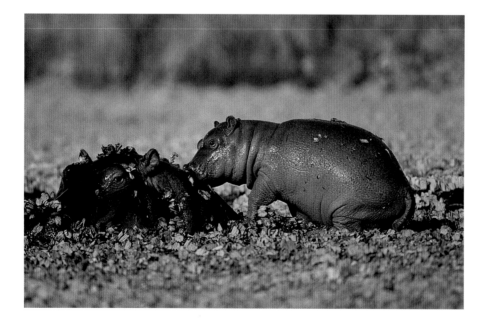

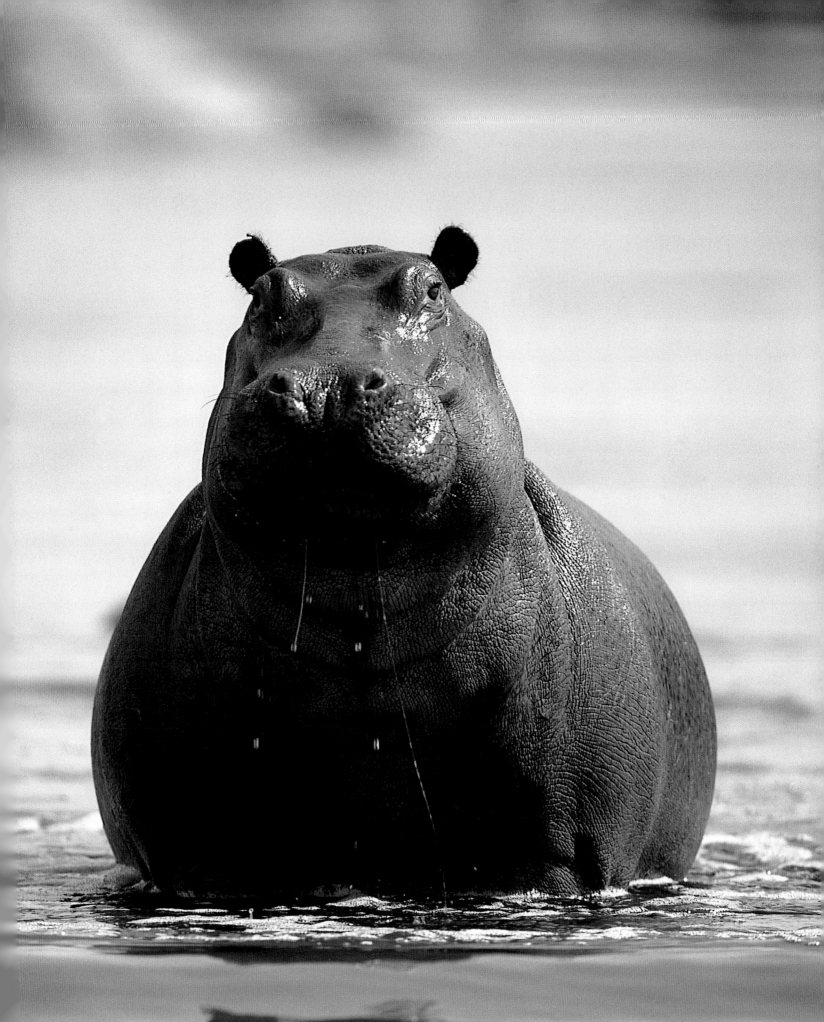

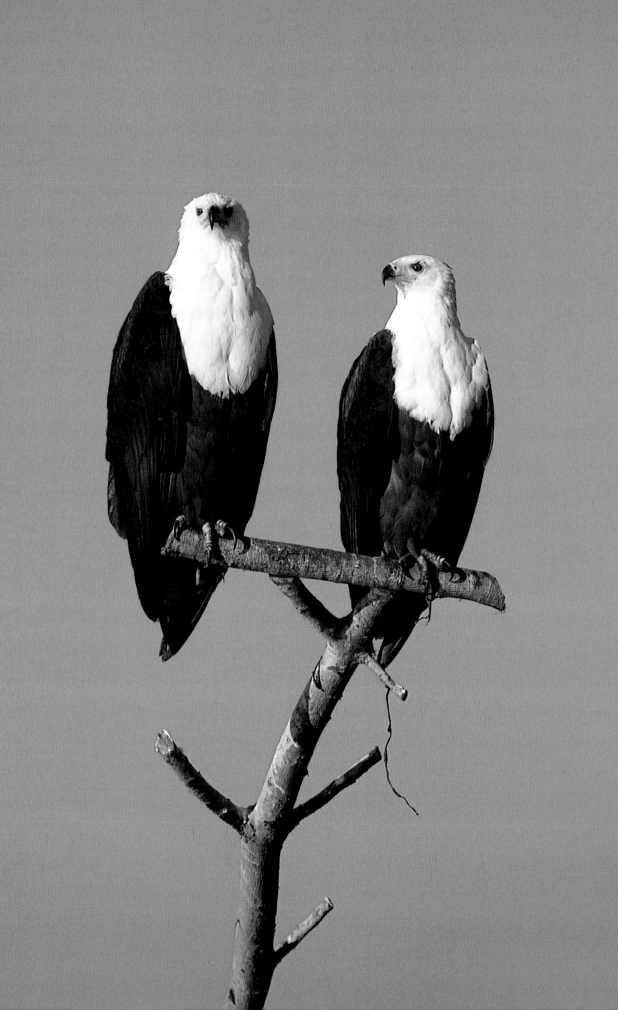

The voice of Africa. The African fish-eagle is sometimes called "the voice of Africa", for its characteristic shrill cry – heard along the continent's rivers – is as distinctive as the bird's appearance. The fish-eagle's white head and breast contrast beautifully with its otherwise brownish-black body. This powerful bird likes to perch on a high branch hanging over a river or lake and keep watch on the water below. With its sharp eyes it spots fish, then dives down and sweeps up its dinner. Although the fish-eagle can seize fish weighing up to 9 pounds (4 kg), its catch usually weighs between 7 ounces (200 g) and 2 pounds (1 kg). It can also catch birds, small mammals, reptiles, amphibians and even insects. The African fish-eagle is common in Okavango in Botswana, and also on Lake Naivasha in Kenya, where the pair of eagles in the picture opposite live.

LEFT: *Fish-eagles beside Kenya's Lake Naivasha, which is particularly rich in fish.*

BELOW: *The body of a crocodile. Samburu, Kenya.*

NEXT PAGE: *The crocodile's ability to lie as still as a log in the water allows it to get close to the animals which come to the river to drink, and launch a surprise attack. Victoria Falls, Zimbabwe.*

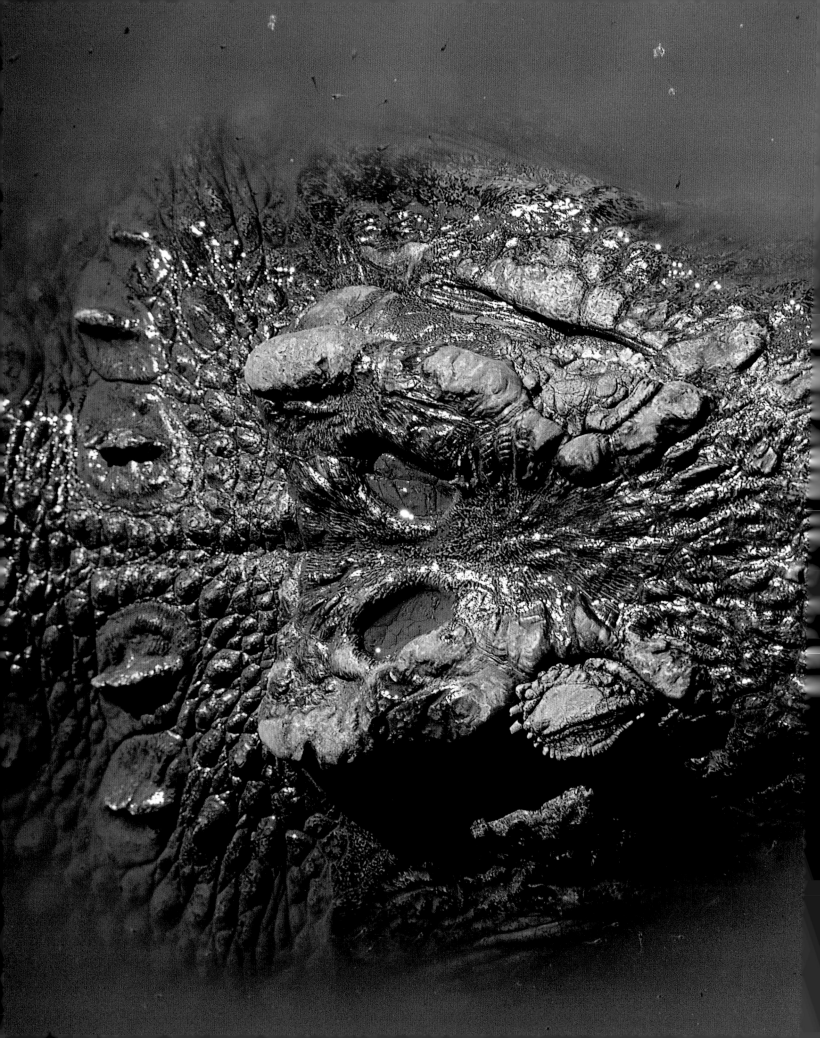

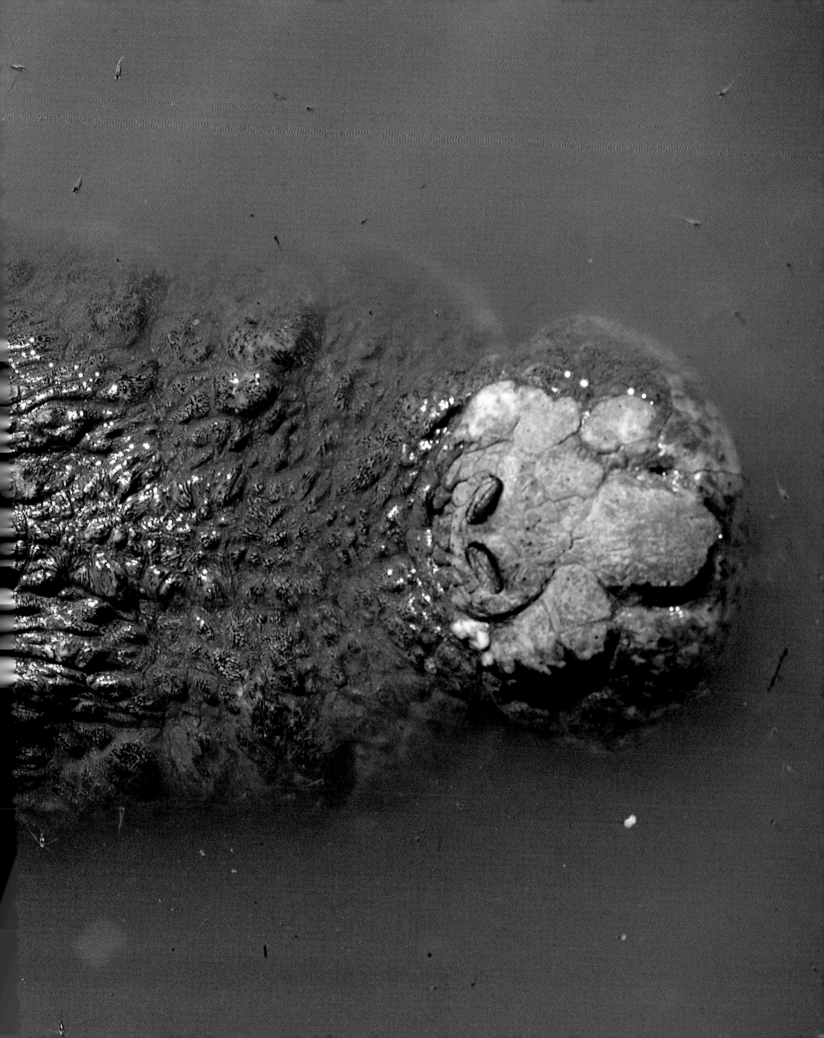

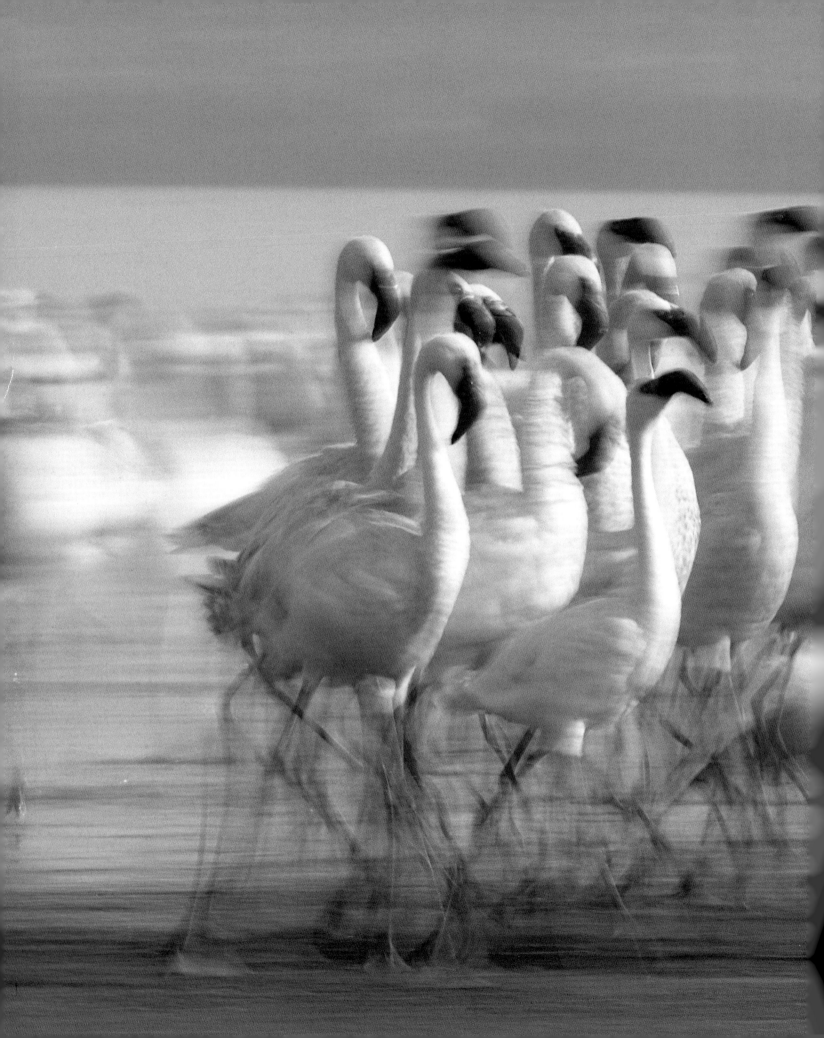

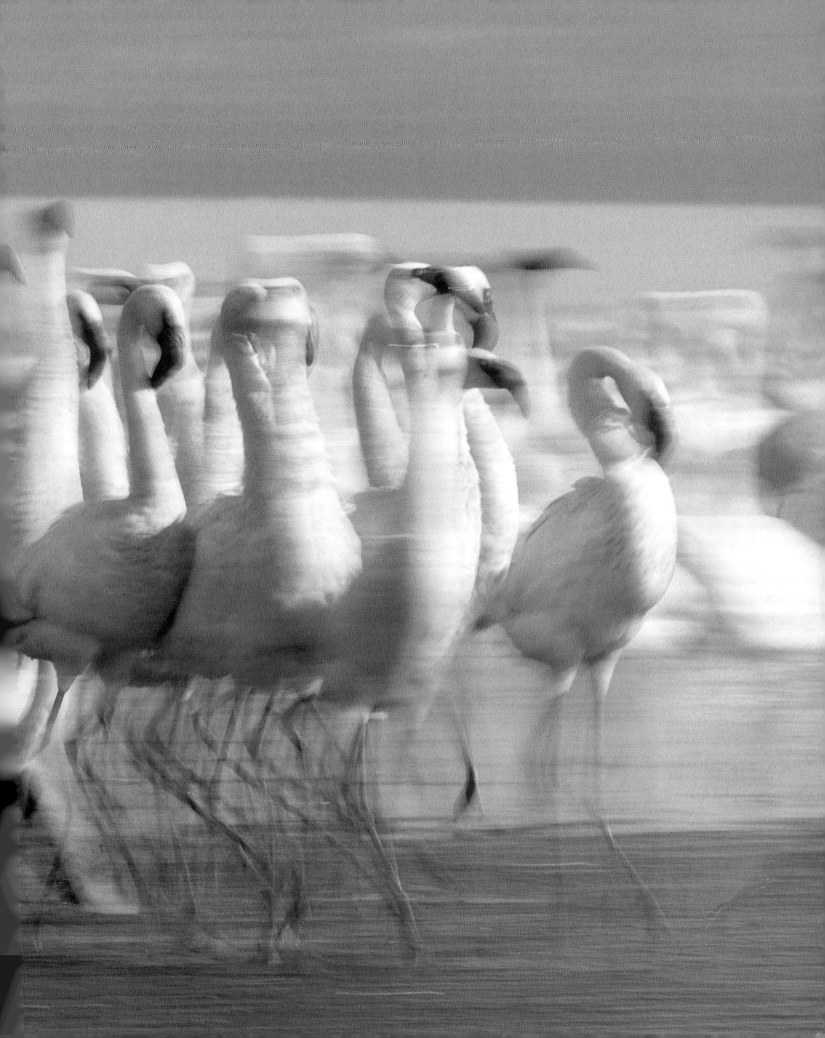

The dance of the flamingos. The great dance of the flamingos goes on for several hours and is a fantastic sight. Packed tightly together these beautiful birds dance in row upon row – hundreds of red legs step out across the bottom of the lake while hundreds of long, pink necks stretch up toward the blue sky. The birds incite one another to join in the massed movement; they are so close that they become almost like a single body. No one knows for sure why flamingos perform their mysterious dance, although some observers believe it may be a mating ritual.

A pink whale on long legs. On the shores of Kenya's very salty Lake Nakuru up to a million lesser flamingos search for food simultaneously. These flamingos love algae soup, especially when it is made from the blue-green algae *Spirulina platensis*. They strut around on their stilt-like legs, pausing to sweep their small heads from side to side in the water.

The flamingo's feeding technique is unique, but basically it works in the same way as that of the great whale, which is also an expert in filter feeding. The flamingo's beak has comb-like structures known as lamellae. To feed, the bird moves its beak up and down in the water while its tongue works like a piston, so that a mixture of mud and water is first sucked into the mouth and then squeezed out through the lamellae, leaving the algae behind. A lesser flamingo has to filter up to 35 pints (20 l) of water a day in order to obtain its daily ration of around 2 ounces (60 g) of algae. That may not seem a lot, but nonetheless it means that a million flamingos eat 60 tons of algae a day – or more than 20,000 tons a year. You might think they would empty Lake Nakuru of algae, but the algae can double in number in just 24 hours.

The pink colour of the flamingo's feathers is caused by carotene contained in the algae. This substance is broken down by enzymes in the bird's liver and turns into vitamin A and pigment.

PREVIOUS PAGE: *Lesser flamingos dance in tightly packed groups. Lake Nakuru, Kenya.*

RIGHT: *A lesser flamingo on the shores of Lake Nakuru, Kenya.*

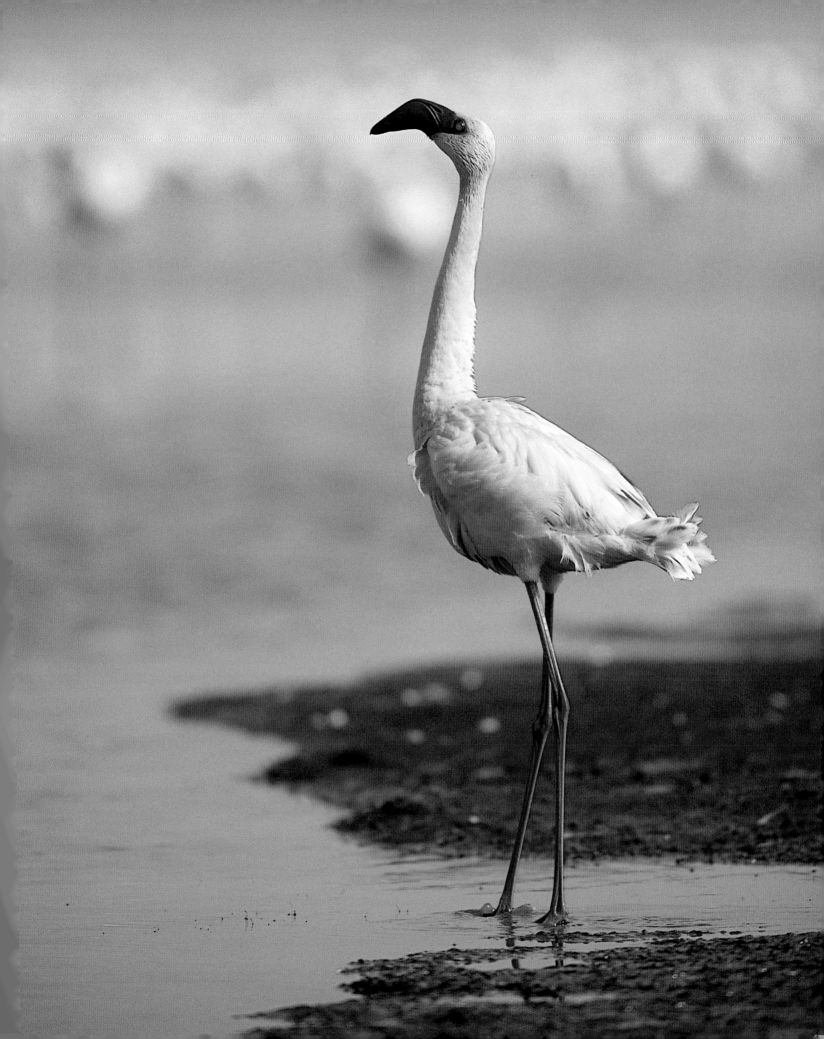

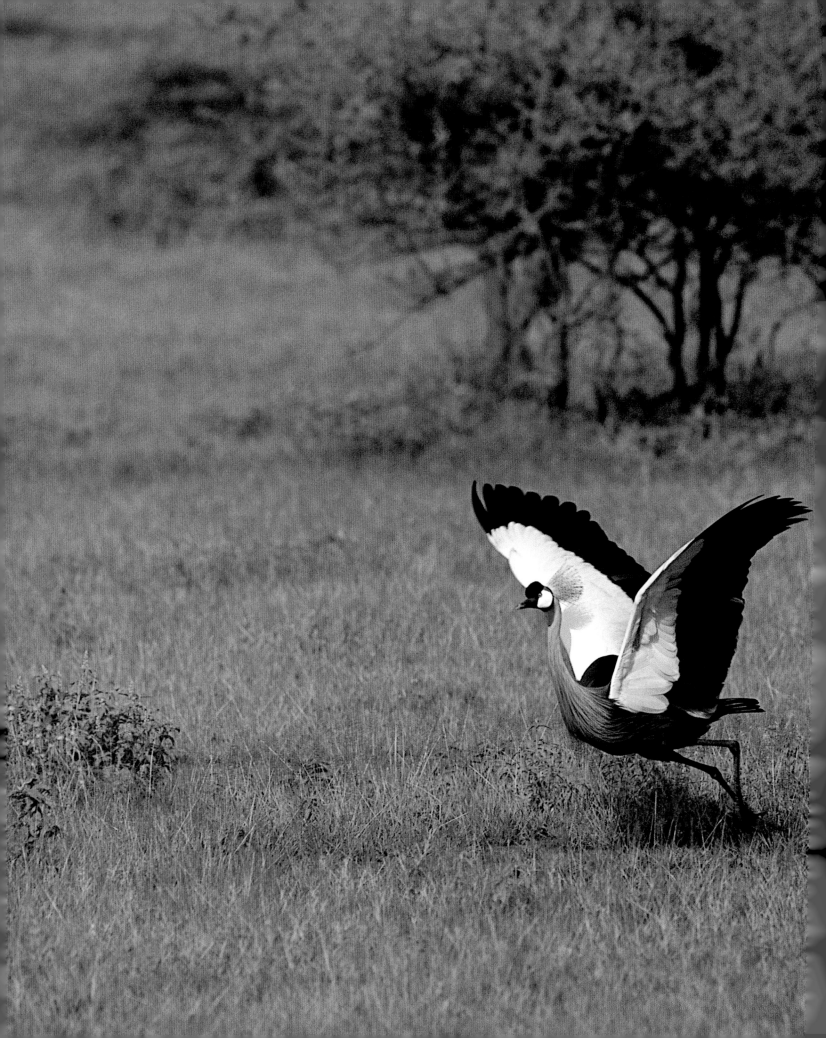

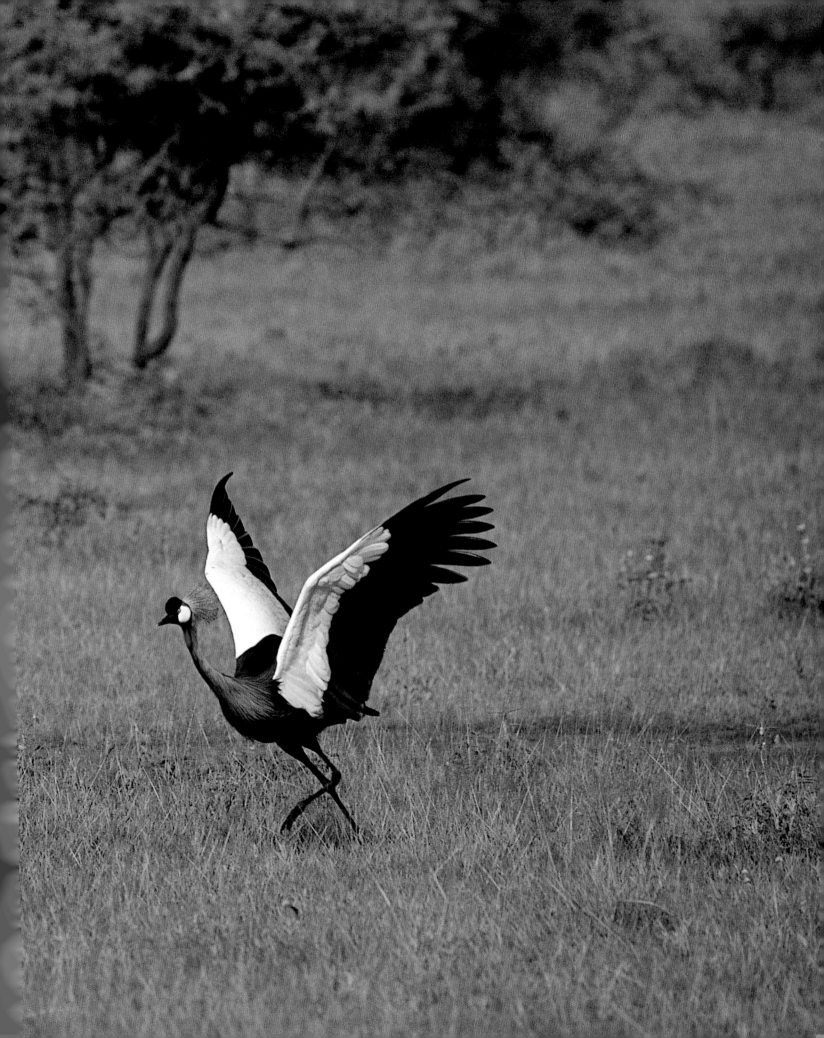

The beautiful crowned-crane. The crowned-cranes, with their hallmark golden crown, are extremely elegant – among the most majestic species of crane in the world. The grey crowned-crane is the species found in Kenya. It is happiest beside water and streams, but can also be seen far out on the savanna. Its distinctive loud, four-syllabled, trumpeting call can be heard from several miles away.

Bird lake. Lake Naivasha in Kenya is one of the cleanest freshwater lakes in the Rift Valley, that great crevice in the earth's crust which stretches from Mozambique in the south to Turkey in the north. Lake Naivasha is a particularly rich inland sea. Here you can spot several kinds of herons, including the little egret with its characteristic long plume on the back of its neck, and various species of kingfishers. In the water around the hippopotamuses, pelicans catch fish using a special technique. They swim in flocks until they find a shoal of fish and then they all dip their heads down into the water simultaneously and fill the pouches under their bills with fish. The pelicans then swim on a short distance and repeat the whole sequence.

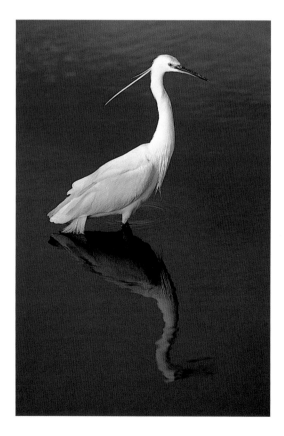

PREVIOUS PAGE: Two grey crowned-cranes about to take off. Nairobi national park, Kenya.

LEFT: *A little egret. Lake Naivasha, Kenya.*

BELOW: *A flock of pelicans takes a break from fishing in Lake Naivasha, Kenya.*

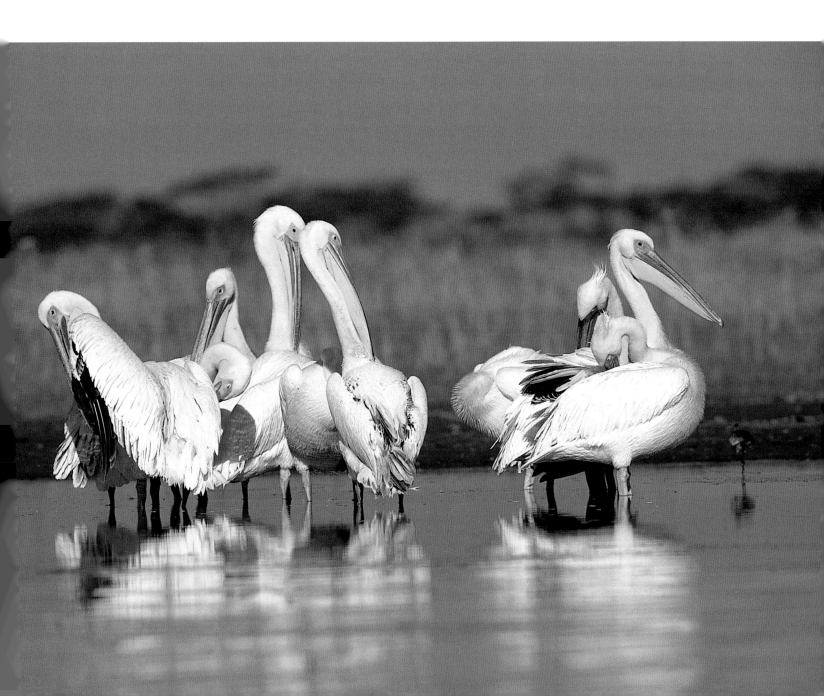

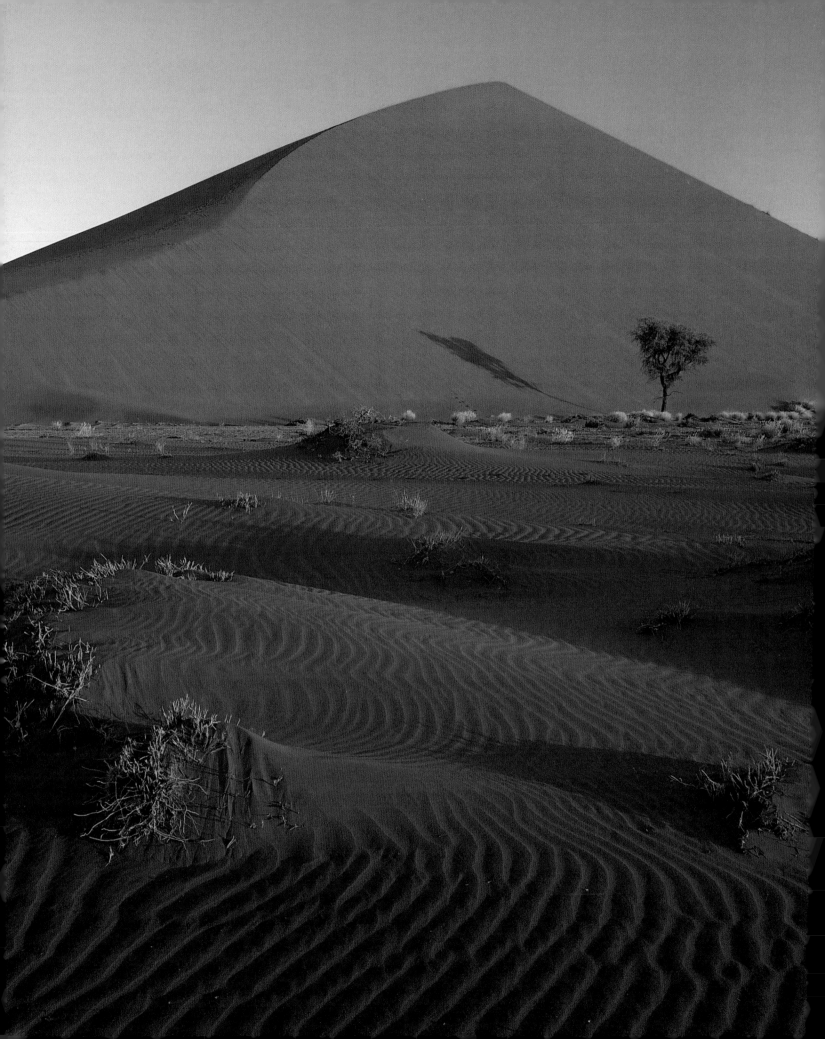

DESERT

Desert means sand and stones, drought and wind. This terrain is desolate, poor, and frightening, yet also immeasurably beautiful, particularly at sunrise and sunset when the desert sand glows red.

Africa has many dry areas. The Sahel is well known, not least for its many famine disasters, but it is the arid area north of Sahel which is a real desert: the Sahara – the world's largest desert. Here there are 3.5 million square miles (9 million sq km) of sand and stone, stretching from Morocco and the Atlantic in the west to Egypt, the Sudan and the Red Sea in the east. There are also deserts further south, in Namibia, Botswana and South Africa. The Kalahari, Namib and Karoo together cover more than 450,000 square miles (1.1 million sq km).

It has not always been thus, however. Once upon a time the Sahara was a sea, and later it was covered in forest and home to dinosaurs. Several thousand years ago, people hunted giraffe and antelope here. And the Kalahari desert too was once a Garden of Eden, with subtropical forests and vast lakes.

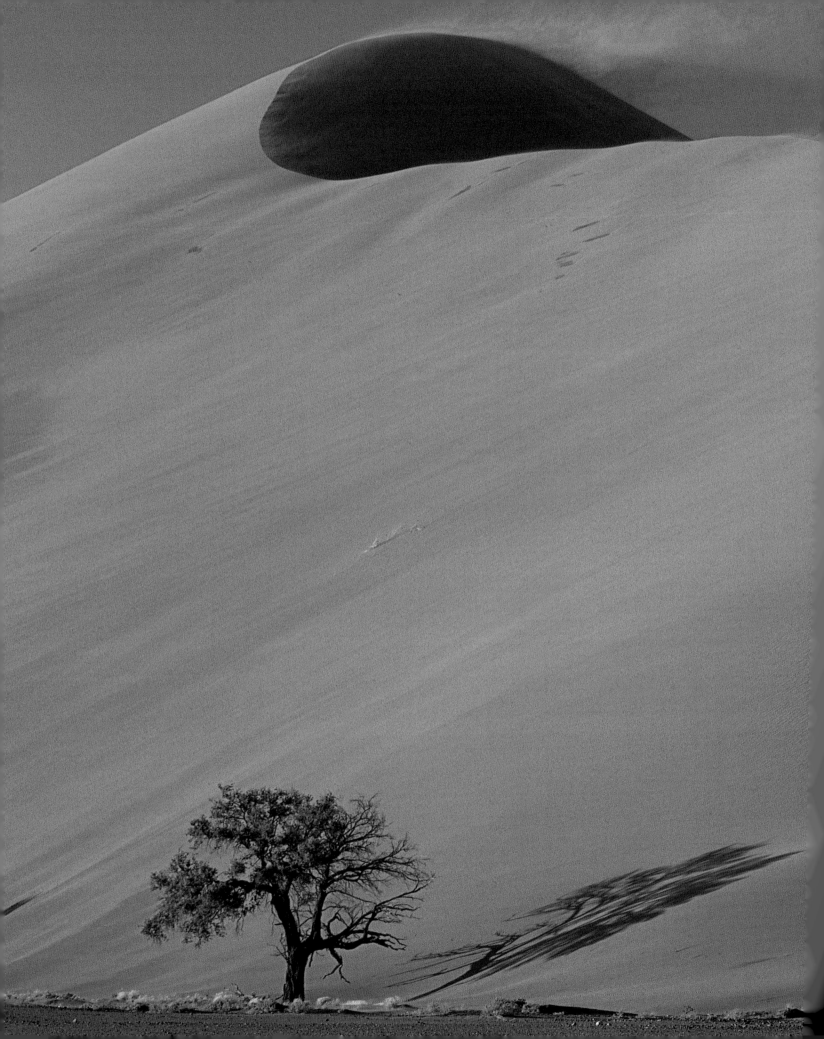

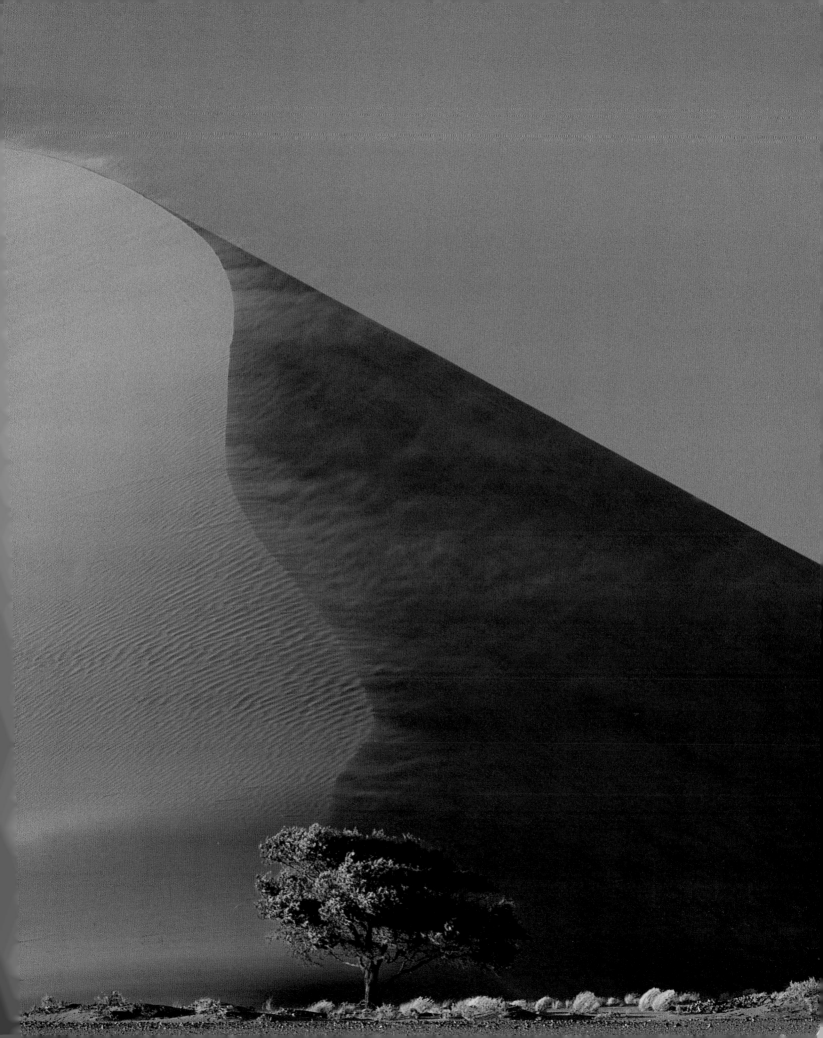

Sand dunes in the wind. It is only a few minutes to sunrise and soon the sand dune will be glowing red in the morning sun. In front of the dune several camel-thorn trees are growing, in sharp contrast to the lifeless desert sand.

Right behind the tree the dune rises like an enormous wave, over the top of which the wind is blowing small clouds of sand. The red desert sand, the blue sky and the green tree form a perfect picture, even if we are about to find ourselves engulfed in a small sandstorm.

Sossusvlei is part of the 19,500 square miles (50,000 sq km) of the Namib Naukluft national park in Namibia, where about 12.5 million acres (5 million hectares) of desert are protected. This is one of the largest protected areas in Africa.

The sand dunes vary in colour from almost white along the coast to orange and red inland. The colours that turn the Namibian desert a glowing red at sunrise and sunset are a result of the rich deposits of iron oxide in the sand.

The world's highest sand dunes. Namibia has the world's highest dunes. The tallest rises about 1,100 feet (325 m) and it can take a couple of hours to climb to the top. Coming down again is much quicker – in less than fifteen minutes you are back at the foot of the dune.

The Namibian sand dunes owe their existence to the Orange river, which forms the border with South Africa. This river transports large quantities of sand from the highlands in Lesotho to the Atlantic. From here the Benguela current carries the sand northward and deposits it along the coast. The wind then blows the sand inland. The whole of Namibia's coastline – all 1,250 miles (2,000 km) of it – is desert. The coast is cool, with an average precipitation of less than an inch (20 mm) a year, but the country's central region is warmer and has around 4 inches (100 mm) or more of precipitation.

PAGE 186: *One of the world's oldest deserts. Namib Naukluft, Namibia.*

PREVIOUS PAGE: *The sand dunes rise up like mountains in Namibia's Namib Naukluft.*

RIGHT: *The cold Benguela current gives rise to humid banks of mist which drift far in across the desert, providing welcome moisture for the area's sparse plants. Namib Naukluft, Namibia.*

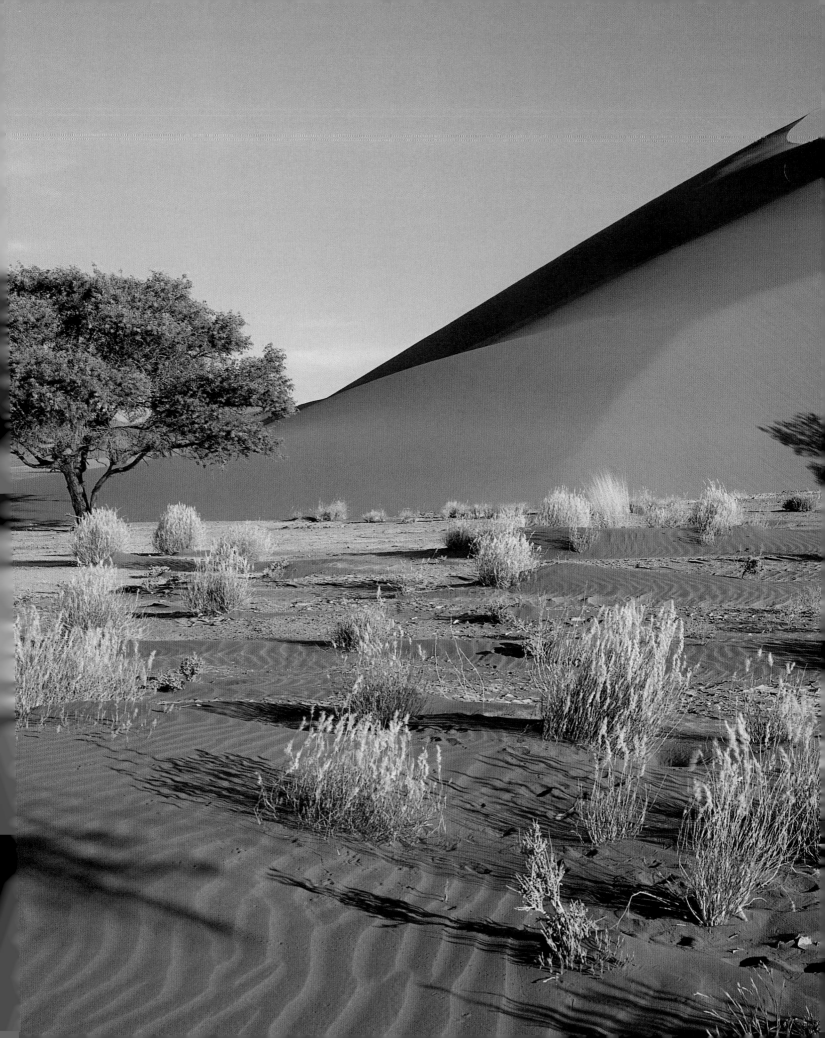

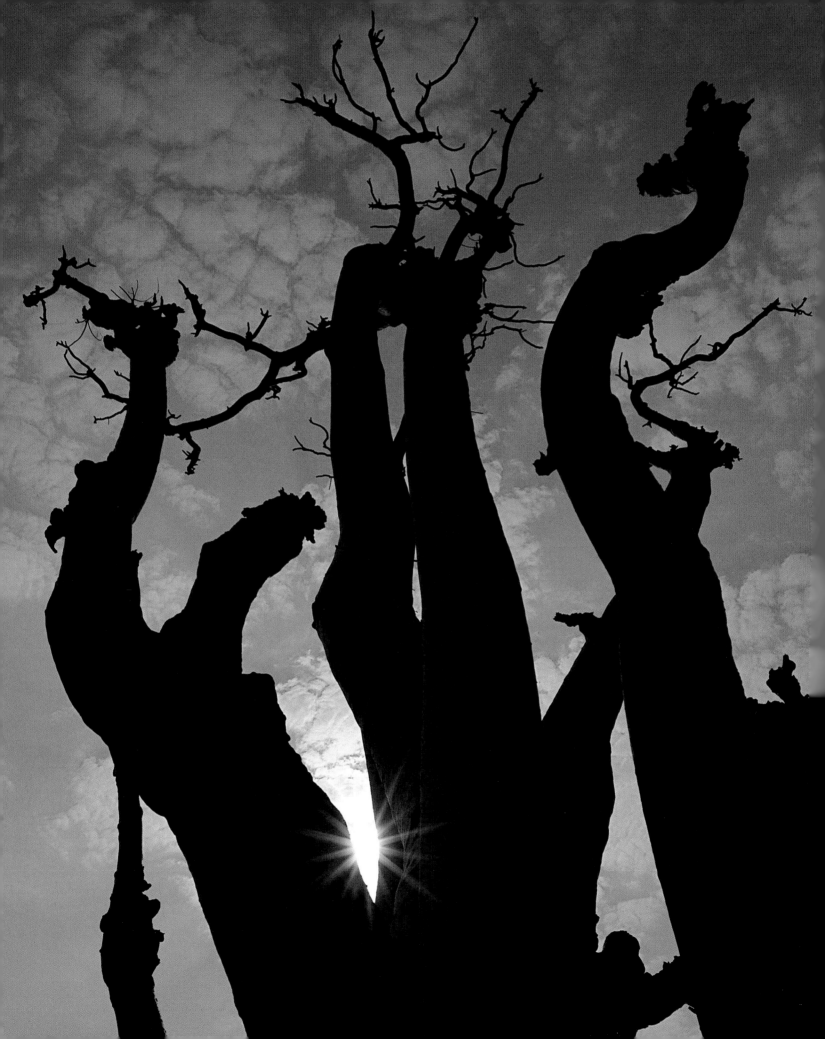

Trees in Namibia. Trees that grow in desert sand are often very special. They almost have a personality – they certainly possess great vitality, which enables them to defy heat, drought and sand. It was about forty degrees in the shade when I photographed this moringa tree in the western part of the Etosha national park, the part which the indigenous people call the "Haunted Forest". According to the legends of the San people it happened that when God had found a home for all the plants and animals on earth, he discovered a few moringa trees which had been left out. He threw them up in the air and they fell to the ground with their roots pointing upward. And so they stand to this day – and only in Namibia.

LEFT: *Moringa tree. Etosha, Namibia.*

Fixed points in the sand. The wind blows through the desert and creates the most unbelievable formations. Camel-thorn trees stand fast while the sand around them changes from day to day. The wind forms the sand dunes, blows away tracks, creates new tracks and new formations. Dry clay cracks and makes its own patterns. The desert is a visual feast for anyone who delights in lines and composition.

BELOW LEFT: *Cracked, dried-up clay. Namib Naukluft, Namibia.*

BELOW RIGHT: *A beetle has left an imprint in the sand. Namib Naukluft, Namibia.*

RIGHT: *In Dead Vlei dead camel-thorn trees are surrounded by gigantic sand dunes. The river that once gave the trees life has long since evaporated in the heat. Namib Naukluft, Namibia.*

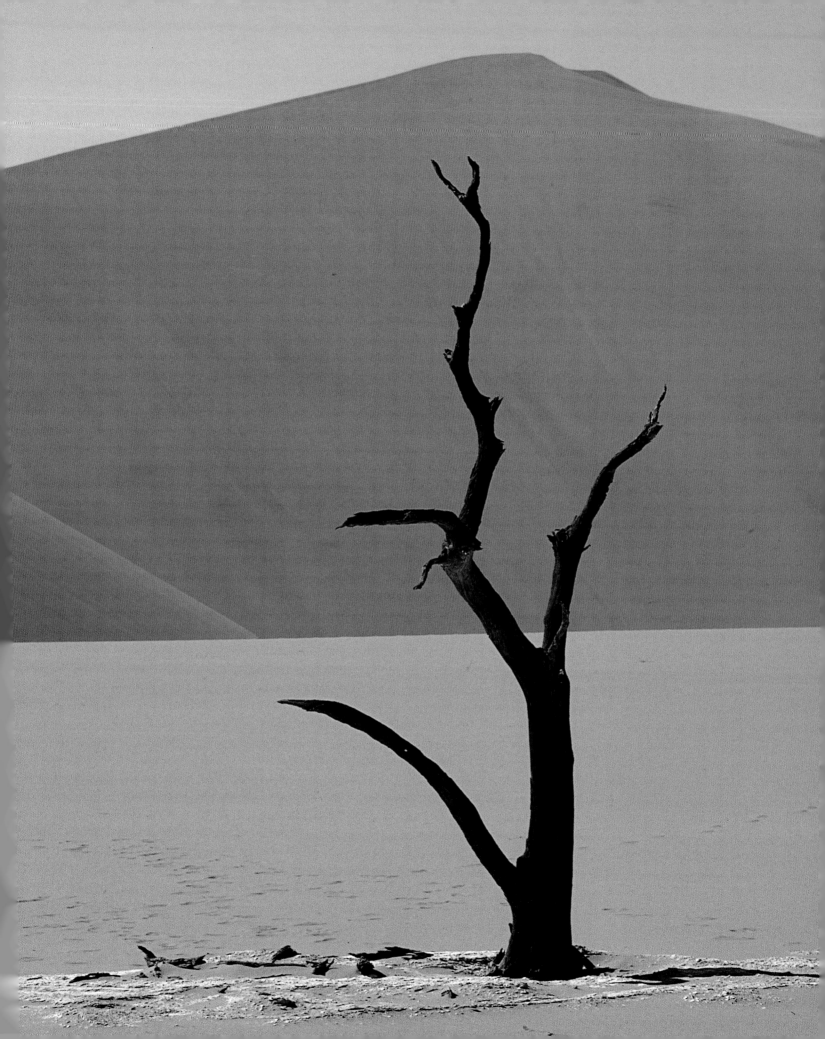

Special adaptation. There are not many species of animals in the desert, but the beautiful gemsbok, or South African oryx as it is also known, is well adapted to the dry environment. It survives on the small quantity of fluid that can be absorbed through its food. Although there is precious little, the oryx is good at retaining moisture. Not one drop leaves its body unnecessarily; its droppings are completely dry.

During the course of a day, there are only a handful of species to be seen. Yet the Namibian desert has the richest sand-dune fauna of any of the world's deserts, thanks to the cold Benguela current. This current creates mists which roll in over the sands, often penetrating as far as 30 miles (50 km) inland from the sea. The humidity in this mist is vital to the desert organisms. Hills, ridges and, especially, sand dunes act as "mist catchers", making the living conditions in these areas particularly favourable. But it is nevertheless important to seize the moment because there are only sixty misty nights a year.

On such misty nights a special black beetle takes up a strategic position. By splaying its legs, dropping its head and thrusting its abdomen into the air, the darkling beetle increases the condensation surface-area of its own body. When the moisture condenses on its body, water droplets run down toward its mouth. Other types of beetle dig miniature pits to collect moisture in the sand, while certain kinds of desert bushes stretch their lengthy, 65 feet (20 m) roots right up to just beneath the desert floor in order to make the most of the "mist water".

There are additional ways of surviving the heat. Most desert creatures hide by day and come out at night, when the temperature is more bearable. One specially adapted creature is "the dancing white lady" – a spider which has developed its own unique technique for keeping out of danger. It forms its legs into a wheel and rolls itself quickly down the sand dunes. A certain type of gecko protects itself against the worst of the sand's heat with a special "temperature-regulating dance" – putting alternating feet down on the sand at the same time, one front leg and one back leg together. Other animals try to switch between sun and shade. When the stars come out in the desert night sky you can hear the "crying gecko" and you may find a scorpion that has wandered into your camp. The next morning you may discern the peculiar tracks of the sidewinder dwarf puff adder, which moves sideways in the sand by throwing its body into S-shaped curves.

RIGHT: *A gemsbok in the desert. Namib Naukluft, Namibia.*

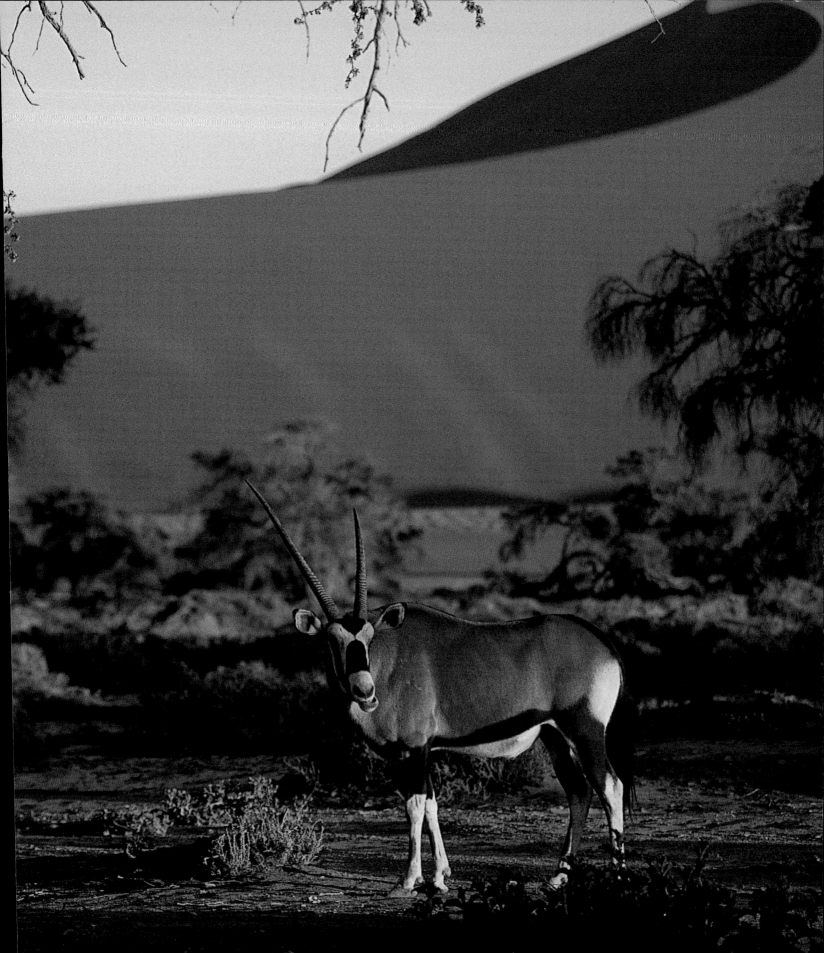

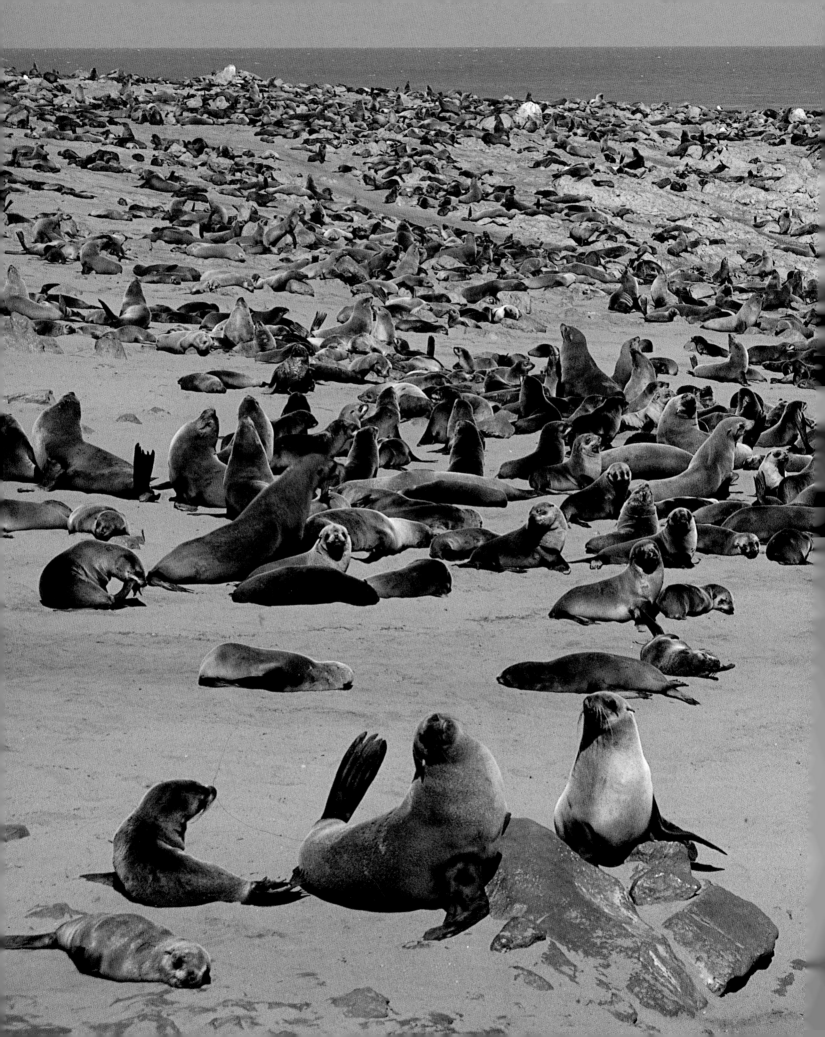

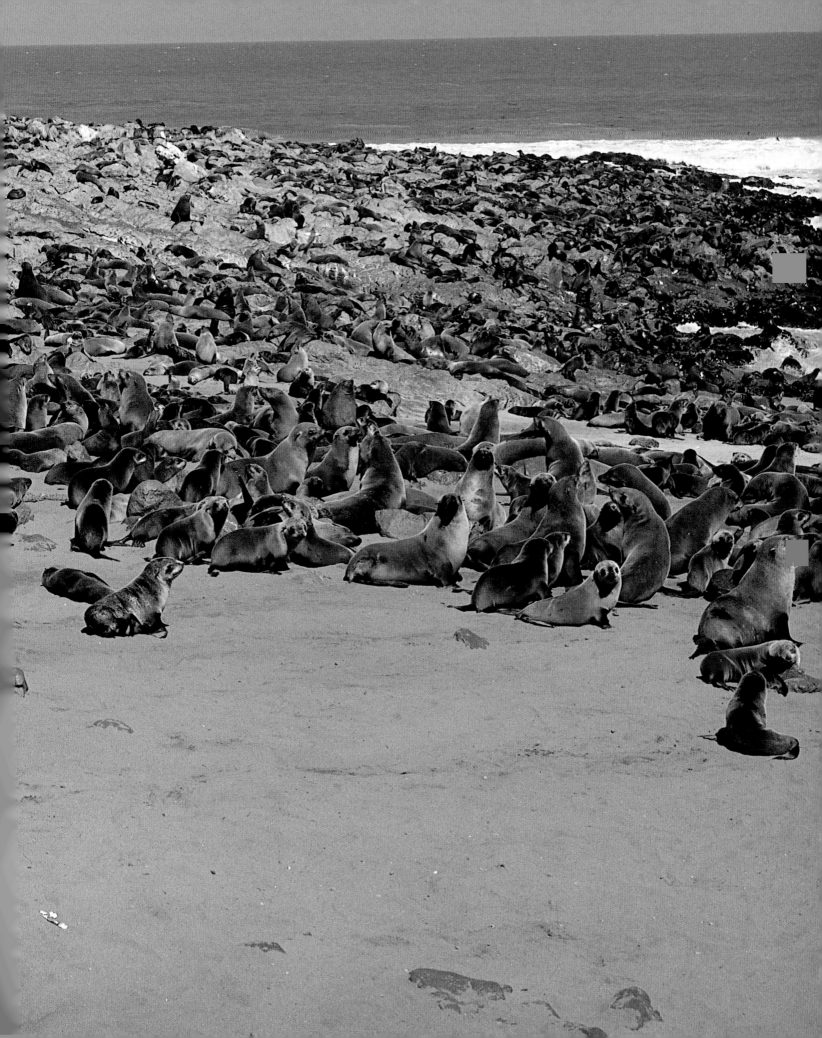

PREVIOUS PAGE AND BELOW: *At Cape Cross saline lagoon, thousands of South African fur seals come ashore. Here they have created their own sanctuary. Cape Cross, Namibia.*

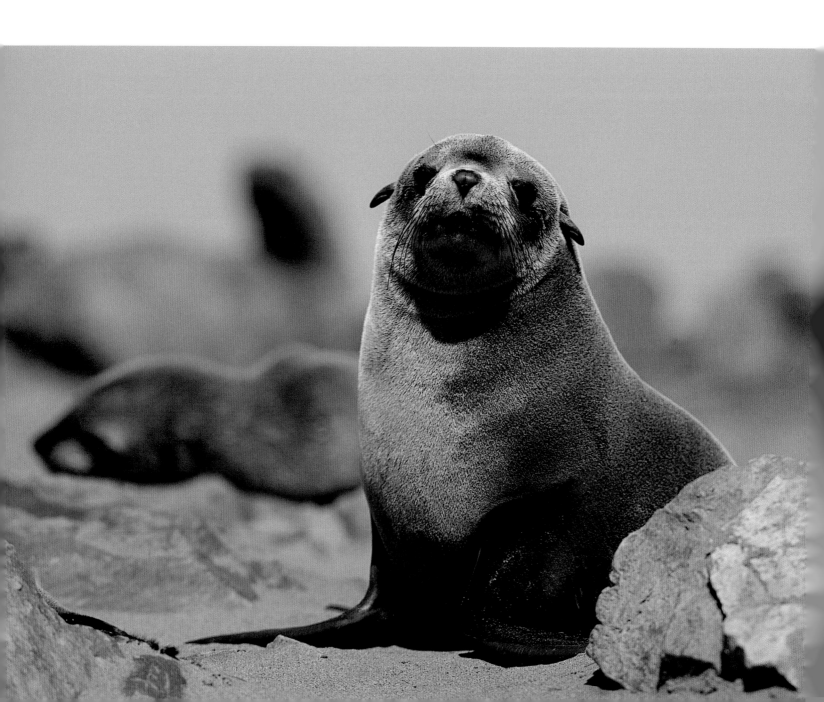

Fur seals at Cape Cross. The desert stretches right out to Namibia's Atlantic coast, where the cold Benguela current that flows up from the Antarctic meets the African continent. The current carries with it nutritious water that is particularly rich in plankton and fish, which is why more than 50,000 South African fur seals gather in the large colony at Cape Cross. Jackass penguins too nest on these shores, adding to the impression that, in the midst of the arid sand, a little bit of the Antarctic has been exported to Africa. The first European who set foot on Cape Cross was the Portuguese explorer Diego Cão, in 1486. A replica of the stone cross he raised on the site can be seen today beside the seal colony.

The stretch of coast north of Cape Cross is known as the Skeleton Coast – innumerable vessels have been shipwrecked here over the years. If the sailors did not drown they died once they reached the shore. Castaways stood no chance of survival in the desert.

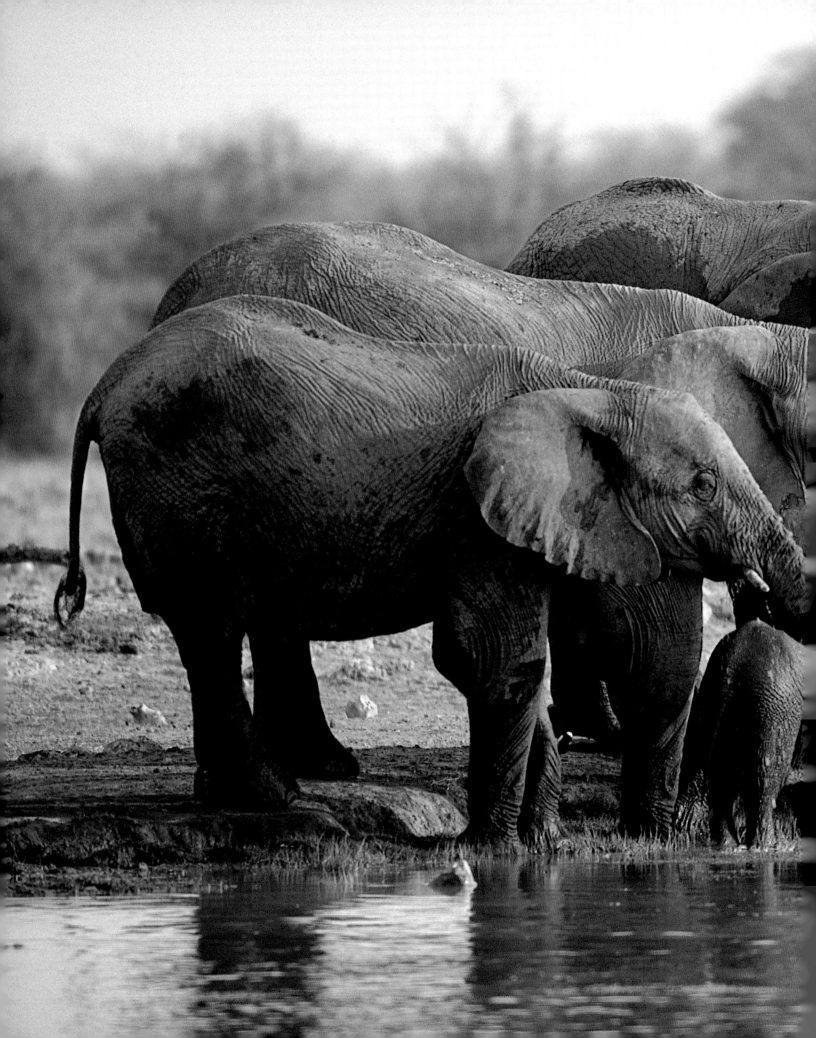

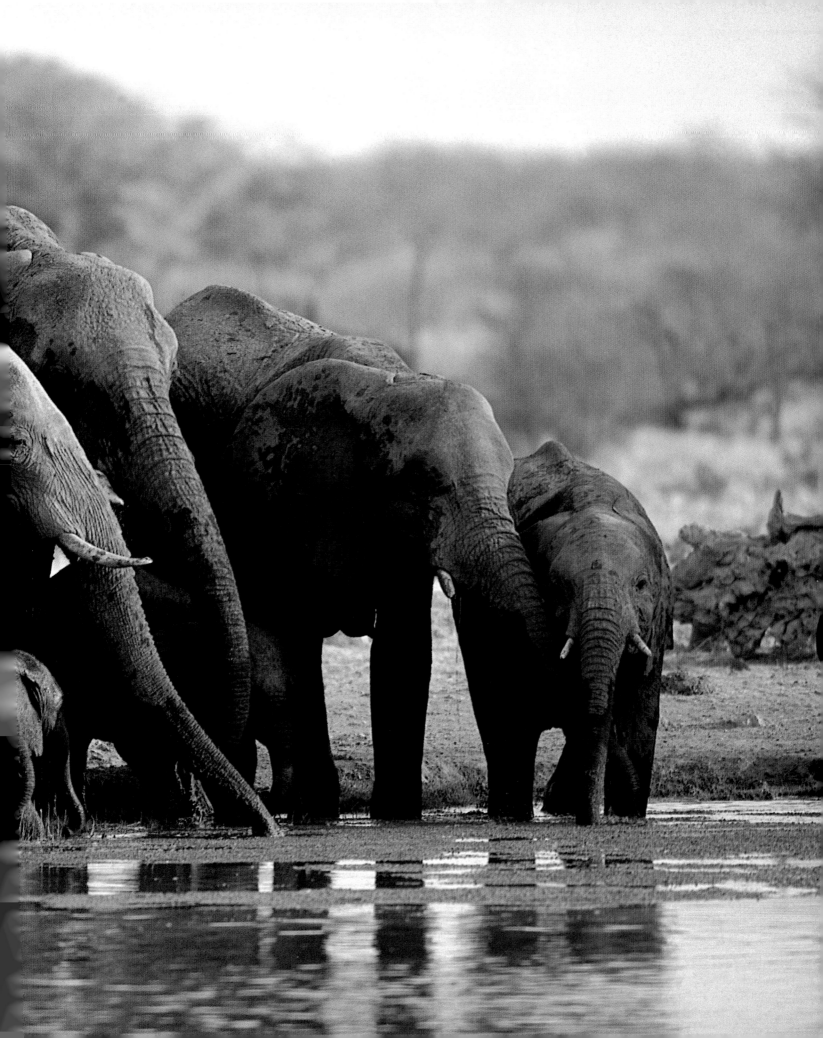

The elephants' drinking party. In the 8,500-square mile (22,000-sq km) Etosha national park in northern Namibia elephants, rhinoceros, gemsbok and springbok flourish – the latter two in large numbers. At a waterhole in the late afternoon at least a hundred elephants take a mass mud bath. They spray water and mud alternately, roll over and wallow, enjoying the chance to cool down after another long, hot day.

Night visit. It is not just in daylight that thirsty guests visit Etosha's waterholes. An elephant cow and her calf come lumbering into view in the spotlights, which have been set up to enable watching tourists – hidden safely behind a 5-foot (1.5-m) high stone wall – to see the animals. A few giraffes also emerge from the murky void, but the biggest treat awaits the visitors who persevere until three in the morning, when four lions come to drink.

At another waterhole on a different night eight rhinoceros come to quench their thirst. We are thrilled – there are very few places where it is possible to see so many rhinoceros together. Although the Namibian desert is famous for its population of black rhinoceros, their numbers are dwindling fast. Only about a hundred of the animals live here today, and they need a lot of space – almost 800 square miles (2,000 sq km) – to survive, ten times more than in other areas of Africa because the food resources in the desert are so limited.

PREVIOUS PAGE: *A group of elephants drinking together. Etosha, Namibia.*

RIGHT: *Giraffes in the spotlight. Etosha, Namibia.*

NEXT PAGE: *An elephant cow and her calf visit an illuminated waterhole. Etosha, Namibia.*

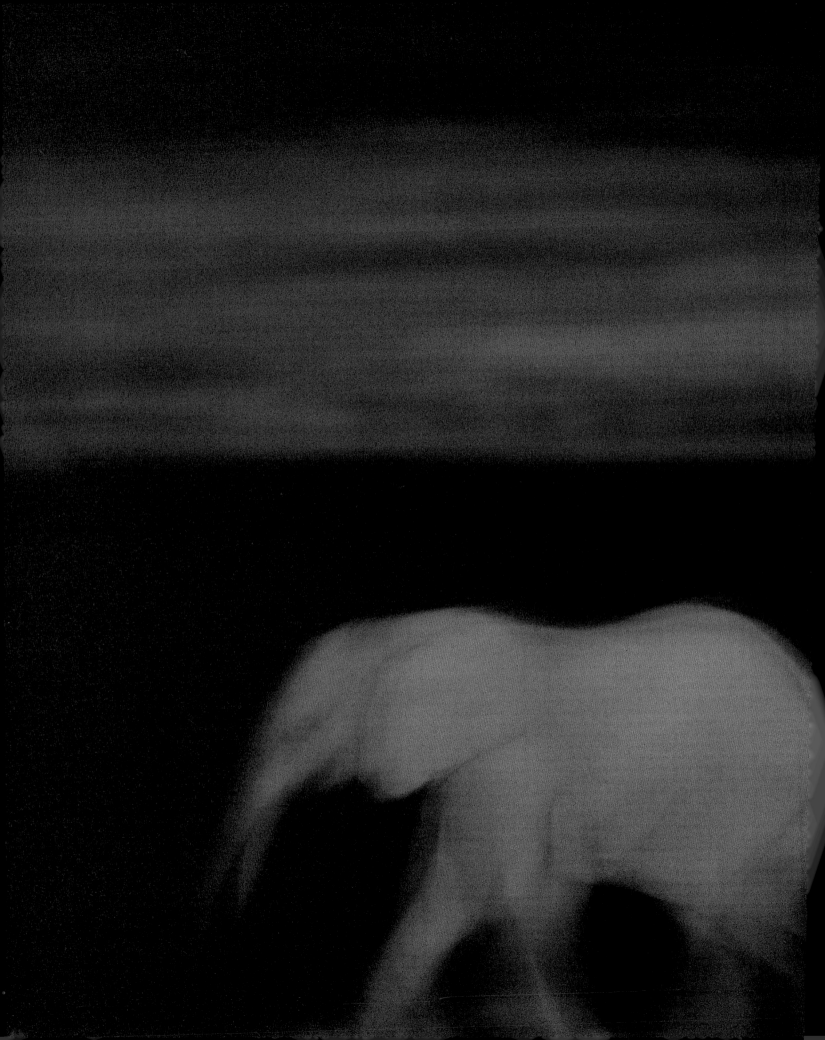

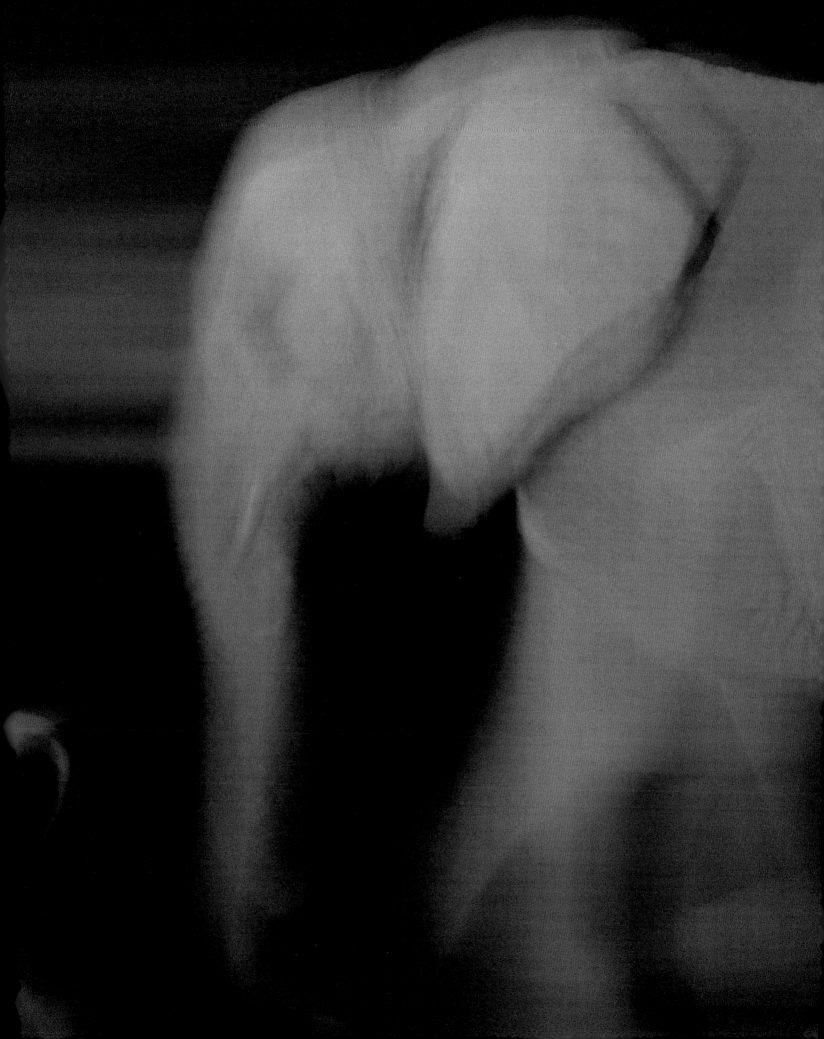

Desert landscape. According to the San people, Namibia is "the land that God created in wrath". When you stand in the middle of the desert, beautiful as it is, it is easy to understand why they think like that.

Namibia is one of Africa's most sparsely populated countries, and has very few towns. The largest – Windhoek – is the capital and a relic of the German colonial era when the country was called German Southwest Africa. The Namibian landscape is varied, ranging from desert sand dunes and savanna, scattered with a few lonely trees, to ridges and mountains, and even meteorite craters.

One of the strangest of all plants flourishes far out on the bare, stony plains, and can live for up to 2,000 years. Described for the first time by the Austrian botanist Friedrich Welwitsch in 1859, and named *Welwitschia mirabilis*, it has two long, leathery leaves growing one on either side of a cork-like stem. Strangely enough the plant is classified as a tree, and is related to conifers.

LEFT: *A tree, as bare and pared down as its surroundings, casts its shadow on the cliff wall. Damaraland, Namibia.*

BELOW: *The remarkable desert plant* Welwitschia mirabilis. *Welwitschia Plain, Namibia.*

Images from the distant past. The cliffs of Twyfelfontein in Namibia are home to Africa's largest collection of prehistoric rock engravings. This is the heart of the territory of the San people, once known as Bushmen, and it is thought that it was their ancestors who carved these remarkable images out of the rock thousands of years ago.

Very few human figures appear in the engravings. Instead, most depict animals, including elephants, rhinoceros, giraffes and lions, and some species that are no longer found in the region. An image of a sea lion indicates that the early San had contact with the coast, more than 60 miles (100 km) away. A total of more than 2,500 stone engravings have been discovered in this area.

BELOW AND RIGHT: *Rock engravings that are thousands of years old decorate cliffs in the San people's homeland. Twyfelfontein, Namibia.*

NEXT PAGE: *Thousands of African buffalo kick up dry earth into the air, creating the reddest sunset imaginable. Chobe, Botswana.*

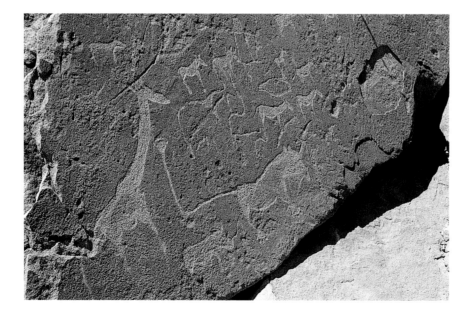

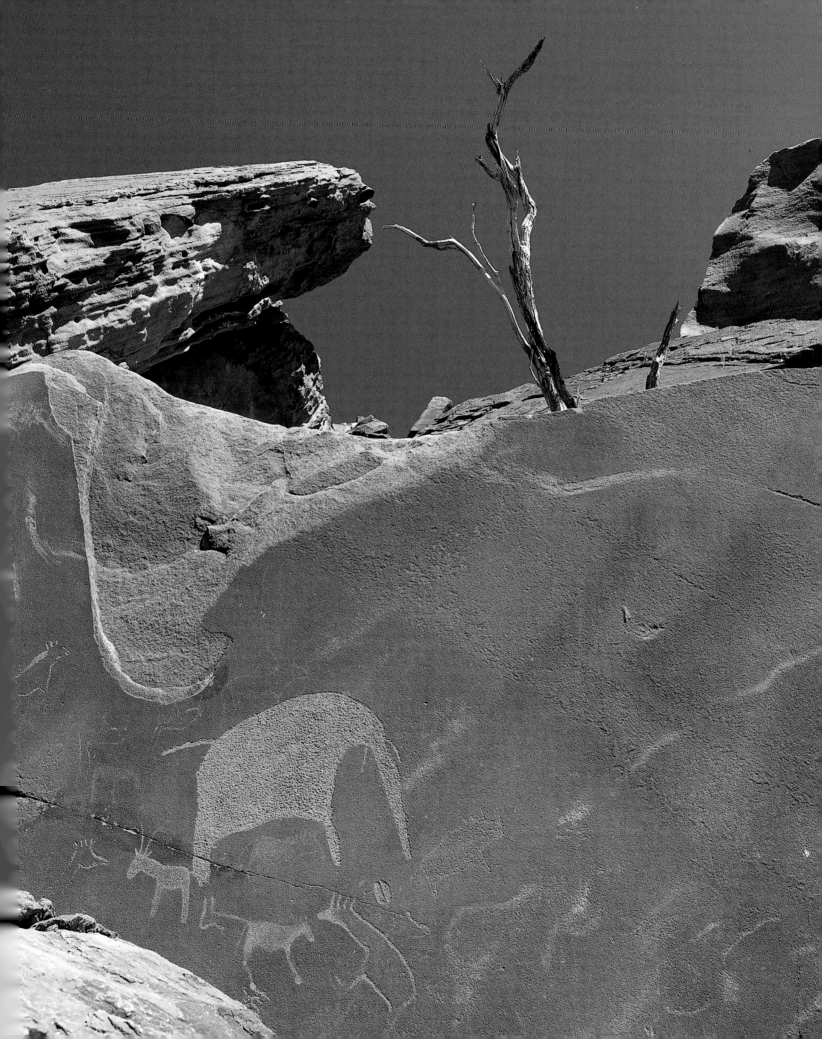

To our relief, the scorching heat has subsided at last, yet we know that in the morning we will awake to frost and bitter cold.

That is part and parcel of a stay in the desert – huge differences in temperature between day and night.

Our journey through wild Africa is over.

INDEX